HIROSHIMA

ASIAN VOICES
A Subseries of Asia/Pacific/Perspectives
Series Editor: Mark Selden

For more books in this series, go to
rowman.com/Action/SERIES/RL/ASV

HIROSHIMA

The Autobiography of Barefoot Gen

Nakazawa Keiji

Edited and Translated by
RICHARD H. MINEAR

ROWMAN & LITTLEFIELD
Lanham • Boulder • New York • London

Published by Rowman & Littlefield
A wholly owned subsidary of The Rowman & Littlefield Publishing Group, Inc.
4501 Forbes Boulevard, Suite 200, Lanham, Maryland 20706
www.rowman.com

Unit A, Whitacre Mews, 26-34 Stannary Street, London SE11 4AB, United Kingdom

British Library Cataloguing in Publication Information Available

The Library of Congress has cataloged the hardcover edition of this book as follows:

Nakazawa, Keiji.
 [Hadashi no Gen jiden. English]
 Hiroshima : the autobiography of Barefoot Gen / Nakazawa Keiji ; edited and translated by Richard H. Minear.
 p. cm. — (Asian voices)
 Includes index.
 1. Nakazawa, Keiji. 2. Cartoonists—Japan—Biography. 3. Comic books, strips, etc.—Japan—History. 4. Nakazawa, Keiji. Hadashi no Gen. 5. Nakazawa, Keiji—Childhood and youth. 6. Nakazawa, Keiji—Family. 7. Atomic bomb victims—Japan—Hiroshima-shi—Biography. 8. Hiroshima-shi (Japan)—History—Bombardment, 1945—Personal narratives. 9. Hiroshima-shi (Japan)—Biography. 10. Japan—Biography. I. Minear, Richard H. II. Title.
 NC1709.N26A2 2010
 741.5'952—dc22
 [B]
 2010020806

ISBN 978-1-4422-0747-9 (cloth : alk. paper)
ISBN 978-1-4422-0748-6 (pbk. : alk. paper)
ISBN 978-1-4422-0749-3 (electronic)

♾™ The paper used in this publication meets the minimum requirements of American National Standard for Information Sciences—Permanence of Paper for Printed Library Materials, ANSI/NISO Z39.48-1992.

Printed in the United States of America

CONTENTS

EDITOR'S INTRODUCTION

Richard H. Minear

Many in the English-speaking world need no introduction to *Barefoot Gen*.* They have read the manga, available in ten volumes in fine translation, or they have seen the animated movie, available on YouTube and elsewhere. *Barefoot Gen* is already international. It started in Japan, as a manga serial, in 1973. Then a relatively unknown manga artist, Nakazawa Keiji completed the serial in 1985. By then it had grown into a ten-volume book. *Barefoot Gen*'s Japanese readers number in the many tens of millions. And there have been film versions: a three-part live-action film (1976–1980), a two-part anime (1983 and 1986), and a two-day television drama (2007). There is a book of readers' responses, *Letters to Barefoot Gen*. On GoogleJapan, "*Hadashi no Gen*" returns more than two million hits.

What has its impact been outside of Japan? In the late 1970s there was a first, partial English translation of the manga. It has now appeared in a second, complete translation (Last Gasp, 2004–2009). Volume I has an introduction by Art Spiegelman, creator of *Maus*. Spiegelman begins: "*Gen* haunts me. The first time I read it was in the late 1970s, shortly after I'd begun working on *Maus*. . . . *Gen* effectively bears witness to one of the central horrors of our time. Give yourself over to . . . this extraordinary book." R. Crumb has called the series "Some of the best comics ever done." Wikipedia has articles on *Barefoot Gen* and Keiji Nakazawa and on the films, the anime, and the television drama. On YouTube, the

Gen is pronounced with a hard *g* and a short *e*, as in *again*, where the second syllable is pronounced to rhyme with *then*. *Hadashi* means barefoot. Hence, "Gen of the Bare Feet." In the final chapter of this autobiography, Nakazawa explains the origin of the name: "I called the protagonist 'Gen' in the sense of the basic composition of humanity so that he'd be someone who wouldn't let war and atomic bomb happen again." (*Gen* is the first half of the compound *Genso*, meaning chemical element.)

anime sequence of the dropping of the bomb—in English—has racked up more than one hundred thousand views, and the rest of the anime is also available. There are translations into Dutch, Esperanto, German, Finnish, French, and Norwegian, with others in the works.

The Autobiography of Barefoot Gen may well come as a surprise to those in the English-language world who don't read manga or watch anime. I hope it will lead them to seek out both versions. Even those who already know *Barefoot Gen* may wish to relive that story in a different genre. After all, manga has its conventions, and they differ from the conventions of prose autobiography. In his introduction to the ten-volume English translation of the manga, Spiegelman mentions the "overt symbolism" as seen in the "relentlessly appearing sun," the "casual violence" as seen in Gen's father's treatment of his children, and the "cloyingly cute" depictions. Under the latter category Spiegelman discusses the "Disney-like oversized Caucasian eyes and generally neotenic faces." Neotenic? *Webster's Encyclopedic Dictionary* (1989) defines *neoteny* as "the retention of larval characters beyond the normal period; the occurrence of adult characteristics in larvae." Spiegelman has the latter definition in mind: consider our cover and its faces of Gen, age six, and Tomoko, a few months old.

Apart from the illustrations he drew specifically for the autobiography, those conventions do not apply to Nakazawa's autobiography. Beyond the conventions Spiegelman mentions, I would comment that even though he *writes* of the extreme hunger that most Japanese experienced in 1945, he *depicts* all of his characters as remarkably well-fed. Such is also the case with the almost Rubenesque figures in the Hiroshima screens of Iri and Toshi Maruki.* Nakazawa had no formal training in art, but perhaps conventions of the art world trumped memory.

The autobiography has appeared in two editions. It appeared first in 1987, with the title *The Void That Is "Hiroshima"—Account of the Nakazawa Clan*. Nakazawa revised that version and reissued it in 1995 in the version that I have translated.† It poses few problems of translation, but I should mention one issue: the names of family members. Throughout the autobiography, Nakazawa refers to his older brothers as "Oldest brother" and "Next oldest brother." I have identified them always by the given names he uses in *Barefoot Gen*, Kōji and Akira. He uses given names consistently

The Hiroshima Murals: The Art of Iri Maruki and Toshi Maruki, ed. John W. Dower and John Junkerman (Tokyo: Kodansha International, 1985).

† *"Hiroshima" no kūhaku—Nakazawa-ke shimatsuki* (Tokyo: Nihon tosho sentā, 1987); *'Hadashi Gen' no jiden* (Tokyo: Misuzu, 1995).

for his older sister, Eiko, and baby sister, Tomoko. He refers to his younger brother throughout as Susumu. (The manga calls him Shinji. *Susumu* and *Shin* are alternate readings of the same character.)*

Nakazawa's *Autobiography of Barefoot Gen* makes compelling reading. Mark Selden has written that it is "in certain ways the most riveting book we have on the bomb." Suitable—if that's the right word—for readers of all ages, this may be the single most accessible account of the Hiroshima experience. Needless to say, it is Nakazawa's account, and it is colored by his biases. These include an intense aversion to the wartime Japanese government and its policies, domestic and foreign, and an understandable hatred of the American military that dropped the atomic bomb on Hiroshima.

This translation preserves the character and quality of the original. To reach the broadest possible English-language audience, I have left few Japanese terms beyond manga and anime untranslated. I have even translated the term *hibakusha* as "bomb victim" or "bomb victims." I have deleted specific place names where it was possible to do so without altering the narrative. I provide maps of Nakazawa's Hiroshima, a limited number of footnotes, and five excerpts from *Barefoot Gen*. But these additions are not essential to a thoughtful reading of the book. As an appendix I include an excerpt from an interview with Nakazawa that took place in August 2007.

This book is a translation of Nakazawa Keiji's prose autobiography. It also includes, between the prose chapters, four-page excerpts from Nakazawa's graphic novel *Barefoot Gen*. The complete *Barefoot Gen* fills ten volumes, a total of some twenty-five hundred pages. These excerpts are intended to give readers who have not read it a taste of the manga.

Graphic novels are works of art with their own conventions and perspectives. They are not "creative nonfiction," an oxymoron I encountered for the first time in a discussion of a recent fraudulent book on Hiroshima.[†] They are fictional even if based on actual events. Like Spiegelman's *Maus*, *Barefoot Gen* is an artistic representation of reality. Compare *Barefoot Gen*

*Nakazawa refers to his mother throughout as Mother/Mom, but on August 6 his father cries out to "Kimiyo." The *manga* gives her name as Kimie. In the *manga*, she calls her husband "Daikichi."

†Charles Pellegrino, *The Last Train from Hiroshima: The Survivors Look Back* (New York: Henry Holt, 2010). A *New York Times* account of the brouhaha that has greeted Pellegrino's book quoted Jeffrey Porter of the University of Iowa, "There's a hazy line between 'truth' and invention in creative non-fiction, but good writers don't have to make things up." Motoko Rich, "Pondering Good Faith in Publishing," *New York Times*, March 9, 2010, p. C6. For an extended discussion of the issues involved in this hoax, see my "Misunderstanding Hiroshima," Japanfocus.org.

and this autobiography, and numerous contrasts emerge. Nakazawa himself has pointed to one important one:

> What differs about the death of my father from *Barefoot Gen* is that I myself wasn't at the scene. Mom told me about it, in gruesome detail. It was in my head, so in the manga I decided to have Gen be there and try to save his father. Mom always had nightmares about it. She said it was unbearable—she could still hear my brother's cries. Saying "I'll die with you," she locked my brother in her arms, but no matter how she pulled, she couldn't free him. Meanwhile, my brother said, "It's hot!" and Dad too said, "Do something!" My older sister Eiko, perhaps because she was pinned between beams, said not a thing. At the time, Mom said, she herself was already crazed. She was crying, "I'll die with you." Fortunately, a neighbor passing by said to her, "Please stop; it's no use. No need for you to die with them." And, taking her by the hand, he got her to flee the spot. When she turned back, the flames were fierce, and she could hear clearly my brother's cries, "Mother, it's hot!" It was unbearable. Mom told me this scene, bitterest of the bitter. A cruel way to kill.[*]

Gen's presence at a crucial moment when Nakazawa Keiji was absent is not the only difference. To sustain the twenty-five hundred pages of *Barefoot Gen*, Nakazawa invented subplots. One example is the character Kondō Ryūta, who appears nowhere in the autobiography. Astonishingly, the recent fraudulent book treats Ryūta as a real person, including him, for example, in his appendix "The People": "A five-year-old Hiroshima orphan, unofficially adopted into the family of Keiji 'Gen' Nakazawa. He lived in the same neighborhood as Dr. Hachiya." It's as if a historian of the European holocaust were to treat one of the characters in Art Spiegelman's *Maus* as a real person.[†]

Barefoot Gen is art. This book is autobiography. Even if, as a genre, autobiography is notorious for a bias in favor of the author, sheer fabrication is beyond the pale.

A word about "translating" manga. Manga traditionally begin at the "back" of the book—"back," that is, to readers of English or German or

[*]"*Barefoot Gen*, Japan, and I: The Hiroshima Legacy: An Interview with Nakazawa Keiji," tr. Richard H. Minear, *International Journal of Comic Art* 10, no. 2 (fall 2008): 311–12. An excerpt from this interview is an appendix to this book.

[†]Pellegrino, *The Last Train from Hiroshima*, 325. Without footnotes, without a list of interviewees and the dates of the interviews, Pellegrino's assertions are impossible to evaluate and hence virtually worthless. At best, those survivor accounts are sixty-year-old memories of the event, and intervening events and experiences have played a major, if undocumented, role.

French. The cartoons read right to left, not left to right. The artist conceives from right to left; readers read from right to left. How do translators deal with this fundamental difference of perspective? One approach is to leave the drawings unchanged and simply reverse the page order: the last page becomes the first page, and the first page becomes the last page. This was the approach taken when *Barefoot Gen* was first translated in 1978. One page (120) is shown on page xii.

A second approach is to reverse the page order *and* flip individual panels. The right side of each frame becomes the left; the left side becomes the right. (Digital technology makes such reversal easy.) So readers accustomed to "reading" drawings from left to right get a better sense of what Japanese artists intend and Japanese readers experience. That is the approach of the recent translation from which these excerpts are taken. A version of the same page can be seen on page xiii.

A comparison of these two examples shows immediately one major disadvantage of flipping pages or panels: the Atomic Bomb Dome here is on the wrong side of the river and to the left of the bridge instead of to the right. We gain in terms of artistic perspective but lose in terms of reality. Further, as this page shows, the third frame has been left unflipped, presumably for aesthetic reasons. On an earlier page (I.111), only one of nine panels has been flipped. This approach emphasizes the integrity of the individual panel, perhaps at some cost to the integrity of the page, especially when the visual impact of a two-page spread is involved. A third approach leaves the Japanese page order *and* panels untouched and begins at the "back." This is the approach many recent manga translations take. Whatever its merits, that approach can hardly work here, where the text is English-language prose and the manga excerpts run between chapters.

The illustrations Nakazawa drew to illustrate this autobiography presuppose a Japanese, not an English-language audience, so I have flipped them; the photographs, of course, are unchanged. But in several of the illustrations Nakazawa drew for this autobiography, Japanese writing is integral to the drawing. Reversing the drawing reverses the characters, too; so a second reversal is necessary. The plates introducing chapters required similar treatment. Still, consider the plate (p. 18) showing Gen's brother's school class marching off to evacuation: the teacher leading the way now salutes with his left hand. Similarly, in the plate for chapter 5 (p. 120), reversal turns the right-handed Nakazawa into a left-handed cartoonist.*

*There are two other changes to note. In the plate showing the principal accusing Gen's sister of stealing from her classmate, the large characters on the wall read (right to left) "patriotism." These are the third and fourth characters of a wartime slogan, "Loyalty and patriotism." But now,

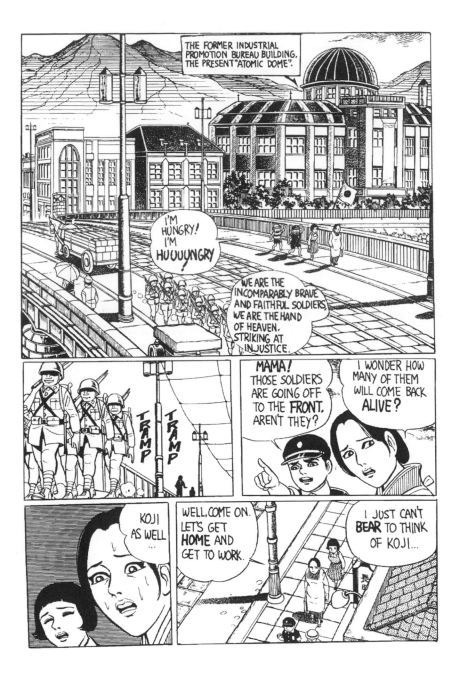

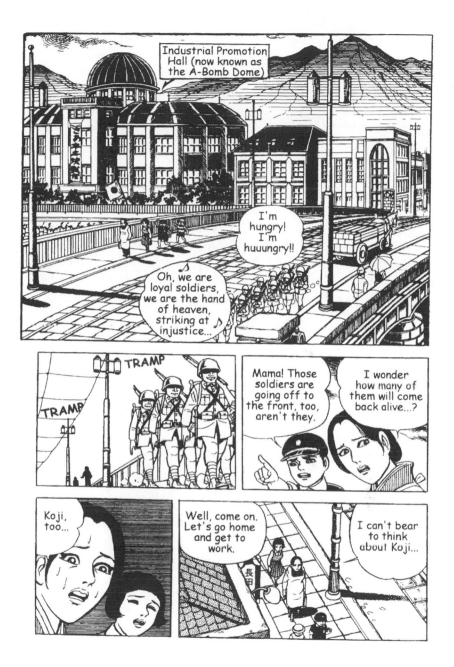

There is no perfect solution. As with all translation from one language to another, so with manga: readers should remain constantly aware that what they have in front of them is an approximation or interpretation of Nakazawa's original, not a replication.

Nakazawa Keiji was born in March 1939. I was born less than three months earlier, in December 1938. He experienced wartime Hiroshima, the atomic bomb, and the austerity—to put it mildly—of the early postwar days. I experienced Evanston, Illinois, and Newton Center, Massachusetts. I was the child of an academic family. My father was a Protestant theologian; my mother had taught high school English. The Pacific War had no impact on me that I was aware of. How different our two worlds!

Yet Hiroshima has played a major role in my professional life. In the late 1960s, I grew disaffected with U.S. policy in Vietnam. I remember reading Noam Chomsky's essay, "The Responsibility of Intellectuals," which appeared first in the *New York Review of Books* on February 23, 1967. There Chomsky begins by citing Dwight Macdonald on the question of the guilt of peoples for the actions of their governments and mentions Hiroshima briefly: "To what extent are the British or American people responsible for the vicious terror bombings of civilians, perfected as a technique of warfare by the Western democracies and reaching their culmination in Hiroshima and Nagasaki, surely among the most unspeakable crimes in history." The bulk of that essay was about American war crimes in Vietnam, of more concern to me then than Hiroshima. In a later essay that year, Chomsky quotes Justice Radhabinod Pal, the Indian judge at the Tokyo trial, at great length. The passage from Pal concludes: "if any indiscriminate destruction of civilian life and property is still illegitimate in warfare, then, in the Pacific war, this decision to use the atomic bomb is the only near approach to the directives of the German Emperor during the first World War and of the Nazi leaders during the second World War."* With these essays, Chomsky expanded for me the realm of the thinkable and the sayable. That new freedom led directly to the tone and content of my *Victors' Justice: The Tokyo War Crimes Trial* (1971), in which I presented Pal's opinion on a number of issues and found it entirely tenable.

of necessity, the third and fourth characters have become the first and second. In the plate showing water tanks in the ruins of Hiroshima, the tank now on the left edge originally had the third and fourth characters of the four-character phrase: "water for fighting fires." Now those characters have been replaced with the first and second characters, copied from the tank now on the right.

★"The Revolutionary Pacifism of A. J. Muste: On the Backgrounds of the Pacific War," *Liberation* 12 (September–October 1967); reprinted in Chomsky, *American Power and the New Mandarins* (New York: Pantheon, 1969), 168–69.

Beginning in the mid-1980s, I translated the monuments of Hiroshima literature, the literature of the atomic bombing: Hara Tamiki's *Summer Flowers*, Ōta Yōko's *City of Corpses*, Tōge Sankichi's *Poems of the Atomic Bomb*, which were all part of *Hiroshima: Three Witnessees*, and Kurihara Sadako's *Black Eggs*. (In press now is my translation of the autobiography of Ōishi Matashichi, who was on board the Japanese fishing vessel *Lucky Dragon #5* when it was contaminated by radiation from the U.S. hydrogen bomb test at Bikini in 1954.*) In various ways these works affected my teaching, as did the superb film by John Junkerman and John W. Dower about the artists Maruki Iri and Maruki Toshi, *Hellfire: A Journey from Hiroshima* (1986). So also two short films: *The Air War against Japan, 1944–1945*, chapter 23 of *The Air Force Story*, a massive official film history of the air campaigns of World War II (1946), and *Hiroshima Nagasaki August, 1945*, a compilation of footage taken by Japanese photographer Iwasaki Akira and then kept out of circulation until 1970. (U.S. Occupation censors were responsible for the blackout until 1952; thereafter it was largely a matter of chance.) These two films are short enough that I could show both of them in a fifty-minute class and still have time for discussion. The sound track of the former features triumphant trumpets as the atomic cloud rises over Hiroshima, its inhabitants, of course, unseen. The atonal, otherworldly soundtrack of the latter underscores close-ups of unspeakable human suffering on the ground. The contrast always left my students stunned and questioning.

That contrast still survives today. American textbook treatments of Hiroshima since World War II, the fiasco at the Smithsonian in 1995, when political pressure prevented even the most careful questioning of the Hiroshima decision, the decision of the Obama administration in spring 2010 against adopting a "no first use" policy: these are all different facets of the same phenomenon—denial. Even sixty-five years after Hiroshima, we refuse to face the reality of nuclear war. Just this spring we learned of an American serviceman who claimed, falsely, to have been in the B-29 that photographed the bombing of Hiroshima.† Why make such a claim except

**Hiroshima: Three Witnesses* (Princeton, N.J.: Princeton University Press, 1990); *Black Eggs* (Ann Arbor: Center for Japanese Studies, University of Michigan, 1994); *When We Say "Hiroshima": Selected Poems* (Ann Arbor: Center for Japanese Studies, University of Michigan, 1999); Ōishi Matashichi, *The Day the Sun Rose in the West: Bikini, the* Lucky Dragon #5*, and I* (Honolulu: University of Hawaii Press, forthcoming).

†In *Last Train* Pellegrino quotes Joseph Fuoco at length. Fuoco claimed to have been a last-minute replacement. Pellegrino himself claimed to have had a Ph.D. in zoology (Victoria University, New Zealand, 1981), but the university has now refuted that claim. So Pellegrino's trust in Fuoco may be an instance of the scammer scammed. Even so, the scammer may well laugh last. James Cameron, director of *Titanic*, for which he won an Oscar, and *Avatar*, for which Pellegrino was a scriptwriter, has already optioned *Last Train* for a film. Indeed, Cameron wrote

to bask in the glory of a "successful" mission? Yet Nakazawa and many other bomb victims who really were there concealed their past, hoping to avoid the supposed shame. Why not admit to having been in Hiroshima on August 6 unless there is a social price to be paid?* A man on the sidelines fakes involvement in order to share supposed glory; many directly involved pretend not to be involved in order to avoid supposed shame. We have all lived in nuclear denial.†

In his note to the 2004 English translation of the manga, Nakazawa writes: "Human beings are foolish. Thanks to bigotry, religious fanaticism, and the greed of those who traffic in war, the Earth is never at peace, and the specter of nuclear war is never far away. I hope that Gen's story conveys to its readers the preciousness of peace and the courage we need to live strongly, yet peacefully. In *Barefoot Gen*, wheat appears as a symbol of that strength and courage. Wheat pushes its shoots up through the winter frost, only to be trampled again and again. But the trampled wheat sends strong roots into the earth and grows straight and tall. And one day, that wheat bears fruit."

ACKNOWLEDGMENTS

I am indebted to Nakazawa Keiji for permission to translate this book into English and for permission to reproduce illustrations from the book and from *Barefoot Gen*. Asai Motofumi, director of the Hiroshima Peace Institute, served as contact person with Nakazawa. I thank him for his very important help. I am most grateful to Colin Turner of Last Gasp for permission to reproduce excerpts from Last Gasp's fine *Barefoot Gen*, 10 volumes (San Francisco: Last Gasp, 2004–2009).

Kyoko Iriye Selden, herself a translator of Hiroshima literature, helped me enormously by comparing the translation very carefully with the original and suggesting many corrections and improvements; I am greatly in her debt. Mark Selden read the manuscript with care. This is the fourth time Susan McEachern of Rowman & Littlefield has acquired a manuscript of mine, and each time it has been a pleasure to work with her. Janice Braunstein served ably as production editor. Don Sluter drew the maps and provided last-minute emergency assistance. Tyran Grillo scanned and reversed the illustrations.

a lead blurb for *Last Train*, and that blurb is true in a way Cameron never suspected: *Last Train* "combines intense forensic detail—some of it new to history—with unfathomable heartbreak."

*Victims of the bomb faced discrimination from nonvictims who feared the effects of radiation on future offspring.

†Cf. Robert Jay Lifton and Greg Mitchell, *Hiroshima in America: Fifty Years of Denial* (New York: Putnam, 1995).

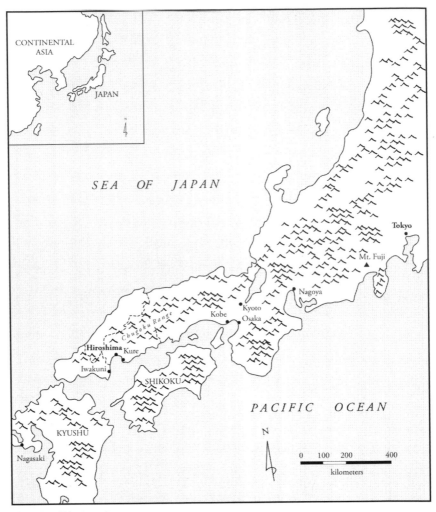

Map 1. Western Japan

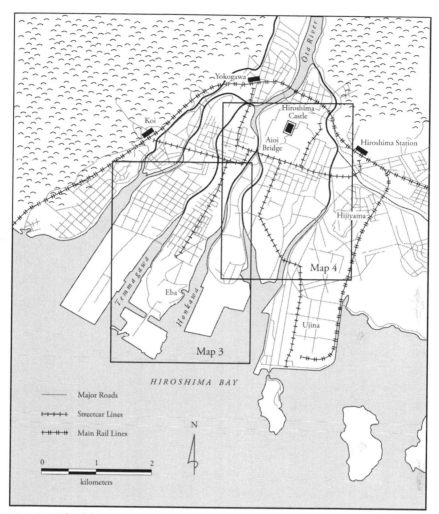

Map 2. Hiroshima

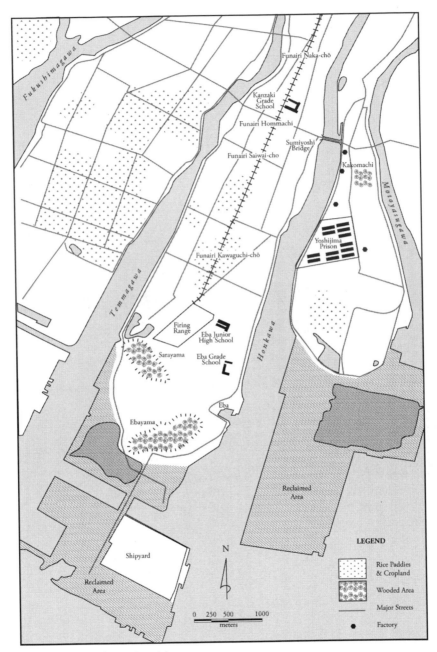

Map 3. Map 1 inset, Funairi

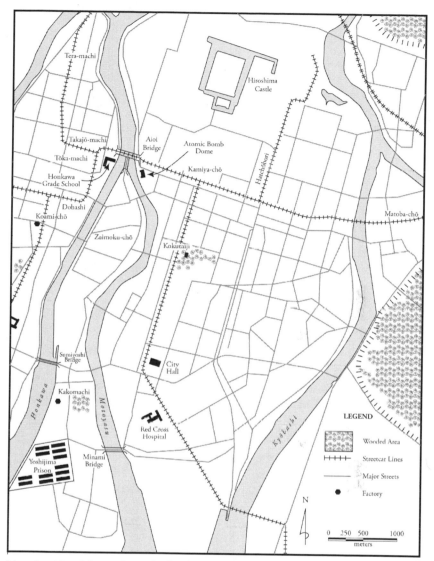

Map 4. Map 2 inset, Central Hiroshima

AUTHOR'S INTRODUCTION

The Dropping of the Atomic Bomb, "Gen," and I

Nakazawa Keiji

You all know the graphic work, *Barefoot Gen*, don't you? It's in libraries and on school bookshelves. You may even have a copy at home.

Barefoot Gen is read not only by Japanese, but also by people around the world. It's been translated into English, French, German, Swedish, Tagalog, and Esperanto, and there are plans for translations into Spanish, Russian, and Chinese. So *Barefoot Gen* is literally the Gen who raced around the world.

I haven't told you yet, but I'm the author of *Barefoot Gen*.

Barefoot Gen depicts a boy (Gen), who on August 6, 1945 witnesses a this-worldly hell when the atomic bomb is dropped on Hiroshima, overcomes the ravages of war, and goes on living life at full speed.

I get letters from lots of people. And when I give speeches—for example, in schools—I'm often asked, "Is Gen's story true?" "Who served as the model for Gen?" Well, who do you think?

Hiroshima's atomic bomb dome stands at right about the center of Hiroshima. Just less than a mile from that dome, there's a place called Funairi Hommachi.* That's where I was born and brought up. Ours was a family of seven. A baby due in August (August 1945!) was in my mother's womb, so perhaps you can say we were a family of eight.

August 6, 1945. I was a first grader. That morning I was at the wall that enclosed the school, talking with the mother of a classmate who had stopped me when the atomic bomb fell. She died instantly. I was pinned beneath the wall and survived miraculously.

*See map 3.

Of my family, Dad, older sister Eiko, and younger brother Susumu died that day. Of my other two brothers, the oldest—Kōji—had gone to Kure as a student-soldier, and the next brother—Akira—had been evacuated with his class to the countryside and was unharmed.

Mom, too, survived, but from then on, her health was fragile from the aftereffects of the bomb. The baby was born into that horror right after the bombing and died soon after birth of malnutrition.

I lost Dad, Eiko, Susumu, and the baby in the atomic bombing and went to live with relatives, where I was treated as an "outsider."

It's true. It's the same life as in *Barefoot Gen*. I'm the model for Gen. *Barefoot Gen* is based on fact. That's why I've given this book the title, *The Autobiography of Barefoot Gen*.

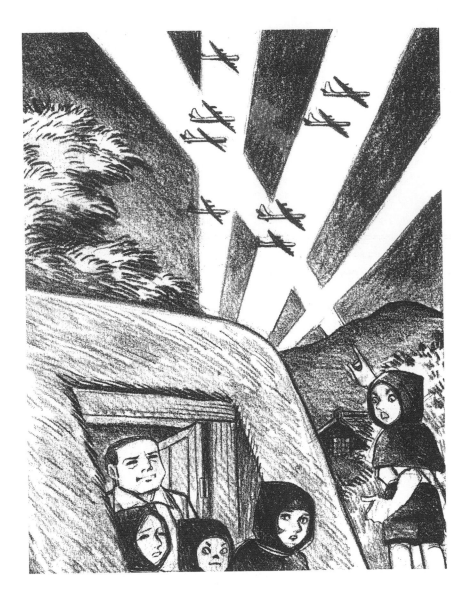

1

PRELUDE TO TRAGEDY

DAD AND MOM

The Nakazawa clan had been low-ranking samurai serving the house of Asano, lords of Hiroshima Castle. With the order of 1871 to abolish the *daimyo* domains and establish instead today's prefectures, the Nakazawa family switched to the business of painting, mainly lacquer, and made its living lacquering the wooden clogs, frames of sliding interior partitions, wooden utensils, and the like, for which Hiroshima was noted.*

My father, Harumi, was the oldest child in a family of three sons and a daughter. Dad didn't enter the family lacquer business. Instead, wanting to set up shop as a printer in the Japanese style, he went to Kyoto and trained in painting and fine lacquering. The Japanese-style painting was in the school of Maruyama Ōkyo.†

My mother, Kimiyo, was the oldest daughter of the Miyake family; she had three brothers and two sisters. The Miyakes lived in Koami-chō; they were bicycle wholesalers. A friend of hers told me that Mom was a fashionable "high collar" girl in the style of the 1920s. At that time if a woman rode a bike, she was derided as a tomboy. But Mom went about town on a bike, stately in split skirt, and went to movies and frequented coffee shops—that is, she was a young woman in free and broad-minded times.

Remembering her arranged marriage with Dad, Mom often laughed.‡ In marriage back then, unlike today, parents made the decisions, and she

*"Hiroshima" can refer narrowly to the city or more broadly to the region or prefecture (Hiroshima Prefecture).

†Maruyama Ōkyo (1733–1795) was a leading ink painter of his day.

‡In traditional Japanese practice, a formal first meeting between prospective marriage partners was arranged by parents or a third party (the go-between).

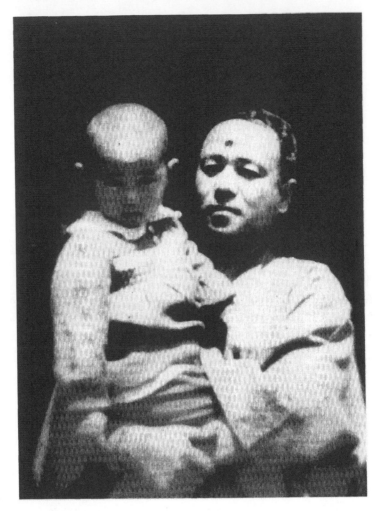

couldn't declare her preferences. Before she knew what was happening, the date for her marriage interview had been set. When, uneasy about not knowing what sort of man she was to marry, she peeked from behind the sliding screen, she was astonished to see someone completely bald, with a shiny pate. She was in tears—"I'll die before I'll marry *him*!" There was a big to-do. Her parents reasoned with her, "You can't call it off at this late date," and the whole family was in turmoil. Then a young man with a full head of hair entered the room and said, "Sorry I'm late." He was the real candidate. Mom said with a smile that when she realized her mistake, she was so embarrassed her face turned flaming red. The bald guy was the go-between.

I was born in March 1939 in Funairi Hommachi, less than a mile from the heart of Hiroshima (the building that is now the atomic bomb dome). There were seven in the family—Dad, Mom, oldest brother Kōji, older sister Eiko, older brother Akira, younger brother Susumu—plus Blackie, the cat. As for my name Keiji, one of my grandfather's brothers had that name. He was apparently a real entrepreneur. He invested his own capital in the development of Ujina Harbor, a project that faced rough going. He cooperated in that enterprise and received a letter of gratitude from the lord of Hiroshima Castle. Later he crossed over to Shikoku, built a home, and died there. Mom told me I was named for him.

Hiroshima was a castle town blessed by nature and climate, with both mountains and ocean: the mountains of the Chūgoku range to the north; the Inland Sea, a calm small-scale landscape, to the south; seven rivers running through town. On the other hand, Hiroshima flourished as a military city. During the Russo-Japanese War, General Headquarters was set up in Hiroshima Castle. Thereafter, too, Ujina Harbor served as the base from which to dispatch soldiers to the southern front, and that practice continued right up to Japan's defeat in 1945. This is where I was raised.

"Artist" is another word for poor, and we were extremely poor. Dad had absolutely no mind for business—even paintings he did on commission he'd hand over generously, as if they were hostess gifts, and he hated taking money. The art galleries took advantage of Dad, accepting his work in his spirit, then making money by selling it at a high price. Mom couldn't accept that, so she'd slip out the back door, hurry to the art galleries and, saying nothing to Dad, collect the money from the gallery: "It doesn't matter what you sell it for; just give us our share."

Engrossed in the paintings and lacquer he himself liked, Dad was a "crazy artist" oblivious to family finances. Mom earned money in the family clog-lacquering business, borrowed money from her own family, and worked day and night to make ends meet. When Mom complained about money, he scolded her: "Money's dirty. Merchants are crafty. Their only thought is to turn a profit by enticing people to spend. I hate them. I'm not the sort that can make money, so get used to it!"

You often hear stories of artists or left-wing zealots spouting idealistic talk. To my mind, it stands to reason that things one creates by one's own sweat should sell for a good bit of money as return on the labor. It's silly to make flimsy excuses, such as "Money's dirty."

That's the way Dad was. He couldn't make a living, so he made Mom weep because of our poverty. But that obstinate Dad—Mom loved him.

Our family's fate depended on Mom's slender arms, and the sight of Mom working herself to the bone is burned into my memory.

DAD DISAPPEARS

The Industrial Arts Exposition Hall (now the atomic bomb dome) was a venue for exhibitions and prefectural art shows. Dad's ink paintings and lacquer were exhibited there, and we children went proudly to see them.

The Dad we were so proud of once disappeared. Scenes from that time etched themselves into my young mind. Evening: two sharp-eyed men stand in our entryway, then pack Dad off with them. Mom's face is ashen, her lips tremble, her hair is in disarray. Watching Dad intently, prayers in her eyes, she sees him off. He sets off with one man holding each arm. I can never forget the sight. Even though I was a child, I understood that a family tragedy had occurred, and I trembled with terror. That after-image is etched onto my heart, painfully.

From that day on, Dad was not there. I often asked Mom where he was. She replied, "Your father went for his military physical." Thereafter my memory fades and goes blank. Was he was away six months? Twelve?— I don't know. The significance of Dad's disappearance became clear only after Japan's defeat, when I met people who knew him.

At the time Dad was devoted not only to ink painting and lacquer but also to the stage. He belonged to the left-wing New Theater Group; it rented halls to put on Shimazaki Tōson's *Before the Dawn*, Gorky's *The Lower Depths*, and other plays. Today, no matter what bookstore or library you go to, it's easy to lay your hands on *Before the Dawn* or *The Lower Depths* and read them, but during the war, under the Peace Protection Law, the winds of ideological oppression blew fiercely, and the authorities were piti-less, throwing into jail those who took issue with the wartime regime. *Before the Dawn* and *The Lower Depths* were classified as "dangerous thought," couldn't be published, and of course couldn't be performed. One after the other, left-wing theater groups disbanded.

Dad's theater group, too, was the subject of police surveillance; it was watched from the rooftop, raided constantly, had its materials confiscated. As suspect individuals, Dad and his buddies were under surveillance. The last left-wing stage performance took place in Osaka, and having seen that, the members of Dad's troupe decided to disband. At its dissolution, the entire group met and took a commemorative photograph. Among them, I understand, were "thought police" spies pretending to be troupe members.

With that commemorative photograph as unshakable evidence, the members of Dad's theater group were arrested as thought criminals, taken to the jail in the Hiroshima Prefectural Offices, and held as prisoners awaiting trial. The sight of Dad being taken from our house is still engraved on my heart, an afterimage of panic.

After the war I mentioned that afterimage to Dad's younger brother Uncle H., and staring at me with surprise, he muttered: "You remember that? Toddlers never forget what they see." Mom, Uncle H., the relatives: they all thought it shameful that the Nakazawa clan had produced a thought criminal, so they kept us children in the dark about the fact that Dad had been detained. Uncle H. became his guarantor, and he met Dad at the jail on his release. That was October 1941, fourteen months after Dad was detained.

Dad's return home after his release from jail is seared onto my retinas. Wearing kimono, he was hunched over, fingers to his teeth, his expression filled with bitterness. Dad's teeth were all loose. When we ate, he tried to use bowl and chopsticks, but his fingers didn't cooperate. Food lay scattered all over his place at the table.

I can't forget the words Dad muttered in mortification: "Inside, they give you food with no salt, and you get so that your hands and fingers stop moving. No pickles." In jail back then, they removed salt from the food they gave detainees. Remove the salt, and people's energy and muscles

atrophy, and they stop functioning. If you're active in jail and cause prob-
lems, the authorities worry that they'll be in trouble. He'd had this diet for
over a year, so of course his teeth grew loose and his muscles atrophied.
Dad came home utterly debilitated, but Mom looked happy as she tried to
cheer him up.

It was always there in a corner of my mind, the thought that I wanted
to learn what Dad's jail life had been like. Years later, I had a visit from a
woman in the same theater group as Dad. The instant she saw me, she said,

"Without a doubt! You're the spitting image of him!" This woman, S., was shocked that I resembled Dad so exactly.

According to S., her most vivid memory of jail life was on January 1. They were all let out of their isolation cells, lined up in the corridor, and the whole theater group sang favorite antiwar songs. The guard was considerate: while they sang antiwar songs, he abandoned his post and took no notice. He must have sympathized with Dad's theater group and thought well of them. After her release, S., too, had had bitter experiences. When talk of marriage arose and the day of the marriage interview approached, the other side always called things off. Like serpents coiling about S., the detectives of the thought police kept up their surveillance; to teach her a lesson, they broke up all her marriage negotiations. They continued to spread rumors about her, that she was a wicked woman; they even treated her family harshly, leaving bad memories.

S. spoke of Dad as if she were leafing through the pages of a fond past. Dad was great in the spotlight reading his lines; when he'd got married, she had thanked Dad for all he'd done for her. The leader of Dad's theater group had been held in Yoshijima Prison, awaiting trial, until Japan's defeat in 1945.

For the fourteen months Dad was detained, Mom had faced great worries about money. With us young ones to feed, she earned money working for all she was worth at the painting of clogs that was the family business. I spoke to the young boss of the guild that handled clogs then; he said it pained him to see Mom at that time—she was so haggard. Her technique wasn't great, so he couldn't give her much work, but he couldn't simply stand by silent. So he'd sent work her way behind his boss's back. But she hadn't produced good stuff, and one time his boss caught on and thundered at him not to send orders Mom's way. Throwing herself on the mercy of her parents, Mom got money to live on. Frantic, she raised us.

DON'T DIE A DOG'S DEATH!

There is another vivid memory from November 1941 burned onto my heart. Mom's younger brother, Uncle Y., resplendent in the uniform of a naval officer and grasping his military sword by its white handle, appeared at our home looking stern. I liked Uncle Y. He was very attractive. I'd told Mom that I wanted to be like him when I grew up. Uncle Y. often came to visit us. When I had a cold or at other times, he'd take off his short sword

and let me play with it. I can't forget the heft of the short sword and the feel of its polished blade.

That day Uncle Y. climbed with nervous step up to Dad's workroom on the second floor and, a serious expression on his face, listened to Dad. That tense atmosphere came across to me, young as I was. I'd gone up with him. Dad unsheathed Uncle Y.'s sword, stood the blade upright, and stared at it. Oppressed by the extraordinary tension, I sat beside Dad and stroked the remarkable white sword. And I compared Dad's grave expression with Uncle Y.'s. I always wondered, "What *was* that all about?"

After the war ended, I learned from Uncle Y., who'd been repatriated, and understood the reason for the tension. Uncle Y. was set to leave from Kure harbor on a submarine to be in the front lines of the Pearl Harbor attack on December 7, 1941, as Japan plunged into the Pacific War. That day he'd come to pay a final farewell to Dad and Mom. The image that lingered, of tension, was because life and death were at stake.

Soon after Uncle Y. set sail, Mom grieved. "Y. died in battle. I felt closest of all to him." She greatly mourned his death. When told that Uncle Y., handsome man, had died, I was stunned. But days later, I remember going to see Uncle Y. at Kure Naval Base accompanying Mom, who was ecstatic—"He survived!"

According to what Mom heard from Uncle Y., the submarine on which Uncle Y. embarked got almost as far as Pearl Harbor, rammed its bow into the mud of the seafloor, got stuck, and couldn't take part in the attack. The air inside the sub turned humid and suffocating, and with their whole bodies drenched in sweat, the crew tried desperately to free themselves. But the bow wouldn't come free, and they all figured they were dead. Uncle Y. was chief engineer, so his responsibility was especially grave. Fortunately, as he was trying desperately to escape by backing the sub out, the bow pulled loose from the mud of the ocean floor, floated free, and the crew tried to take part in the attack. But the sneak attack on Pearl Harbor was already over.

After the war Uncle Y. visited us in our hut, and he often said to us brothers, "Your father was a great man!" I hadn't had the faintest idea why he was great. It was from Uncle Y. that I first learned of Dad's thinking.

Uncle Y. said, "I was the model gung-ho militarist young man." He was a believer, without the slightest doubt: "I would have died happily for the country, for the emperor; Japan was the eternal land of the gods; it was only natural for a 'son of Yamato' to offer up his life to that land of the gods." Forcing a smile, he said he was the model male conforming to the mold of patriotic education. With a flourish, this Uncle Y. said to Dad, "I'm off now to take part in the Pearl Harbor attack. I'll die a splendid death for the country, for the emperor." Dad glared at Y. and said angrily, "Down with the emperor system! This war is wrong. Japan will surely lose! Don't die a dog's death!" Dad went on and on, arguing about how terrible the emperor system was, speaking earnestly about its structure, and arguing about the process whereby the Japanese people, bound hand and foot in the coils of emperor-system fascism, were plunging into war.

When Uncle Y., a firm believer in militarism, heard, "down with the emperor," whom he had thought a god, he thought his head would explode. Stunned, he left for Pearl Harbor. Against all odds, he survived, and with Dad's words always in mind, he avoided exposing himself to danger. When, under fire-bombing by B-29s and strafing by Grumman fighter planes, he was running about at Kure Naval Base, he thought to himself, it's happened just as Dad said it would, and he understood just how prescient Dad had been.

But I found it hard to talk with Uncle Y. He had lived a long time amid the din of submarine engines, so he spoke in a very loud voice, and it was tough for me, listening—I felt I was always being yelled at.

I figured Dad had given that advice only to Uncle Y., but I learned years later from a visit by S., one of the young men who were in and out of our house, that Dad gave them the same advice.

S.'s call-up notice came, and his dispatch to "Manchuria" (now northeastern China) was set. He came to take his leave, and Dad told him, "Down with the emperor system! Japan will surely lose this war, so don't throw your life away!" and Dad made him listen in detail about the process leading from the structure of emperor-system fascism to defeat. S., a militaristic young man, turned white with shock. But when he got to Manchuria and saw Japan's situation, it was as Dad said. He realized that Japan's home islands would be beaten hollow, and he sent frantic letters to his family living in the center of Hiroshima. There was censorship in the service, so he couldn't write what he wanted. He could write only, "Get out!"

S.'s family was puzzled to read all the letters saying, "Quickly, get our possessions together and evacuate from Hiroshima to the countryside." There must be some reason their son was always writing from Manchuria telling them to get out. They gathered their possessions and evacuated. Soon after the family evacuated, the atomic bomb was dropped on Hiroshima. S. listened to Dad's warning, so the lives of his family were saved, and his cherished collection of books didn't burn up, and he was grateful to Dad—that I learned when he came to Tokyo and visited me. I'd had no idea how much influence Dad had exerted over the young men.

Dad was antiwar. I remember the song popular among children— "Mr. Tōjō, Mr. Tōjō, Mr. Tōjō, great man." When we sang it, Dad glared fiercely at us, took us up to the second-floor workroom and angrily told us: "That guy Tōjō you were singing about just now is a bad guy. Don't sing that song!" Dad couldn't excuse Tōjō Hideki, prime minister when they pushed the war. At the time I couldn't understand why Dad was so angry.

"TRAITOR'S KID"

For me, "head of the neighborhood association" resonates unpleasantly. Since Dad had been released from jail, the head of the neighborhood association began to appear at our house for one reason or another and got into big arguments with Dad. To my child's mind, it was very strange that at each visit Dad and the neighborhood association head fought like cats and dogs. On the other hand, it was fun, too, to watch them fight.

When the head of the neighborhood association came to our door—"Anyone home?"—and climbed from the entryway up to Dad's workroom on the second floor, Susumu and I would be downstairs looking up the staircase, scoping out the situation and thinking, "Now the fireworks will begin." Gradually, the conversation grew agitated, and when Dad snarled, "Get out!" the neighborhood association head hurried down the stairs, burst out the entryway, and ran off. Chasing and arguing, Dad came after him. The scene was both diverting and strange.

After the war I learned that the head of the neighborhood association functioned as the lowest level of governmental authority. It was his role to make sure Dad, who'd been jailed for a thought crime and released back into the neighborhood, wasn't speaking or acting "seditiously." Dad was unapologetically antiwar in thought and deed, so to come to remonstrate with Dad to "be careful what you say and do" was to start a major argument. The neighborhood association head feared he'd be blamed if the neighborhood produced a criminal. Today, too, the neighborhood association system is being revived, and I get really angry when the local boss becomes head and comes around to lecture people arbitrarily. They built the fascist order wrapped in pretty talk: "Improve human relations, make the neighborhood happy. . . ." I think we should be leery of the neighborhood association system.

People extended their spite for Dad, their dislike of Dad, to daughter Eiko, too. The scene comes back to me clearly. Here's what happened.

In the rays of the evening sun, the houses are dyed red, the mountains turn into a black silhouette, and soon the sky will be dark. Looking up at the sky, Mom seems worried and mutters to Dad and me: "Hmm. . . . Eiko's late. Something must have happened. All her classmates are already home. What's up?" Uneasy, she kept looking up at the darkening sky. Dad, too, began to worry and said he'd go to the school to get her. Just then, Eiko appeared, and we were all relieved. Mom asked Eiko why she was

late. Silent, Eiko shut herself in her room and wouldn't come out. Soon
we heard her faint sobs, and as they consoled the weeping Eiko, Dad and
Mom found out why.

That day at school a classmate's money had gone missing. Eiko sat in
the seat next to her and was suspected of having stolen it. She was taken to
the teachers' room, stripped to the skin, and questioned. No matter how
often she pleaded her innocence—"I didn't take it!"—the teacher wouldn't
believe her. He blamed her—"You took it. Confess!"—and she was kept

in the teachers' room until late. Red-hot mad, Dad dashed off on his bike, heading through the dusk for the school.

That day Dad didn't come home until late. I don't know what Dad said at school, but when he got home, he was angry, as if still not satisfied. He said to Mom: "They give a child a scar she'll never forget! The principal and that teacher—I really told them off!" Dad asked the teacher, "What evidence do you have that Eiko stole it?" The reply: the missing money had turned up in the classmate's notebook. She'd forgotten where she'd put it, then reported the money stolen. The teacher had suspected Eiko had taken it. Dad had a short fuse, so he was undoubtedly really angry. Afterward I heard from Mom that the teacher remembered that Dad was a thought criminal who'd been in jail and disliked Eiko, the "traitor's kid."

Next day Dad encouraged Eiko, who was off to school, "Hold your head high!" Then he said, "I'm off to the school once more; I'll give that principal and teacher a talking to!" Not listening to Mom, who tried to stop him, Dad set off for the school. Even to my child's mind, Dad was tenacious, dependable.

DAYS OF HUNGER

Toward the end of 1944 Hiroshima suffered severe food shortages, and every day was a struggle against hunger. To eat our fill of white rice, we thought, would be the greatest good fortune; white rice haunted us even in our dreams. Each day we held bowls filled with sodden soybeans; we pushed the soybeans aside and searched first for the grains of rice—that soybean-rice was horrible to eat. The soybeans clunked against each other in our mouths; no matter how hungry we were, they were hard to swallow. Yet even that might have been okay if we could have eaten our fill, but it was always a single bowl and an empty stomach.

Under the wartime controls, everything was rationed, and Mom's job—making ends meet, dealing with our hunger—was huge: scarce soy beans, potatoes, kaoliang, dehydrated potatoes, squash, vegetables, fish. She made dumplings by pulverizing soybeans in a grindstone, and she tried all possible edibles. We wanted to cry from hunger and blame Mom, but watching Mom, even we children knew we couldn't do that. Mom continued to work at getting food. When Blackie, our cat, brought home a fish or a sparrow, Susumu and I were green with envy and chased Blackie up onto the second-story drying porch. Every day was a day spent searching for food—"Isn't there anything to eat?"

I relished nothing so much as eluding Mom's eye, sneaking a hand into the rice tin, grabbing a handful of raw rice, then hiding out with Susumu and eating it. With Susumu, I immersed myself in clandestine joy: I chewed the kernels of rice, and the sweet juice filled my mouth, white liquid dripped from both sides of my mouth. I wiped it away with my wrist. Soon Mom noticed that the rice was dwindling and put the tin on a high shelf I couldn't reach, and our joy—stealing and eating raw rice—also came to an end. Mom must have realized we were stealing and been sad she couldn't feed us enough. Gently, sadly, Mom said to me: "The rice in the tin—everyone's life depends on it, so don't open it unless I give you permission."

If we learn, via the kid's grapevine, that "the stew at ——— Restaurant today is so thick chopsticks stand upright!" we brothers get excited, grab food coupon and bowl, hurry to the restaurant, and take our place in the line. In a great vat a fluid bubbles, stew containing a very few grains of rice and some chopped-up vegetables and white radish; one coupon lets us buy only one bowlful. We wait a long time for our turn, finally getting together and setting our chopsticks upright in the bowl of stew; we stare intently as the chopsticks fall over slowly and give off shouts that are close to shrieks of pain.

If the chopsticks fall over slowly, that means the stew is good. The normal stew looks like dark liquid, nothing more, and if you stand your chopsticks upright, they fall right over. When we get hold of thick stew with lots in it, we're as happy as if we have the devil by the neck. We head for home, sloshing the stew back and forth in the bowl, opening the lid and breathing in the smell any number of times, and thinking, each one of us, how lucky we'd be if we could eat this all ourselves—and this is a meal for the whole family.

About twenty minutes by foot from our house was Eba, the end of the trolley line. Just this side of the stop was the army's firing range, a broad field. A tall embankment had been thrown up left and right to stop bullets, and tall poplars had been planted. When the wind blew, the branches moved in unison, and the sound of their leaves carried all over. That firing range field was also where grasshoppers swarmed and bred. After Eiko came home from school, we went often, the two of us urging Eiko on, to hunt grasshoppers. We took a bag, hunting grasshoppers till the evening sun set, cramming the bag full. Then happy, singing at the top of our lungs the words of the song, "The evening sky clears, the autumn wind blows, the moon sinks, crickets chirp," we headed for home. We transferred the grasshoppers we'd caught to a bucket and let them sit overnight, so they'd cough up reddish-black leaf juice. And then we began to make a meal of

the cleaned grasshoppers. Splitting bamboo into thin pieces, we made spits, impaled a dozen grasshoppers, painted them with soy sauce, and fried them over the charcoal stove. A delicious smell came wafting. Carving spits with the big kitchen knife we used for cutting vegetables, Susumu cut his finger and cried, "Ouch! Ouch!" But when he bit into a batch of fried grasshoppers, he danced a jig and ate and ate.

On days when the lunchroom in the fishing town of Eba had sales of "Eba dumplings," we were beside ourselves with anticipation. These were dumplings in the shape of coins, made by mixing wheat and acorn flour, seaweed, and mugwort. They'd let you buy only two per person. We'd line up early in front of the store, buy dumplings, put them in the shopping bag Eiko carried, then go to the end of the line once more, and buy up as many as we could before they sold out. Waiting our turn in line was really tough. Uneasy, we were almost praying, "Don't let them run out before our turn!" They tasted so bad that if you put them in your mouth today, you'd spit them right out. But at that time of no sweets, they were sweet, and we ate every last crumb and were happy.

At the ceremony invoking the spirits of the dead at the Gokoku Shrine, on the grounds of Hiroshima Castle, we persuaded Dad to buy us a sugar cane stalk all of six feet long. Cutting it carefully into sections, we peeled off the husk with our teeth and sucked the fresh sweet juice until the cane was absolutely dry.

Morning and night, we thought only of food. Our Nakazawa relatives lived mainly in the center of the city, so we were endlessly jealous of neighbors who got food shipped from the country. We glared at neighborhood children who made a show of eating rice cakes in front of us. Susumu and I lamented how unlucky we were not to have relatives in the country.

In 1945 the food situation became worse and worse; we couldn't even get potato vines to eat. The food rations—dehydrated potatoes—alternated with strained soybean lees as staples. Extremity approached.

In front of our house was the mansion of the T. family. The man of the house was a colonel in the army. Each morning a private second-class came leading a horse, and Colonel T., boots shiny and military sword at his belt, mounted and went off to duty. The T.'s had a son who was my classmate, and we always played together. Watching the family ostentatiously eating sweets and canned goods and the like that we'd never seen, I was simultaneously angry and jealous. They lived a truly luxurious life, and the difference between them and us was heaven and hell. I could only marvel that the "haves" indeed had.

Time and again, because of malnutrition, we children got large boils on our legs. They swelled up, the pus ran, and we screamed, "Ouch! It hurts!" Hearing that they'd heal if you immersed them in seawater, Dad took us to Itsukushima Shrine, combining that goal with his search for scenes to paint. With the tide out, he had us strip beneath the large vermilion shrine gate and swim. Dad sketched the scenery and the trees, and we

stayed in the water all day, playing. But the boils didn't heal. Lancing the boils with a pin, we let the pus flow and endured the pain.

At that time my oldest brother Kōji was a student-soldier. Mobilized as a welder at the Kure Naval Armory, he lived in a dormitory and came home only two or three times a month. His trips home were fun for us. Why? Because he packed leftover rice from the dorm into lunch boxes and brought it home with him. We listened with shining eyes to the stories he told us. He bragged that he had welded part of the hull of the battleship *Yamato* and that he had crawled into the mouth of its large cannon. From the size of the cannon—he fit all the way in—we could well imagine how big the battleship was. Giving our imaginations free rein, we talked. Another time, damaged warships and submarines came into dock, and peeking inside, he saw chunks of flesh and blood splattered about. Kōji did the repairs, but he felt uneasy.

My next brother Akira also left, sent off as part of a group evacuation of schoolchildren to a temple on the border between Hiroshima and Shimane. On saying goodbye, he cried, "I don't want to go!" Mom was annoyed and scolded him: "What if the bombs fell and all of us died? I want at least one of us to survive!"

My big sister Eiko, then a sixth grader, was sickly, so it was decided she would remain at home. We saw Akira off as he marched out the school gate, and our family shrank to five. Feeling lonely, we were told that our next sibling was in Mom's womb, due to be born in August, and we looked forward to the baby's birth: "I want a boy!" "No! I want a girl!"

I was hopelessly jealous of Akira, evacuated to the countryside. I thought the countryside had rice and wheat, persimmons and chestnuts, all sorts of food that you could eat your fill every day, so I had wanted to go on the evacuation. But upon learning there was a minimum age, I was disappointed and vexed. School evacuations began with the third grade. I regretted I wasn't older.

But the letters Akira wrote from the place to which he'd been evacuated told me how wishful my thoughts were. On the day they arrived at the site, there was a welcome party, and a rich spread of foods was set out—food I'd dreamed about: rice dumplings and bean paste, sweet buns, red bean rice. The children had gobbled it down in a frenzy. They'd eaten too much, so in the middle of the night they had stomachaches, and cries resounded here and there as children spat it up. He figured that thereafter, too, they'd have lots to eat, but from the next day on, the food was one cup of soup and a little soybean rice. Day after day he was hungry. Preparing for the worst, Mom had boiled soybeans and packed them in his pillow, and at

night he opened the parcel quietly, huddled under his blanket so that those around him wouldn't notice, and not making a sound, ate the soybeans to ease his hunger. He finished up those, too, and reported endlessly in petulant letters, "I'm going crazy with hunger, so please send soybeans."

Nights were full of crying under the blankets because of homesickness for relatives in Hiroshima. Some children ran away—that too was in his letters. Dad and Mom conferred, "Poor kid. Shall we call him home?" For my part, I was astonished to learn that even in the country there was no food.

In Hiroshima as August approached, the air raid sirens rang out on more and more days. At school, air raid drills continued—what to do in case of a direct bomb hit. We pupils donned air raid hoods and lined up in the schoolyard. We put our thumbs in our ears, covered our faces with the other fingers, and lay down quickly on the ground. These were actions to keep the sound of the bomb exploding from bursting our eardrums and to protect our eyes and face from shrapnel. Earnestly, we "little patriots" continued air raid training.* Diligently, we stood up and lay down on command, getting our faces all sandy.

As the war situation increasingly took on the air of defeat, the neighborhood training with bamboo spears and for fire drills became more frequent, too. Dad was totally skeptical: "They really think they can fight American soldiers with those bamboo spears? Before getting that close, the Americans will kill 'em all with machine guns. It's utterly unrealistic!" Against their will, the whole neighborhood had to assemble with bamboo spears, and an old man from the Reservists Association, swaggering with a triumphant air, taught them how to "kill the U.S. and British beasts."

In the Russo-Japanese War, he said, he'd killed many Russkies; he bragged about that experience. If you stab an enemy in the chest with a bamboo spear, his muscles contract suddenly, and you can't pull the spear out. So if you spear someone, pull the spear out right away; if you can't pull it out, push against his body with your foot. U.S. soldiers spend their lives in chairs, so their stomachs get weak. If it's a matter of hand-to-hand fighting, of course, with our national arts of sumo and judo and because we've hardened ourselves by sitting on straw mats on the floor, Japanese have the upper hand. Against feeble U.S. soldiers, there's no way human-bullet tactics can lose. Given logical sounding lectures, the neighborhood folks were all diligent and serious in training to kill U.S. and British soldiers. We children critiqued their performance stabbing straw-bale dummies—deciding whose father threw his weight into it and had good form.

Smudge pots were placed on the roof beneath the eaves, and people pretended that bombs had fallen and fires started. They ran a ladder up to the roof, and bucket brigades brought water to put the fires out. Mom was rounded up for this task. The baby was due very soon. With her big belly, Mom puffed and panted as she passed along buckets of water. Watching her, we could only feel sorry for her.

*"Little patriots" (*shokokumin*) was a wartime term for schoolchildren.

In order to prevent the anticipated spread of fires from B-29 fire-bombing, they created firebreaks in neighborhoods where the houses were dense. The central beam of the designated house had a rope tied around it, and then at the shout of the crowd rounded up for labor detail, the house collapsed. One after another, houses were razed. Through our neighborhood wafted the smell of mildewed red earth. Cleared spots appeared, like the broken teeth of a comb.

Before and after meals we children had to sit up straight and listen to Dad: "Japan'll lose soon. You'll be able to eat your fill of your favorite foods—white rice, bread, noodles, buckwheat noodles. By the time you're adults, really good times will come for Japan." It was as if we were hearing fairy tales; we simply couldn't believe what Dad said.

When I'm asked what gave me the worst feeling, this is what I answer. When, late at night, you're sound asleep, the sirens blow piercingly and a megaphone voice cries, "Air raid! Air raid!" and rapid steps come up the stairs to wake the household. I really couldn't bear the oppressive unease, as if your stomach was crammed full of vinegar and lead. Giving up, you're determined to stay in bed, but Mom scolds you: "Bombs are falling! Do you want to die? Fools!" and you go down the stairs against your will and run to the neighborhood bomb shelter. Leading up to August, we had day after day like that.

Dead-of-night visitors, the B-29s passed through the skies over Hiroshima and went east or west, to attack and burn out Kure or Iwakuni. At Kure were the naval armory and the naval base where the battleship *Yamato* and other warships lay at anchor. The firebomb raids of the B-29s were horrific. Mom's younger sister had gone to Kure as a bride, and to learn whether she was safe, Mom took me with her and headed for Kure. Kure was a town on a hill, and when you looked from the railroad station, it appeared bare and clean—that's how completely it had been burned over, had disappeared. I was shocked: only at the foot of the hill were houses still standing. The city had become one vast burned-out field. In Iwakuni, west of Hiroshima, the military factories had stood in a row, vulnerable to the firebombs of the B-29s, and had been burned out.

Day after day we were plagued by the dead-of-night visits of B-29s flying over Hiroshima. It wouldn't do to be spotted by the enemy planes, so in every home, black bunting is wrapped even around lampshades lest light leak out. A single point of light in the dark room falls on the straw mats on the floor, and quite like moths to a flame, the family gathers silently around the circle of light. Wearing air raid hoods and carrying knapsacks, each making the preparations assigned him in advance, we hold our breaths and head for the large neighborhood air raid trench. I simply hated it. We were like cattle being led to the slaughterhouse. When we look up at the night sky, it glows red in the direction of Kure, and we whisper to each other, "It's Kure again tonight."

Searchlight beams crisscross the night sky, and we point and watch as one B-29 after another passes through the beams. In the air raid trench

rainwater has pooled up to our waists. We can't stand it, trembling with cold in the winter and bitten by the mosquitoes that breed there in the summer. The responding anti-aircraft fire resounds like distant thunder, all the more terrifying. Time drags, and we wait, practically praying for the "all clear!"

People exchanged uneasy whispers. Everybody thought it strange— "They're attacking the cities on both sides of us. Why no attack on Hiroshima?" Speculation abounded. Fearing that the big attack on Hiroshima would begin soon and we'd be burned out, Mom talked Dad into packing wicker baskets and chests with daily necessities and clothing and loading it all on a cart. Under the hot sun, sweat pouring, the whole family pushed, taking the stuff to leave in safe storage at the home of Dad's acquaintance in the country.

Living directly behind us was a Korean, Mr. Pak, who always treated me with kindness; he, too, was forced to evacuate and had his house razed. The Pak family included a child my age, Chunchana, and we often played together. When I went to the Pak's house, I saw his wife doing the laundry by beating the clothes with a stick—that was strange, and it caught my eye. Mr. Pak's father had a long beard; he sat on the veranda, his clay pipe resting between his toes, and puffed sweet-smelling smoke—that too was strange, and I watched with interest. Sometimes they served me wheat flour pancakes fried in a pan, and I ate with Chunchana. But on the other hand, unawares, we also spoke thoughtless words to this wonderful Pak family. We made fun of them, jeering in pidgin Japanese, "Korea, Korea—don't make fun of us. We eat same food, so where different? Toes of shoes a bit different."

I don't know when he learned of it, but Dad got angry at us for making fun of Koreans. He told what bad things the Japanese had done to Koreans. Japan had invaded Korea and colonized it and stolen its resources, and many Koreans had been brought to Japan against their will and were mistreated as cheap labor. I couldn't understand entirely, but I was sorry for saying bad things. I think prejudice had been implanted in me unconsciously. Both Mr. Pak and Chunchana went away, and I couldn't eat wheat pancakes any more. I missed them.

As before, the air raid sirens sounded in Hiroshima, but no attack came. I was aware of attacks nearby only twice. Once, a formation of three carrier planes attacked the city in broad daylight, firing their machine guns and flying off, and a bullet hit the alley by our house. We took a shovel and dug it out, still too hot to touch. I showed that eight-inch piece of shrapnel around boastfully and got scolded sternly by Mom. Again, the anti-aircraft

guns placed on Ebayama got a lucky hit on a B–29 passing over Hiroshima and it crashed close to the city. The neighborhood men said they'd take the American crew captive and, grabbing their bamboo spears, set out excitedly to comb the hills.

Later there was a kid who somehow had gotten hold of a piece of the windscreen of a downed B–29. If you rubbed the glass with a piece of wood, it gave off an indescribably sweet, irresistible smell. We lavished praise on the proud owner of that piece of glass and borrowed it; rubbing it all the time with a stick, we kept that sweet smell in the air. We treated him as a hero, making him top dog among us.

The fact that no attack on Hiroshima came caused rumors to circulate. An older boy gathered us children and told us that according to a shortwave transmission from the U.S. military his father had listened in on, Hiroshima had to be left untouched so it could be an important U.S. military base. So there's no way they'd attack. Hiroshima, he said complacently, was safe. We believed him and nodded. When the sirens sounded, we took refuge in the trench, but we agreed among ourselves, "It's only an observation plane. It's not an attack." We watched with no apprehension as B–29s high in the sky flew over. That comforting thought spread among the kids and the Hiroshima residents. We had no idea that the U.S. military was saving Hiroshima to be the stage, making preparations step by step, on which to create a this-worldly hell. We had become wholly accustomed to thinking we were safe.

For a particular period on summer evenings in Hiroshima, there was no wind, and it was hot and humid, suffocating, and disagreeable. Time passed, with the city's residents still feeling both secure and insecure.

BAREFOOT GEN: EXCERPT 1

This first excerpt appears one quarter of the way through volume I. It depicts Gen, his mother, his older sister, and his younger brother (in the cartoon Shinji, not Susumu) hunting grasshoppers in the tall grass at the Army Firing Range. Despite the extreme shortage of food of which Nakazawa writes, his images show strikingly well-fed people; perhaps artistic convention trumped real-life emaciation. (The same holds true of the stunning Hiroshima murals of Maruki Iri and Maruki Toshi; see *The Hiroshima Murals: The Art of Iri Maruki and Toshi Maruki*, ed. John W. Dower and John Junkerman [Tokyo: Kodansha, 1985].) The sun is a major leitmotif of *Barefoot Gen*, as is grass, especially wheat. On the first page of this excerpt, the vertical panel that includes only the sun provides a transition from hunting for food to the father's return from jail. This is the tenth time in the first seventy pages that Nakazawa devotes a panel entirely to the sun. Despite the bruises on his face that testify to police torture, the father, too, is remarkably sturdy in appearance. These scenes of hunger and the return of the father segue into a scene in which the Korean neighbor, Pak, appears with a large bowl of rice to offer the family and then a lengthy discussion of Japan's prewar and wartime mistreatment of Koreans and Japanese.

For a discussion of the presentation of these excerpts, including the reasoning behind flipping the pages, see the editor's introduction. This and the following excerpts are from the fine ten-volume *Barefoot Gen* (San Francisco: Last Gasp, 2004–2009). They appear here by permission.

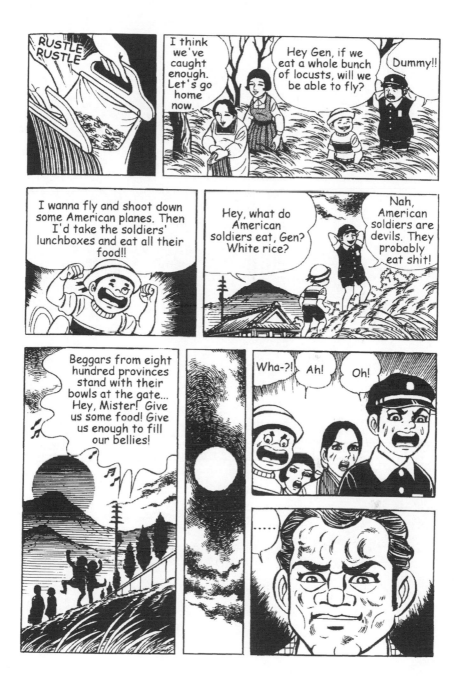

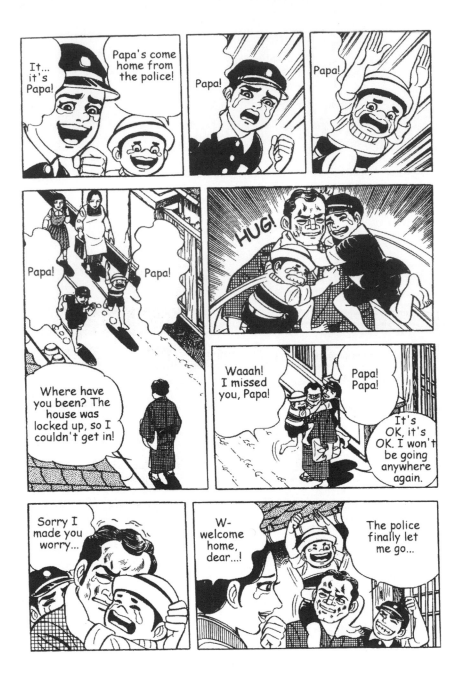

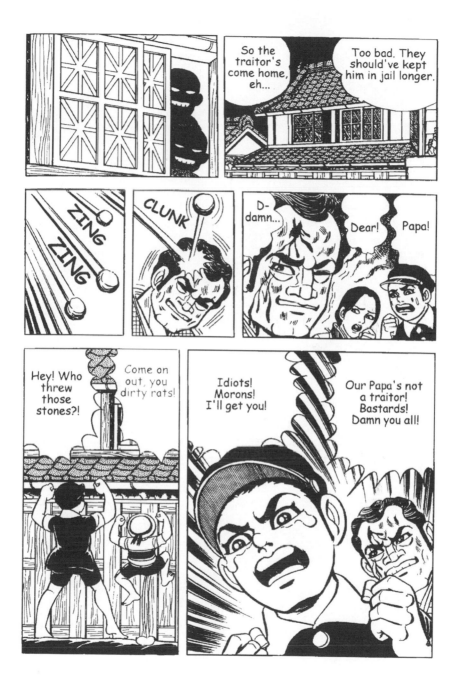

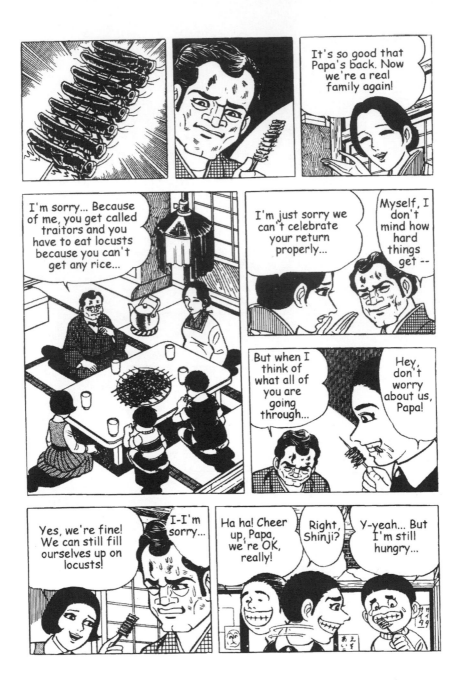

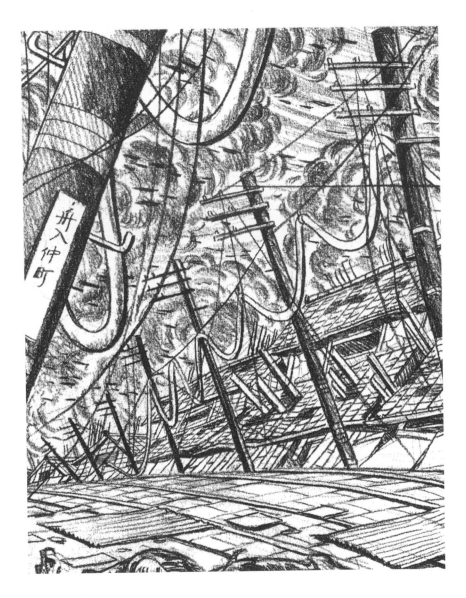

2

A SUDDEN FLASH OF LIGHT

THE DAY OF THE FLASH AND BOOM

August 6, 1945, Monday. B-29s had flown over Hiroshima twice the night before, and air raid sirens had sounded constantly. I awoke unhappy that I hadn't gotten enough sleep. The weather the morning of August 6 swept that unhappiness away. The sky was cloudless and absolutely clear, bright sunlight pierced our eyes, and houses and trees stood out as if painted in primary colors. My eyes felt as if they'd been washed clean, and my unhappiness over lack of sleep vanished, too.

Suddenly, at about 7:20, soon after the whole family, gathered about the round table, had finished breakfast, the sirens sounded. I was surprised. Strange: I didn't remember sirens sounding that early in the morning. Dad muttered, "Mr. Enemy is coming really early. Unusual." Urged on by Mom, who said we'd be in danger if bombs fell, we made our preparations and headed for the neighborhood air raid trench. Mom's due date was approaching, and clutching her swollen belly, she huffed and puffed as she ran. In the trench, I said, "At worst, it's another observation plane. No need to worry," and played with Susumu. Sure enough, the megaphone voice came, "All clear!" and we returned home, kidding ourselves for getting all flustered over the alert—"An observation plane, after all."

Looking up into the clear blue sky, I could still see the contrail of the B-29, a white strip; in the distance it had already fanned out. Dad said to Mom, burdened by her big belly, "Today will be hot." The B-29 that flew in that morning was a reconnaissance plane to check the weather conditions over Hiroshima and to photograph the target before the bombing. Had the atomic bomb been dropped then, many would have survived because they'd run to the trenches.

31

The "all clear" came, and reassured, the four hundred thousand residents of Hiroshima all began the day's activities. City trolleys went busily on their rounds, car after car disgorging its passengers; a continual flow of people headed for businesses and factories. People began their activities. Children headed to school. Housewives cleared away breakfast things and set about cleaning or doing the wash. Soldiers started drilling. Mobilized for labor service, women and students collected the detritus from collapsed houses and carted the stuff off.

At that time the elementary school we were going to had no summer vacation; we had to go to school to study to become strong "little patriots." With my air raid hood hanging off one shoulder and my satchel on my back, I went out onto the clothes-drying porch off the second floor and said to Mom, who was hanging laundry out to dry, "I'm off." In her apron, wiping off sweat, Mom went on hanging out the clothes.

On the drying porch, flowers and plants in pots were lined up, models for Dad to paint. A strange thing had happened with these potted plants. There was fruit on the loquat. The whole family stared: "Fruit on a *potted* tree?" Dad told us, sharply, "When it's ripe, I'm going to paint it, so hands off!" With a sinister premonition, Mom worried, "Something must be out of kilter meteorologically." I'm not a fatalist, but Mom's sinister premonition turned out to be accurate.

With one eye on the loquat, I went downstairs. Eiko was sitting in the nine-by-twelve-foot room leading to the entryway. On the round table she'd lined up textbook and notes and was sharpening a pencil. I called to Eiko, "C'mon." For once Eiko said, "I have to look something up; you go on ahead." Beside the entryway was a nine-by-nine-foot room, and Dad, clad in kimono, was setting to work. I said to Dad, "I'm off," and he nodded and straightened his kimono. In the entryway my younger brother Susumu (age four) was plumped down, holding a model warship, pretending that it was making headway through waves. He was singing in a loud voice, "Tater, tater, white potato, sweet potato."* Seeing me, Susumu urged, "Hurry home after school. We'll go to the river and sail this ship."

I never dreamed that this would be the last time I saw Dad, Eiko, and Susumu. With Susumu's song at my back, I joined the neighborhood kids, and we went to Kanzaki Elementary School, less than half a mile from our house. Kanzaki Elementary School faced the trolley street linking Eba and Yokogawa. It was surrounded by a concrete wall. The gate on the trolley street was the back gate. In the center of the schoolyard towered a huge

*This ditty was a take-off on the "Battleship March," which had the syllable *mo* twice in its opening line. *Imo* is the Japanese word for potato.

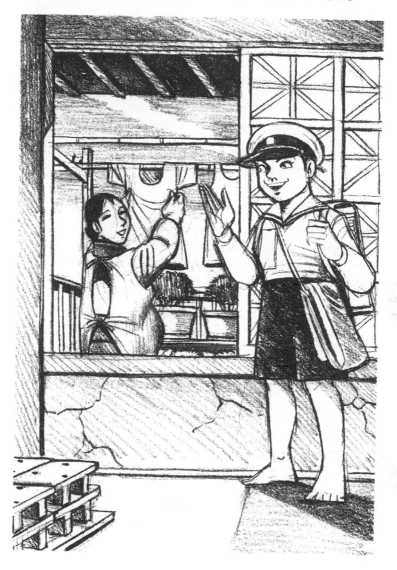

willow tree, spreading its branches wide. Behind it was the two-story
wooden school building, L-shaped. Those of us in the lower grades would
enter the school singing, led by students in the upper grades:

> We owe it to the soldiers
> That today, too, we can go to school
> Shoulder to shoulder with our classmates.
> Thank you, you soldiers
> Who fought for country, for country.

Singing at the top of our lungs this totally militaristic anthem, we'd advance up the trolley street and go through the gate.

A person's fate—life or death—truly is a matter of sheerest chance. Had I entered the gate that day as I always did, I would have been wiped off the face of the earth. Standing in the broad schoolyard with absolutely no cover, I would have been bathed—my whole body—in the rays the atomic bomb radiated, more than 9,000 degrees Fahrenheit, hot enough to melt iron. Burned pitch-black, I would have died.

That day, a moment before entering the gate, I was stopped by a class-mate's mother. She asked me, "The air raid alert sounded a bit ago. Are today's classes at the school or at the temple?" At that time, those in the lower grades alternated between the school and a local temple as place of instruction because of the danger that we wouldn't be able to flee if bombs fell. The concrete wall on either side of the gate was a foot thick. Moving close to it, I replied to her, "We won't know till we ask Teacher," and I happened to look up.

In the sky, the vapor trail of a B-29 stretched along the mountains of the Chūgoku range, seemingly headed for the center of Hiroshima. The sun reflected off the nose of the plane's glittering duralumin body. Pointing at the B-29 approaching steadily, I called, "Ma'am, it's a B. . . ." She too looked up and said, "You're right: a B-29. Strange that the air raid alert hasn't sounded," and the two of us looked up at the approaching B-29.

Had the sirens sounded at this point, as they had earlier that morning with the reconnaissance plane, many people would have fled to air raid trenches and survived. I think it was truly a clever psychological tactic on the part of the U.S. military. To make the residents short of sleep from having the air raid alarm go off twice the previous night and to foster the mind-set "Hiroshima is safe": that's what enabled the *Enola Gay*, carrying the atomic bomb, to fly over majestically on the attack. That way, even if a B-29 flew over, we'd think, "It's only a reconnaissance plane," and let our guard down.

"Why didn't the air raid alert sound?" That thought has stayed in my heart forever, a gap in the Hiroshima story. After the war, I checked the documents and found that NHK Hiroshima began to broadcast an air raid alert at 8:15. It was at 8:15 that the bomb was dropped and exploded. If only the alert had sounded earlier!

The *Enola Gay* cut its engines, penetrated quietly to the heart of Hi-roshima, and dropped the atomic bomb, raising the curtain on hell. Even today, if I close my eyes, the colors of the atomic bomb the moment it exploded come floating right up. A pale light like the flash of a flashbulb

camera, white at the center, engulfed me, a great ball of light with yellow and red mixed at its outer edges. Once that violent flash burned itself onto my retinas, all memory stopped.

PICTURES OF HELL

How long was it? When consciousness returned and I opened my eyes, it was pitch dark. I was confused: "Huh? A moment ago it was broad daylight, and suddenly it's night?" When I rolled over and tried to stand, pain shot through my right cheek. "What happened?" I focused and looked about and saw that a six-inch nail sticking out of a board had pierced me. Raising my head had torn my cheek. Blood was flowing. The weird atmosphere frightened me. I realized I was sweating.

I tried to stand up, but my body didn't move. Turning my head, I saw that bricks, stones, tree branches, scraps of lumber lay on top of me. The concrete wall, too, had fallen over and was covering me.

Frantically I pushed at the stones and wood on top of me and scrambled my way out. Instinctively, I looked about for the satchel that had been on my back and the air raid hood that had been hanging from my shoulder. But I didn't find them—perhaps they'd been sent flying, torn off in the blast? Turning to look at the trolley street, I gasped.

Until just a moment ago, the mother of my classmate had been standing right in front of me and, like me, looking up at the B-29. Her entire body had been burned pitch-black. Her hair was in tatters. The workpants and jacket she'd been wearing, charred and looking like seaweed, hung about her neck and waist. And she'd been blown across to the other sidewalk and was lying on her back. Her white eyes, wide open in her blackened and sooty face, glared across at me.

Confused, not knowing what had happened, I stood in the middle of the trolley street. This familiar street had been transformed shockingly; I stood in amazement. The trolley wires had been cut from the poles lining either side of the street and were coiled like spiderwebs on the pavement; thick telephone line sagged from telephone poles like a great snake sleeping on a tree branch. It sagged into the distance. The rows of two-story houses on each side had been crushed, and the lower stories had collapsed utterly like popped paper balloons, flat. Atop them, the second stories lay piled, undulating off into the distance. Drop India ink into water, and it thins and spreads. Smoke just like pale ink covered the sky and wafted all about. The sky was like an ink painting; boards and sheets of metal danced

helter-skelter into the sky, quite like birds. Every now and then, out of the collapsed rows of houses a dragon's tongue of bright red flames crawled, disappeared, moved. Aghast, I burned that scene onto my retinas.

I learned that when people are thrust suddenly into extremity, they are without emotion. They act only by instinct. Returning instinctively to the nest, my feet moved on their own in the direction of home. There's an expression, "Spinning your wheels," and that's precisely the way it was. I felt I was running and running, yet getting nowhere. Up ahead, the pale-ink smoke drifted, as if bubbling up. When people materialized out of it, I was shocked and raced up to them, wanting to know what on earth had happened to them.

First I met five or six women. Hiroshima's summers are very hot, so they'd probably been wearing only simple chemises as they tidied their kitchens or cleaned house. One after another, the women I saw had chemises on. As I got near them, I was amazed. They had countless slivers of glass sticking in their flesh: in the front of some of the women, on the right sides of others, on the left or on the backs of still others.

People who'd been in rooms with windows to their right had been pierced only on the right sides of their bodies as the bomb blast pulverized the windowpanes. They were like pincushions, with blood flowing. People who'd been in rooms with windows straight ahead of them had their fronts covered with glass splinters. The glass splinters had pierced even their eyeballs, so they couldn't open their eyes. They felt their way along, like blind people. How they'd been standing in relation to the windows determined where on their bodies the glass splinters stuck, and one person differed from the next.

I noticed one woman. Her hair was dusty and swirling in disarray, the shoulder strap of her chemise was cut and her breasts exposed, and her breasts were blue, as if tattooed. As I was able to understand later, the glass splinters looked blue, and she had so many piercing her, mainly her breasts, and countless splinters buried in her that the glass splinters seemed like a tattoo dyeing her breasts blue.

The women pierced by glass splinters were bleeding. They walked silently. Countless pieces of glass were embedded in their bodies, so that each time they took a step, the glass splinters jingle-jangled. Aghast, I watched these women go by, then raced for home.

On the sidewalk on the left side of the trolley street, naked people burned so black that I couldn't tell male from female sat with both legs outstretched, eyes wide and fixed on a point in the sky, cowering, as if simpleminded. Pumps for firefighting had been installed earlier at set in-

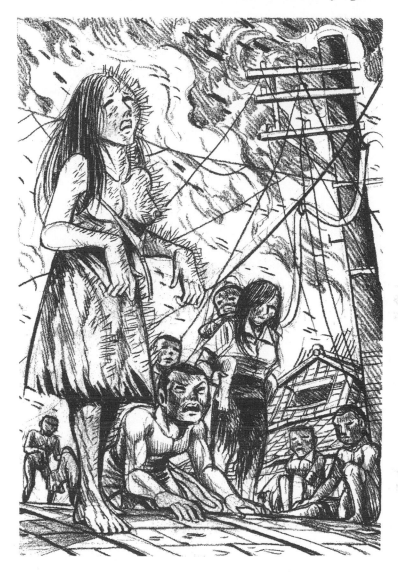

tervals along the sidewalk on the right side of the trolley street. Uninjured people hurried to those pumps, twisted the cocks, and scooped up water. People clustered suddenly about the pumps. The women with innumerable glass splinters in them took the pump's water with both hands and poured it all over themselves. Washing their blackened bodies covered with blood and dust, they exposed the glass fragments that stuck into their bodies and silently pulled them out.

On the opposite pavement, too, were people with not a stitch on, dazed and burned so black I couldn't tell male from female. Seeing water flowing from the pumps, they crawled sluggishly along the ground and approached the pumps, each of them sticking their hands into the flow of water, scooping up water and lifting it trancelike to their mouths. Around the pump women gathered, absorbed in washing off the blood and picking out glass splinters, and people burned black were drinking water blindly. The same scene occurred at each pump. They were acting simply on instinct. The glass was sticking into them, and it hurt, so they pulled it out. They'd been burned all over by the rays, and they were thirsty, so they drank. Neither words nor poses showed conscious intent.

In scenes of carnage—fire or calamity—in movies or plays, voices cry, "Ouch!" "Horrible!" "Help!" People suffer and writhe. But those scenes are unreal. When people are thrown suddenly into the carnage of an extreme situation, they utter not a single emotion-laden word but act silently on instinct. Just as if watching a silent movie, I, too, looked on at the quiet scene, not saying a word. From time to time gasoline drums exploded, the sound carrying in all directions.

Coming to myself, I took the street leading to our house. But at the beginning of the lane to our home, fires were spreading along the row of structures on either side. Flames crept along the ground. The two fires stretched forward from either side, as if joining hands, and in an instant the road became a sea of fire. The roadway functioned as a chimney, and a hot wind gusted through. The road ahead became a wall of fire, and flames completely blocked the way.

Sensing instinctively that I'd burn to death if I went farther, I reversed course, as if in a daze. I followed the trolley street, and suddenly, for the first time, like an electric current running through my body, wild terror ruled. Loneliness—my family's abandoned me!—and terror—I'm all alone!— seized my mind. I ran back and forth on the trolley street, searching desperately, crying "Daddy!" "Mommy!"

The trolley street from Funairi Naka-chō as far as Saiwai-chō was a human exhibition, inhuman forms utterly transformed. Naked bodies moving sluggishly, burned by rays and trailing blackened bits of clothing like seaweed. Moving forward, glass splinters from the explosion sticking into all parts of their bodies, spurting blood. People whose eyeballs hung down their cheeks and trembled; they'd been blown out by the sudden pressure of the blast. People whose bellies had been ripped open, trailing a yard of intestines, crawling along on all fours. Shrikes impale fish and frogs on dead tree branches, storing them to eat later; people, too, had been sent flying

and hung from branches, impaled. I ran among these horrific humans, threading my way, crying out, searching for family.

Black smoke eddied violently, covering the area. Flames danced crazily, wildly. The trolley street, too, became dangerous. The terror I felt then sank into my heart; I will have it with me as long as I live.

BLACK RAIN

Luckily, a neighbor found me as I was running about and crying. She too wore a chemise, and bits of glass pierced her entire body. She was dousing herself with pump water to wash off the blood. Her white chemise was dyed bright red. It was as if it had been red to begin with.

"Aren't you Nakazawa Kei?" she asked. "Your mother's on this road at the Funairi Kawaguchi-chō trolley stop. Quick, go!" In a trance, I headed for the Funairi Kawaguchi-chō trolley stop. The crowd fleeing in the same direction proceeded, naked bodies blackened, each holding both hands chest-high, leaning forward, just like the specters depicted in paintings.

In this sluggish procession, I noticed a strange thing. The parts of a person wearing white clothing—white shirt, white pants—were completely uninjured. White shirt, white pants alone caught my eye, bright, as if dancing in space, flickering. When the instant rays, hotter than 9,000 degrees, shone on people on the ground below, their white clothing acted as a mirror, reflecting the rays. By contrast, people wearing black were consumed instantly, clothing and body, by the radiant light. During the war, clothing that stood out and was easy for enemy planes to spot was outlawed, so most people wore dark clothes. Hence the number of those suffering from burns over their entire body increased several times over.

Struck by 9,000 degree rays, your skin immediately developed countless blisters, one connected with the next; scattered over your whole body, they grew to eight inches in diameter. When you walked, the fluid inside the large blisters sloshed with the vibration, and finally the fragile blisters burst, the liquid poured out, and the skin peeled off.

I wouldn't have thought human skin would peel so easily. The skin of the chest peeled off, from the shoulders down; the backs of the hands peeled; the skin of the arms peeled off, down to the five fingernails, and dangled. From the fingertips of both hands, yard-long skin hung and trembled. The skin of the back peeled from both shoulders, stopped at the waist, and hung like a droopy loincloth. The skin of the legs peeled to the anklebone and dragged, a yard long, on the ground. People couldn't help

looking like apparitions. If they walked with arms down, the skin hanging off their fingertips dragged painfully on the ground, so they raised their arms and held them at shoulder level, which was less painful. Even if they wanted to run, the skin of their legs was dragging along on the ground, impeding their steps. Shuffling one step at a time, they proceeded, a procession of ghosts.

In this procession of ghosts, I made my way to the Funairi Kawaguchi-chō trolley stop. On both sides of the trolley street in Kawaguchi-chō were sweet potato and vegetable fields. The farmhouses scattered in the fields were leaning from the blast. Wide-eyed, I looked about the trolley street. There, on the sidewalk on the left, sat Mom. She had spread a blanket on the sidewalk, set some pots beside it, and was sitting in her apron, face sooty, a vacant expression on her face. I stood in front of her. We looked each other in the face, silent, exhausted, and I sank to the ground beside her. I was overcome with joy and relief that I had finally found family. Soon I noticed that Mom was holding carefully to her chest something wrapped in a dirty blanket. I peeked inside the blanket and saw a baby, newborn, face red and wrinkled. It was a mystery: "Huh? Suddenly a baby. . . ." I looked again at Mom's tummy, and it had shrunk.

The shock had sent Mom into labor, and in the carnage of atomic hell she had given birth on the pavement to a baby girl. As she writhed in pain on the pavement, several passersby had gathered and helped with the birth.

Exhausted, I squatted on the pavement. Perhaps because of the effect of the radiation, I was nauseous. I vomited a yellow fluid, and I felt bad; I hadn't the energy to sit up. Trying to hold back the urge to vomit, dazed, I watched the scene unfolding before me. From the direction of town, the procession of ghosts continued one after the other, passing before me. Right before my eyes, skin trembled from arms now completely skinless, drooping twenty inches from fingers. I watched in amazement, "Skin really does come right off!"

Each person shuffled, dragging a yard of skin from each leg, so from way back in the direction of town, dust swirled into the air. When the procession of ghosts reached the trolley street, they climbed down into the potato and vegetable fields on either side, collapsed atop the plants, and fell asleep. Burned by the rays and blistering, their entire bodies were hot and painful, and the cool of plants against their skin felt good. Instead of blankets, they lay on plants. As I watched, the vegetable fields turned into row upon row of people whose skin had melted.

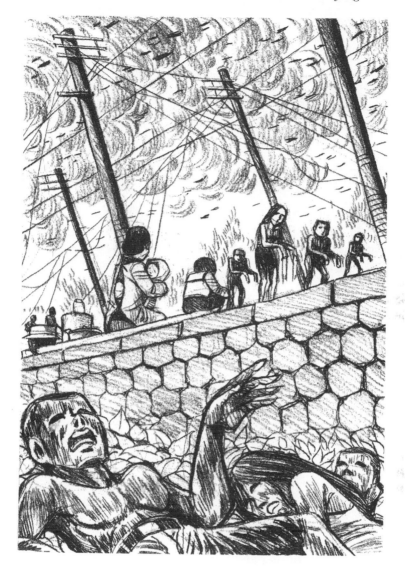

The sky suddenly turned quite dark, and when I looked up, a stormy black cloud had covered the sky. Large raindrops spattered against the asphalt and created a pattern of spots. Large drops of rain struck my head and my clothes. The surface of the drops was oily and glittering; it was "black rain." Black spots clung here and there to Mom's clothing and mine. When I wiped the drops from my face with my hand, they were slippery.

I didn't like how they felt. Somehow or other a rumor spread: "Those damned Yanks! This time they're dropping heavy oil from the sky to make Hiroshima burn easier!" The black cloud moved rapidly to the west, the black rain stopped, and the sky cleared. I never dreamed that this black rain contained radioactivity that forever after destroyed your cells.

We were lucky. Had we fled to the northwestern part of Hiroshima, we would have been soaked in radioactivity, quickly contracted leukemia, and died. Black rain continued to fall, concentrated in northwestern Hiroshima. Where we were, it rained a bit and then stopped, and we avoided being drenched in a lot of radioactivity. While I watched the pavement, patterned with large black raindrops and gleaming eerily, I was overtaken by drowsiness and, before I knew it, dropped off to sleep.

When, feeling as if I was choking, I opened my eyes, night had fallen. With no electricity and virtually no lights, it should have been pitch-dark, but all Hiroshima, leading city of the Chūgoku region, was going up in flames, a waterfall flowing upward instead of downward. By the light of the fires, you could see clearly. The heat reflected from the flames blazing brightly had made me gasp for air and wakened me. I turned my eyes to the right, and on the shore of the lower reaches of the Honkawa, thick tree trunks had been piled high in a long row. The hot wind quickly dried the wood, and the fire spread to them, one after the other. The tree trunks made loud sounds, split apart, and flew up into the air. The heat reflected from the flames was hot; we moved right up next to the field's stone wall and shielded ourselves from the heat. The stones were cool and felt good. I looked up at the night sky, dyed red, scorching; smoke eddied in columns, and the flames reflected off the smoke. It was as if a double red curtain covered us. Watching that night sky, I fell asleep again.

Twice, three times, I was awakened by a sound as if dozens of insects had flown into my ears, flapping their wings. Already confused, I kept thinking, "What a racket! What is it?" As time passed, the sound became louder, and I couldn't sleep. When I listened carefully, it turned out to be a one-word chorus: "Water!" "Water!" From the fields on either side resounded the agonized chorus. I looked at Mom, and she too had been awakened by the chorus crying, "Water!" Mom said, "Those poor people—let's get them some water. Go scoop some up." At her urging, I picked up a metal helmet that was rolling about on the pavement and pumped it full of water.

Mom found the cup we needed, scooped water from the helmet I was holding, and offered it to a person groaning, "Water! Water!" With a start, as if he'd caught the scent of water, he bent his head over the cup, and

emptied it in one gulp. Then, three or four seconds later, he collapsed, his head striking the ground. Alarmed, Mom shook him and cried, "What's wrong?" but he was already dead. We offered the cup of water to others groaning "Water! Water!" and each and every one buried his or her face in the cup and drank it off in one gulp. And then, three or four seconds later, they all died, their heads hitting the ground. When we gave them water, they died, one after the other. Amazed at this strange phenomenon, Mom and I stood stock-still in the field.

On August 6, the day the bomb fell, this phenomenon occurred in the suburbs on every side of Hiroshima: when water was given to survivors fleeing the atomic bombing, they died. Quickly the rumor spread, "Absolutely don't give water to people with burns! If you give them something to drink, they'll die right off!" We, too, heard the rumor and believed that water was dangerous, bad. People clutched Mom's leg and mine and cried and pleaded, "Please, water!" Mom said to them, "Water will kill you. Do without. You have to do without," and we brushed off the hands clutching wildly at our legs. When we walked about the field, we were plagued by hands reaching out, seeking water. The strange question remained: why did they collapse and die after drinking water?

On reflection, I decided it was death by shock. Medically speaking, it was fine to give lots of water to people with burns. With burns over your entire body, your flesh contracted and froze and you couldn't move or crawl, but lay in the field tormented by your body's physiological demand for water. With "water!" as your sole thought, you held on to life. Many people who had been burned went virtually crazy thinking about water. Give water to those in that psychological state, and they relax—"Ah! At last! The water I've longed for!"—and the result is shock: stretched taut till then, the thread of life is suddenly cut, and they die.

"Sonny, please! Water!" "Please give me water!" All over the field voices called to Mom and me for water almost until dawn. Soon, however, I fell into a deep sleep.

A GATHERING OF GHOSTS

Hot, I woke up. Overhead, the August 7 sun was glaring down. A strange odor was wafting about us, an odor to make you puke. The odor—rotting corpses and all the stuff that had burned—was impossible to describe. I retched any number of times, bringing up yellow fluid. Holding my hand over my nose, I looked around. Half the people lying in the fields on either

side of the road were already dead. The August sun hastened the putrefaction of those corpses with melted skin. When I turned my gaze toward town, ghosts came marching, sending dust up into the air; their numbers had increased over those of August 6, when the bomb fell. When they got this far, they collapsed in the fields on either side, one after the other, and their voices echoed sadly, always the same: "Water. Water, please!"

Dazed, with a fixed gaze and a scary expression, Mom was suckling the baby. Unable to stand the burning August sun, she told me, "Find something to give us shade." Holding back the urge to vomit, I shuffled along the trolley street searching for likely objects. Things had been tossed aside on the pavement. A bicycle, steel helmets, clothes, and the like lay scattered. I found an umbrella, brought it back, and opened it over Mom and the baby, and I sat down, holding the umbrella over them.

On the street, the silent procession of ghosts continued. People hauled corpses in the fields by hand or foot, piling them up along the edges of the fields. The next ghostlike people to arrive collapsed in the spaces this opened up in the field. And in the same way, they too died, one after the other, and were added to the piles. I simply watched, struck dumb. The stench of death floating on the air became all the fiercer.

Around noon a truck stopped in front of us, and a civilian warden holding a megaphone called repeatedly to us, "We're distributing food, so come get it!" A stream of people who, like us, were living on the street squirmed their way toward the truck. Mom had me go: "Get some food!" Carrying a steel helmet, I lined up behind the truck. A straw mat had been spread on the truck bed, and on it was a mountain of rice balls. A man shoved a flat, square shovel into the heap of rice balls, scooped them up, and dropped them into the bowl or bucket each of us held out. The steel helmet I held out became a heap of rice balls. The rice balls had been grilled till the rice was brown. That way they wouldn't go bad so quickly in the summer heat.

I'd dreamed of white rice, but even with rice balls right there—rice balls made entirely with white rice—I simply had no appetite. Normally I'd have gulped them down in a second, but perhaps because of the strange odor or because I'd been bathed in radioactivity, I vomited frequently, spitting up the yellow fluid. Mom kept stuffing food into her mouth, saying, "For the baby, I've got to produce milk!"

That night, too, the great chorus continued from the fields on either side—"Water! Water!" I thought, "What an annoyance!" Still, I fell into a deep sleep.

Next day, too, we were plagued by the August sun and the stench of death. Not able to stand the heat reflecting off the pavement, Mom said, "Let's get out of here and go find some shade at Sarayama or Ebayama, beyond the end of the trolley line in Eba." We concealed blanket, bowl, and axe behind a clump of grass; I took the metal helmet of rice balls, Mom carried the baby, and we moved off, holding the umbrella over us. Every-

where on the road there were large numbers of corpses, and the stench of death hung in the air everywhere.

When we got to the Eba terminus of the city trolley, there in front of us was the broad field, the army rifle range. We'd come here occasionally to catch grasshoppers, but now there were army trucks coming and going. Those coming were loaded with corpses. Soldiers lined up the corpses and cremated them. The smoke danced in columns above the field, and an ugly smell wafted, like the smell of burning hair. Next to the Eba trolley stop was a can factory. Climbing up the sloping road beside the factory, we went along the embankment of the lower Temma River toward Sarayama. At the foot of Sarayama people squatted, leaning against the slope, their burns and injuries rotting, the pus flowing. People lay fallen, blocking the path; they had already turned into corpses. Seeking shade, Mom and I pushed on up Sarayama.

When we got to the foot of a huge tree that seemed to promise shade, we found a circle of people, silent, squatting. We had climbed the hill searching one tree after another for shade, but the space under all the big trees was taken by burned and wounded people. Mom and I were shocked anew at how many people had fled to the hill and collapsed. We saw we wouldn't find shade, so we had no choice but to go back down the hill. With twigs for chopsticks, people with burns were often picking at their own arms and legs. When we looked more closely, we saw that dozens of maggots were seething, wriggling amid the pus flowing from putrefied burns. It must have been impossibly painful when the maggots crawled, so with these tweezers, people silently grabbed the maggots teeming on their bodies. We understood that, borne by air, fly eggs attached themselves to burns, and with plenty to feed on, turned into maggots with frightening speed.

By this time I, too, hurt—on the back of my head and the nape of my neck. When I touched those spots, the skin felt greasy; pus flowed. I realized for the first time that I had burns. In my dazed condition, the pain hadn't registered. An army relief tent had been set up right where we came down the hill. Mom urged me to go to the tent: "We're lucky. Quick, go and have them treat you." The tent was surrounded by people with wounds and people with burns, all seeking treatment. I entered the tent to find it filled with people who looked exactly like Stone Age humans: their whole bodies were smeared with a white fluid (zinc oxide), white like coal ash dissolved in water. When I got to the military doctor, he scolded me, "We don't have any medicine, so there's no point in your coming here."

One after the other, people waiting to be treated fell and lay on the pavement. It was a cruel, horrible scene; but when you got used to it, the bodies seemed merely like felled tree trunks, and you felt absolutely no horror. No matter how horrible the conditions to which they're subjected, humans quickly adapt to their environment.

When you slice into the stems of squash and cucumbers, juice oozes out. Seeing people who had smeared their burns with that juice, I asked

Mom why. She told me, "It helps to paint burns with the juice of squash and cucumber. So do it!" So I too painted the wounds on the back of my head and neck with squash juice.

The Eba shore near the military hospital was teeming with people with burns and wounds. Those who'd got admitted into the military hospital and treated were the lucky ones. Searching for a shady spot, Mom and I wandered along the shore, pursued by the broiling sun. Stepping over fallen corpses, we sometimes missed, stepped on the bodies, and slipped. It felt like slipping on banana peels, and the burned skin clung to the soles of our feet. We scraped the skin off on the ground.

LIFE IN RENTED QUARTERS BEGINS

We returned to the trolley stop at Kawaguchi-chō. Why did Mom insist on returning to the trolley street? My oldest brother Kōji would be coming home from Kure Naval Arsenal, and she judged that the trolley street, with all its traffic, was better for letting him know that we were still alive. We raised the umbrella and continued to wait on the pavement for Kōji's return. The pus started flowing heavily from the back of my head and neck; the burns hurt and made me feel terrible. "How did I get burned?" My thoughts turned back to the situation at the time of the explosion.

It really must have been destined that I survive. I'd been saved by the school's concrete wall. I had drawn near the wall and was talking with my classmate's mother, and the heat rays from the atomic bomb came from behind and at an angle. My head and neck had been exposed, and I'd got off with light burns. Had I been one yard farther from the wall, I would have received burns over my whole body, like my classmate's mother. Moreover, after the heat rays flashed, a blast hit the city at a speed of 140 miles an hour. It blew off roofs. It knocked over everything, blew it away. I, too, was blown over, along with the school wall. Had the wall fallen on top of me and covered me, it would have squashed, flattened, killed me. But trees had been planted along the street two yards in front of the wall, and the blast first broke those trees off, leaving about two feet of trunk sticking up. The wall fell over onto those stumps and lay propped at an angle. That's why I wasn't crushed. As I thought about that spot, I realized there'd been a double miracle. I was amazed I had survived.

A strong stench of death was in the air, but my sense of smell became utterly deadened, and I stopped noticing it. In the heat, even the rice balls in the steel helmet began to go bad; I pulled out gooey strands. As before,

I felt like vomiting, and I had no appetite; I merely stared at the rice balls. "They've gone bad," Mom said, but for the baby's sake, she went on stuffing herself with the gooey rice balls. The baby slept on. When I got thirsty, I went into the fields and sucked the flesh and juice of sweet squash.

About then, soldiers began coming with fire hooks to clear away the corpses lying in the fields and on the trolley street. Hooking the corpses at neck and waist, they pulled them to the road, lining them up. They lined

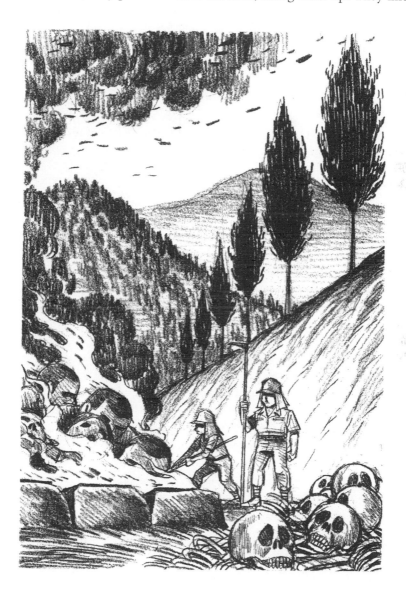

up the charred corpses exactly like tuna at a dockside fish market. Some were still conscious, gasping like goldfish and signaling that they wanted to be saved. But at best they'd live only another hour or two, so the soldiers hooked them by the neck and dragged them off.

Soon a truck came along the row of corpses, and they were thrown one after the other into the truck, quickly piling up. Fully loaded with corpses, the truck took them to the field of the army firing range. At night, the whole area near the end of the city trolley line in Eba was bright from the fires cremating the corpses. In that hell we waited and waited, hoping that Kōji would come back and find us.

By the fourth day after the atomic bombing, I'd pretty much recovered my calm, had my normal energy, and had regained my appetite. Hunting in the fields for sweet squash and cucumber, I brought them back and ate plenty. The numbers of those like us who'd been burned out and thronged pavement and fields shrank, a tide going out. Either they moved in with relatives or acquaintances, or they became corpses and were cleared away. But pus still flowed from the burns on my head and neck, and I kept cutting the stems of squash and cucumbers and smearing the burns with the juice. That's what I was doing when a pair of military boots wrapped in puttees stopped before me. I looked up, and standing there, wearing a battle helmet and khakis, his face and chest drenched in sweat, was Kōji. We looked at each other silently.

Mom spoke: "Great! You found us." Kōji started to speak; his voice was without emotion. The trains weren't running, there were no buses, and he had come back to Hiroshima on foot from the naval arsenal in Kure. From about the eastern edge of Hiroshima, he had a panoramic view of burned-out Hiroshima and had realized that his entire family must have perished. But he'd kept walking toward our house. On the road along the way, there were many corpses covered with sheets of galvanized tin, feet sticking out. Fearing they might be members of his family, he'd moved the sheets to see. He was shocked at the horrific, half-burned corpses; they'd made him want to scream. Still, regaining his courage, he'd walked on, pulling back the tin sheets and checking the corpses. Not able to bear the sight of too-grisly corpses, thoughtful people had covered them with the tin. When he stood where our house had been, where nothing at all remained, neighbors were cremating their relatives. They told him that Mom and I were at the Kawaguchi-chō stop.

With Kōji, we appealed to the M. family, distant relatives in the half-farming, half-fishing town of Eba, and we moved in with them. Carrying blanket, bowl, and axe we'd picked up on the street, which were now our

sole earthly possessions, we bade farewell to the pavement life we'd lived for what seemed like ten years.

To get to the M. family's house, we went past the army rifle range, where they were methodically cremating corpses, and as we came near, the stench of burning corpses was so fierce that we had difficulty breathing. We held our breath and walked. At several spots in the rifle range field, corpses were piled a yard high. Soldiers poured oil on them and lit them, one after the other. The light from the flames consuming the corpses illuminated the pitch-dark road, taking the place of electric lights.

The M. family's house was at the foot of Ebayama. On top of the hill there was a weather station; the middle slopes were tangerine groves and vegetable fields, and the town crematorium was also there. Mother came out of the M. entryway, relief on her face, and we realized we'd found temporary shelter. When we lay down in the nine-by-twelve room, the feel and smell of straw mats reawakened in us the realization that human living conditions actually existed. Mom worked like a beaver doing the laundry and making clothes for the baby.

Before we knew it, a week had passed. Meanwhile, on August 9 an atomic bomb was dropped on Nagasaki, too, and a grim situation unfolded, like that in Hiroshima. On August 15 came the emperor's radio broadcast informing us, through heavy static, that Japan had lost by unconditional surrender. Mom and the M. family gathered in the kitchen, faces gloomy all around, and talked: "What will become of Japan? How are we going to make ends meet?" I could have cared less what happened to Japan. What I kept thinking about every day was filling my stomach. I roamed the neighborhood of the M. family's house searching for food.

Counting the baby, the four of us had barged in on the M. family, so it stood to reason that our presence would be resented. M.'s mother-in-law treated us with an attitude of "Get out!" They wouldn't divide food fairly. I hunkered down in a corner of the room and studied the M. family's faces. Mom pleaded, "When we earn money working, we'll absolutely repay you." She borrowed money, and the four of us rented a room in one corner of a three-family tenement and moved there. It was a shedlike room, nine feet by twelve. The houses there were full of groaning people who had experienced the atomic bombing, had been burned over their entire bodies, and had come back here from the city proper.

BAREFOOT GEN: EXCERPT 2

Toward the end of volume I, Nakazawa depicts the events of August 6. Here Gen and his mother try to rescue Shinji and Gen's father from the ruins of their home. We know from the autobiography that Nakazawa himself was not present, that he learned about these events only after the fact, from his mother. But in *Barefoot Gen*, Gen is the focus throughout, and here he tries heroically first to rally neighbors and then to lift the roof beams himself.

The treatment of bomb damage begins fourteen pages earlier and includes a striking variety of form: one panel fills the entire left half of a page (the explosion itself), one panel stretches across the top half of two pages (a scene of collapsed houses on either side of a highway down the middle of which run trolley tracks), and one panel fills a full page (a burning horse). This treatment of bomb damage completes volume I and extends through much of volume II.

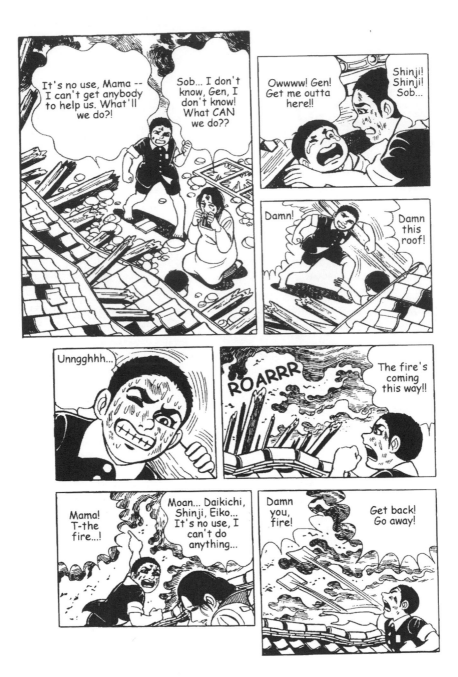

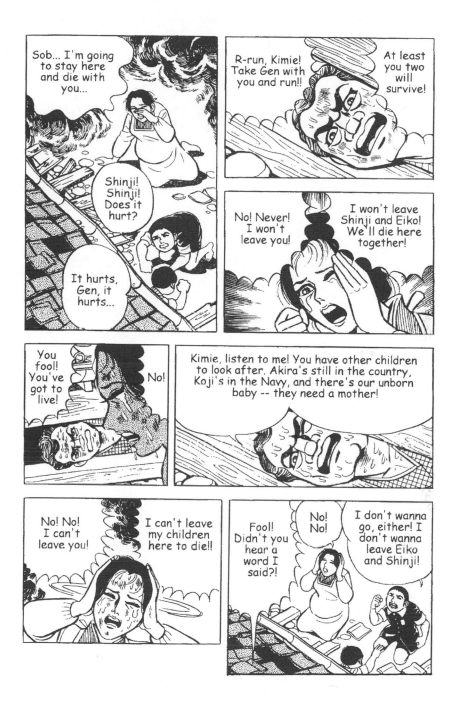

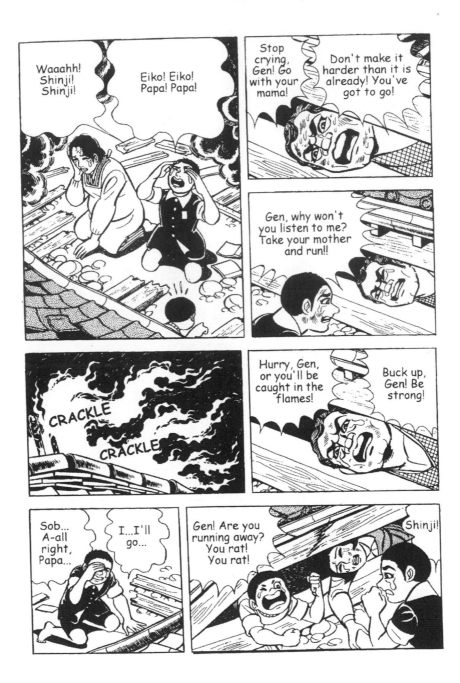

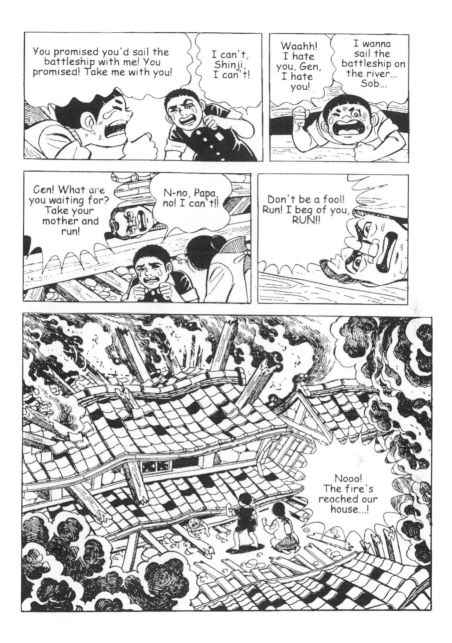

3

TERROR

THE DEATHS OF DAD, EIKO, SUSUMU

Uncle T., Mom's youngest brother, was chief of the KP squad of his battalion, stationed in Hiroshima. Perhaps you could call it one of the perks of his job, but he could eat as much as he wanted. He was tall (about five feet nine) and of a large build, plump and sturdy. Uncle T. had been mobilized to clear away corpses and because he was coming to Eba, he visited the M. family, who were his relatives, and brought Mom hardtack. In our mouths, the army hardtack, with stars impressed in three parallel lines, was startlingly sweet.

Uncle T. told us how things were in the burned out city. That to load corpses onto army dispatch boats, they placed sheets of metal between boat and shore, troughlike, slid the corpses down into a pile, and transported them to Ninoshima and other sites. That if in collecting the corpses you grabbed a hand or foot, the flesh would slip off and expose bone, making you feel terrible, as if you'd become a vulture. That the seven rivers flowing through Hiroshima were full of corpses and that when the corpses reached the mouths of the rivers, it was an exhausting job to hoist them out onto the bank. That the stench of rotting corpses was unbearable: no matter how many corpses you cleared away, there were always more. He grumbled to Mom then went back to his unit.

Two days later, Uncle T.'s buddy stopped by, and we learned that Uncle T. had died. We were all stunned. Uncle T., the very picture of health, had suddenly died. We simply couldn't believe it. He had been so very alive yesterday, and now he was already dead. It left us stunned. Mom kept saying, "Strange, strange." In nearby houses, too, there were people who died as Uncle T. had died. Worried about whether relatives had sur-

59

vived, they'd searched the ruins of the city and come back; up until several days ago, they'd been so alive, and now suddenly they were dead.

At the time we had no idea that the "flash-boom" that was dropped on Hiroshima was an atomic bomb. We called it "flash-boom" because there was a bright flash, then a boom. Rumors were rampant: it contained poison gas, and you'd die if you breathed the poison; it contained infectious germs, and you'd die if you passed acute, bloody stool, as with dysentery.

Actually, people who'd been bathed in the radioactive black rain and healthy people who'd passed near where radioactivity had fallen to earth and pooled did have their bodies invaded and cells destroyed, and there were many cases of rapid leukemia and cancer and the like. The effects of radioactivity, this second, life-stealing terror of the atom bomb, began to appear rapidly, attacking many people one after another. And it ate away at surviving bomb victims forever. Among people terrified by the fear of dying, rumors flew to erase the unease, and people acted on them. Some said you wouldn't die if you pulverized human skulls and swallowed the powder or spread it on burns and wounds, so some people did just that.

Perhaps because she'd found sanctuary, Mom gained some emotional leeway, her face began to brighten, and she became more human. She asked Kōji and me to go to the ashes of our house and dig up the bones of Dad and Eiko and Susumu—doing so had been on her mind every day. And she told us in great detail where and how they'd died. Staring at Mom's face in the flickering candlelight, Kōji and I caught every last word that came from her mouth. So much had been happening that I'd not had time to ask about Dad and the others. Learning now for the first time how they died, I shook with the tension.

I learned, too, how Mom had survived the explosion of the atomic bomb so miraculously.

I remembered seeing Mom hanging up clothes that morning on the laundry porch off the second floor. Then, at the moment when she finished hanging out the clothes and went to enter the house and had just moved under the second-floor eaves, the bomb exploded. The violent rays, 9,000 degrees, were blocked by the single board of the eaves. Had she not been under the eaves, her whole body would have been burned black. And had she gotten a step farther into the house, the house that the blast struck from directly overhead and flattened, she would have been crushed by beams and killed. But even though the house itself collapsed, the drying porch floated up in the opposite direction, flew up, carrying Mom with her huge belly, and came to earth, just like an airplane landing, in the back alley. Thanks

to the fact she was on the drying porch, Mom escaped without even a scratch. Survival truly is a matter of inches. Both Mom and I felt we'd been protected by something—"So we have to live!"

Miraculously spared, Mom became aware of Susumu's cries—"Ouch! Ouch!"—from the entryway of our collapsed house, and she rushed to the entryway. Susumu's head was pinned at the threshold by thick beams; his body protruded, and he continued to cry and kick his feet. He'd been sitting in the entryway playing with the model boat and singing, "Tater, tater," so when the house suddenly collapsed, it pinned his head. She could hear Dad crying from the six-by-nine room beside the entryway, "Kimiyo! Do something! Do something!" She couldn't hear Eiko, who had been in the nine-by-twelve room. Crushed by the thick beams, Eiko had died instantly. Desperate, Mom pulled off tiles and pieces of crumbled wall to lighten the weight of the roof even a bit. She tried with all her might to lift the roof, but it wouldn't budge.

Susumu's voice cried, "Mommy! Ouch! Ouch!" Dad's voice called, "Quick! Do something!" Urged on by their voices, Mom did everything she could to try and lift the roof, but she couldn't move it an inch. Old houses have heavy beams, and one woman alone had absolutely no effect. Mom appealed desperately to the people who came fleeing along the road in front of the house. Prostrating herself, she appealed in tears to them, "Please give me a hand! My husband and children are pinned. Help me lift the roof!" One person tried several times to lift the roof, then said, "There's no way! Give up!" Then he ran off. Mom appealed desperately to passerby after passerby, entreating them to lift the roof, but as soon as they tried, they left.

Susumu was crying in the entryway. Half-crazed, Mom tried to save at least him. She inserted a piece of lumber between the beams pinning his head and put her shoulder to the lumber to try to lift, but the roof wouldn't move. Utterly at a loss, she could only sit in the entryway and put her arms around his body. Thinking that injuring him a bit wouldn't matter, she grabbed his legs and pulled, but no matter what she did, his head didn't come free. He cried sharply, "Ouch! Ouch!" So Mom stopped pulling at him. Susumu's body moved sideways, but his head simply wouldn't come free. Pounding on the beams in her frustration, Mom went on weeping.

Susumu had been crying, "Mommy! Ouch!" Then it changed to, "Mommy! It's hot! Hot!" When Mom looked at the far side of the collapsed house, tongues of flame were spreading and had gotten close to Dad and Susumu. Dad's voice became much more urgent, and he scolded Mom: "Can't you do something? Do something!" Susumu cried and

groaned, "It's hot! Hot!" Mom was going mad. She squatted in the entryway, embracing Susumu's body and crying, "Mommy'll die with you! We'll all die together!"

As the flames began to engulf our house, a person who lived behind us came past and found Mom weeping that "Mommy'll die with you!" He said, "Nakazawa-san! Give up! There's no point in your dying, too!" Mom didn't want to leave the entryway, but tugging firmly at Mom's hand, the

neighbor got her to flee the flames. When Mom looked back at our house, the flames had attacked the entryway and had become a pillar of fire. From out of those flames, she could hear clearly the cries of Susumu—"Mommy! It's hot! Hot!"—and Dad—"Kimiyo! Do something!"

The last anguished cries of Dad and Susumu rang in her ears and came back to her in her dreams as she slept; wiping away tears, Mom said that every day had become unbearable. She blamed herself for being unable to rescue them, and that thought continued to torture her.

That's how I learned that Dad and Susumu had burned to death. Mom muttered, "Eiko had an easy death, thank goodness." Eiko had died instantly, crushed under the beams. Mom murmured forlornly any number of times, "Her suffering wasn't prolonged, so that was a blessing."

Next day, through the sizzling August sun, on a bike borrowed from neighbors, Kōji and I headed for the ruins of our house. Carrying a bucket, I climbed onto the rack on the back of the bike and watched as an utterly transformed Hiroshima went by.

RETRIEVING THEIR BONES

As we went toward the city, the air was filled with an intense, strange stench—of death and of all burned things mixed together—that tortured our noses; we held our breath against it. When we came to the road leading to our house in Funairi Hommachi and looked at the burned-out ruins, charred hands and feet poked up from the rubble, quite like the flowers in an artistic flower arrangement. Here and there were metal drying porches, twisted like taffy.

Standing in our entryway, we found unmistakable evidence that this really was the burned remains of our house. Dad was a painter, so in his workroom he had dozens of white ceramic palettes, some flat, some partitioned. Melted, fused and twisted, they were scattered about.

Taking the shovel we'd stuck into the bike frame, Kōji began to dig in the entryway. I took a burned board and pried off pieces of the tile that covered everything. The soil was burned and utterly dry, white as bone. The dust swirled, and there was a small skull. Kōji said, "It's Susumu!" He picked it up and handed it to me. Susumu's skull was pure white, absolutely clean.

As long as I live, I'll never forget the moment I held his skull in my hands. The August sun was still strong and stiflingly hot, yet a chill came over me, as if buckets of ice had been dumped on my back, as if all the

blood in my body stopped flowing; the hair on my head stood on end, and I trembled. Susumu had been burned alive, pinned by the entryway's thick beams and crying, "Mommy! Ouch! Ouch!" and as that thought came to me, I put myself in his place—"How hot it must have been"—and the hair on my whole body stood on end. And I remembered my last sight of Susumu, as I left the entryway to go to school. He was sitting on the step,

holding the model ship, and singing at the top of his lungs, "Tater, tater," and making me promise to "Hurry home. We'll sail the ship on the river."

One after another, happy times with Susumu came to mind. The time I shared the raw rice I'd stolen with Susumu, and he put the grains one at a time, carefully, in his mouth, and ate them with a happy face—"Keiji: it's delicious! Delicious!" The time we divided the staircase into upper and lower and staged sword attacks and uprisings. Seeing us, Dad cut up a board and made us swords complete with hilts, and we had great fun immersing ourselves in a swordfight that lasted for days. The times I ran about the field with Susumu hunting grasshoppers, and we headed for home as the bright red sun sank, singing a nonsense song at the top of our lungs. These scenes seemed to be superimposed on Susumu's skull. I put the skull in the bucket and, digging up other bones with my hands, added them to the bucket.

Kōji was digging in the room next to the entry and said, "Got it!" I turned, and he had in his hands a skull a full size bigger than Susumu's. He gave it to me, saying, "It's Dad." As I held Dad's skull, my hair really stood on end, and I trembled. Imagining Dad pinned under the beams and burning to death, leaving behind only his anguished cry—"Kimiyo, can't you do something?"—I broke out in sweat all over. I stared at Dad's heavy skull, and memories of Dad flooded over me.

Dad's many faces came back to me. His serious look when, shutting himself up in his second-floor workplace in winter, he put the charcoal heater between his legs, sat up straight, and stared fixedly as he worked up the structure of a painting. His satisfied smile when, after sketching several landscapes and hanging them on the wall, he shouted to me, often asking, "Which do you like?" and I pointed at one. His angry face after I'd scribbled, "Dad's a shit," on the side of the staircase and, very upset, he threw me into the closet. His happy smile when he was in good humor and embraced me, his whiskers scratching my face, or to encourage me when I was hurting. His stubborn face: one time I got into a fight with the son of the neighborhood stableman, and his father intervened, hitting me and giving me a lump. Dad witnessed the scene, rushed over to the stableman, and argued angrily with him: "Parents shouldn't intervene in children's fights! Kids have their own world! Those experiences will be useful when they grow up! Don't do it again!" His serious face when he took me with him to Ebayama or Mitakeyama to sketch, and as we walked, hot, amid thick tall grass and trees murmuring in the wind, he observed the scene. His smile when, back from a trip, he put a souvenir, a model airplane, on our bed and saw how delighted we were. His look of contentment when I entered

elementary school, and under a small electric light, cloaked in dark cloth for air-raid blackout, he drew hurried pictures of monkeys and rabbits and wrote my name on my textbook, notebook, pencil case, abacus, knapsack, and shoe bag, studying each item closely.

I felt chagrin that Dad had been killed in the war he'd opposed so strongly—how cruel! Around the now-empty eye sockets of his skull—perhaps brain matter had oozed out and been burned—blackened incrustations made it look as if he was crying. I rubbed these off with my finger and, having cleaned the skull, put it in the bucket.

As for the nine-by-twelve room behind the entryway where Eiko had been, we had a hard time digging it out because the second story, utterly destroyed, was piled atop it. Kōji kept digging, and a graceful, girlish skull and bones emerged. I said, "That's Eiko," and Kōji nodded silently. As I transferred her bones to the bucket, I remembered times I'd spent with Eiko.

We'd always gone to school together. Eiko's voice seemed even now to be calling to me to hurry up: "Keiji! I'm leaving!" Looking very serious, she said she'd teach me the songs she'd learned in music class, and I could hear her singing, "Beautiful flowers, mums white and yellow." When we set off for Ninoshima with a note of introduction from a neighbor to try to buy potatoes, she saw me dressed for the excursion, hugged me, and said, "Keiji, you look cool!" Worried she'd never let me go, I screamed, "Let me go! Hands off!" A scene at the entryway floated up, a day when snow fell and piled up. It was a cold morning. When Eiko opened the window and exhaled, her breath turned white. She shouted for joy; it was pretty, so she wanted me to join her and made me stand at the window and exhale with her. Eiko crying when she was suspected of being the thief at school. The times we went to catch grasshoppers or buy dumplings in Eba. The time Eiko hid and—perhaps because of malnutrition on account of the food shortage—took an afternoon nap, and Mom found out and scolded her: "Sleep this much, and you'll die early!"

As I stared at Eiko's skull, I thought that everything had happened just as Mom had predicted. I pondered Mom's words: "Crushed by the beams, Eiko didn't utter a peep. It was an instant death, so it was an easy death—I'm glad for that."

The three sets of bones filled the bucket. Exhausted, Kōji and I squatted in the ashes. The sun sizzled. The neighborhood air raid trench in front of our house had caved in, and on a whim I peeked inside. The fierce flames must have blown clear through the trench. Where usually there were puddles of water, the dirt had been baked white, like desert sand.

Suddenly, in a corner of the doorway, I saw something I hadn't expected: dried cat. It was our cat, utterly transformed. It was thin, only fur. I wondered what had happened. I'd been told that if you feed dogs for three days, they never forget you, but that cats, no matter how you dote on them, are unfeeling, forget you, and run off. But I realized that cats remember you even longer than dogs. Blackie had found her way home through the fierce flames. But unable to escape the raging sea of fire, she'd

run to the air raid trench and been baked, the liquid part of her sucked out. She had died and become desiccated cat. You'd have thought Blackie's fur would have blown away in the wind, but now it was only the fur that remained. How sad!

When it rained, Blackie would come in from outside and leave her paw prints—they looked like plum blossoms—on the floor mats. Smiling wryly—"Flower-viewing! Flower-viewing!"—Mom would take a rag and wipe them away. One winter night, she crawled up under my blanket, and when, having difficulty breathing, I woke and rolled back the blanket, Blackie was lying across my warm chest, asleep. Late one night the whole house woke to Eiko's shrieks, and when we looked at Eiko's blanket, Blackie had a mouse in her teeth and was playing with it. Mom chased her away with a broom, and the house was in an uproar. It was fun to watch Blackie react when she sniffed a fart. We had Susumu hold Blackie's neck and blew farts her way; Blackie sneezed a lot, then ran off in distress. We'd heard that if in a dark room you rubbed a piece of hard rubber over the cat's fur, you'd generate static electricity and it would look like an electric current was flowing. So we had Susumu hold Blackie, and I stroked Blackie's back for all I was worth. But we didn't see any static electricity, and Blackie stretched and as if saying, "Enough already," grew angry and mewed. All these memories were happy ones. I said goodbye to the flat, desiccated cat Blackie had become and left the trench. I realized that our family was no longer the same.

IN THE CITY OF DEATH

During the war, concrete cisterns stood in every entryway. They were three by three feet, filled with water, and labeled "fire-fighting water." The tanks were for putting out the fires started by bombs; they were required. In the twinkling of an eye, with the dropping of a single atomic bomb, Hiroshima, biggest city in the region, was burned out. The only things still standing in the burned-out waste as far as the eye could see were the tanks of "fire-fighting water." Tanks beyond counting lay scattered way off into the distance. Approach these tanks thinking to use their water to wash off your dirt-smeared body, and you were in for a shock.

The tanks held horrific corpses—red, half-burned, swollen, eyes glaring at the sky. Staring again at the corpses, I was surprised: people burned and dead in water—well, that's how they swell up. Faces had swollen,

round like melons a foot in diameter; bodies swelled three times normal size. Every single tank held corpses—red, swollen, like the giant guardian gods at temple entrances. Examine these corpses closely, and you noticed that with all the mother-and-child corpses, the mother's arms were wrapped around the child, holding it close. The embrace was tight so that when the corpses swelled up, the child's face was engulfed by the mother's breasts. Mothers had protected their children desperately to the very last. With brother-and-sister corpses, brother wrapped his arms around sister and died holding her tight. They were deaths befitting older brothers—the desire to save their sisters was evident.

I went around looking at cisterns, thinking, "How hot it must have been." When the atomic bomb exploded 750 yards above Hiroshima, the temperature at the center was millions of degrees, and its heat rays of 9,000 degrees consumed those who were outdoors. It smashed the houses with a blast of more than 140 miles an hour, and people fortunate enough to be indoors crawled their way out of flattened houses. Just when they thought they'd escaped, they were surrounded by the flames, chased by the fire, and cornered. Unable to endure the heat, they'd jumped into the three-foot-square tanks and burned to death. When I realized all this, I trembled with rage at the cruelty of the atomic bomb.

At last I found a tank that contained no corpses and, with the water remaining in the bottom, washed the dust off my body. The city had become a burned-out plain as far as the eye could see. Nothing moved except smoke rising from where the corpses were cremated. Shifting with the wind, the nauseating stench of death waxed and waned in the air above the scorched earth. Kōji suggested we take a look downtown before we went home, and holding the bucket filled with the bones of Dad, Eiko, and Susumu, I got on the back of the bike. Kōji said, "I'm going to fly. So hold tight!" and started pedaling. He steered the bike toward Dobashi, Hiroshima's western business district.

The telephone poles to left and right were scorched but still standing and suspended from them, quite like long snakes, were the thick lead tubes of telephone wires; apparently fused at high temperature, they sagged from the poles off into the distance. Seeing a trolley car charred and blown a full five yards off its track, I marveled at the force of the blast: "Such heavy metal objects—even they went flying!" Kōji steered his bike through a city of death in which there was no trace of a living person. When we neared Dobashi, the stench of death was the worst of all. The smell was so bad we had trouble breathing. Red light district, movie theaters, and restaurants were clustered

in Dobashi; most people were still asleep when the atomic bomb fell, and they were crushed instantaneously in their houses. That's probably why the number of corpses was especially large throughout Dobashi. The smell of these corpses decomposing was something else. Water tanks in this part of town were filled with a dozen or more corpses, piled one atop the other. Surrounded by flames and unable to bear the heat, people had jumped into the water tanks simultaneously, so it was natural that the corpses had piled up.

On the asphalt road sloping up into the wartime entertainment quarter, a caricature had been drawn of U.S. President Roosevelt and British Prime Minister Churchill, and beside it was written, "U.S.-G.B. Beasts." On entering or leaving the entertainment quarter, you were supposed to trample on the hated "U.S.-G.B. Beasts." I thought back to happy memories of days when Dad had taken me up this slope to see movies. The powerful scene in *Sugata Sanshirō* when the hero and his nemesis duel in the field. The final scene with Sanshirō on his feet facing the hill at sunrise. The scene in *Tange Sazen* where Sazen panics after throwing the precious urn into the river.* Dobashi was full of happy memories of my infancy. That Dobashi had disappeared, become a town of rubble. I took a last look, and we left.

Entering Tōka-machi, we turned left, and passed the city trolley stops—Sakan-chō, Aioibashi—and there was the Honkawa, the central river running through Hiroshima. The T-shaped bridge over the Honkawa is Aioi Bridge. Its railings had fallen, the roadway was twisted and undulating, and holes had opened up. This bridge was at the epicenter of the atomic bombing; the blast hit from directly overhead. It hit the surface of the river and bounced back, and the bridge was swollen and twisted as if by pressure from beneath. I looked down from the bridge at the river, and from one bank to the other it was a mass of corpses, red and swollen, their big bellies piercing the surface of the water; with the ebb and flow of the tide, they floated upstream and down. Their intestines were rotting, and gas built up in their stomachs. Swollen bellies popped from the pressure of the gas, water poured into the stomachs, the corpses grew heavy, and one after the other, trailing bubbles, they sank to the bottom. Burned tree trunks clustered on the surface, and the fat-bellied corpses drifted and bumped into those trees, veered and went floating off, just like pinballs in a pinball machine. These were people who, pursued by the raging fires, jumped into the river or, throats dry from burns, waded in seeking water and died.

At Kamiya-chō we turned right, onto the city trolley street connecting Bank Street and City Hall. Reaching the Hakushima Shrine trolley stop, we were astonished. The camphor tree at Kokutaiji, so huge that five adults joining hands couldn't reach around it, was down, fallen onto the trolley street. Kōji steered the bike all over the ruins of the city. Crossing Sumiyoshi Bridge, we went along the bank of the lower Honkawa toward Eba. As if racing with us, corpses were being pushed down the river toward its

**Sugata Sanshirō* (1943) was Kurosawa Akira's film debut as director; *Tange Sazen* (1936) was one of a series about a one-eyed, one-armed samurai.

mouth. The bucket I was holding shook as the bicycle bumped along, and the skulls inside clattered against each other. That sad sound—like the cries of Dad, Eiko, and Susumu—echoed in my ears ever after.

Kōji pedaled hard, and the bike sped up. His back trembled, and I realized he was crying. Mom greeted us on our return with, "Thank you." When I gave her the bucket I was carrying, she put it in a corner of the room: "Now my heart's at ease." That night, exhausted, we turned in early.

The burns on the back of my head and my neck hadn't healed, so I slept face down. I couldn't sleep on my back because the burns would open. The burns suppurated and broke, and I closed my mouth against the odor of oozing pus. In the night, a beam of light fell on my eyes, and I awoke: in the unsteady lamplight, I saw Mom. Face full of grief, she was staring at the skulls of Dad, Eiko, and Susumu. That face with its thousand emotions frightened me, and I was quick to pull the blanket up over my head. Poor woman, repressing her desire to raise her voice and weep and cry!

THE FIRES BURNING THE CORPSES

Every single day was a struggle to ensure that we had food and could survive. Mom worked herself to the bone helping the M. family and in other ways, urged us on desperately in our search for food, and staved off hunger by making stew when she could get potatoes or other vegetables. Because of malnutrition, my legs developed many boils. Legs dragging, I went every day in search of food. One day my aunt (Mom's younger sister) who had married into the Tsutsui family dropped by unexpectedly.

She came because she'd heard from neighbors that Mom had survived. This Tsutsui aunt had a weak constitution; simply by looking at her, you could tell she was sick. Her Tsutsui in-laws had been pinned under their house and burned to death, and her husband and three children were missing. To try and learn whether they had survived, she searched daily, going by foot to the Hiroshima relief stations and refuge sites. That day, having turned up hopeful news, she said she was really happy and sat down on the floor. She'd heard from a classmate of her oldest daughter, Reiko, who went to a girls' higher school, that Reiko had fled to the suburb of Kabe. She told Mom, "I'm going tomorrow to Kabe. Can I stay here tonight?" and lay down.

My aunt went to sleep beside me. She slept on, snoring loudly. I awoke in the middle of the night because of a strange sound, as if someone were spraying water, and all around her was bloody stool. On seeing her

own bloody stool sprayed about, she jumped up in shock and rushed to wipe it up with a cloth and kept apologizing, "Sorry! Sorry!" She said she herself had been utterly unaware that she'd been passing stool. She complained, "How strange!"

Walking about Hiroshima, she'd been contaminated with radioactivity, and the disintegration of her cells had already started. The next morning she said she had to get to Kabe. Mom stopped her: "In your weakened state, that's impossible! Regain your strength first!" But she was worried about her daughter, so she wouldn't listen. She set out, and Mom saw her off, saying again and again, "I'm worried . . . worried."

Three days passed. She didn't return. That evening, very worried, Mom suddenly spoke about going to look for her. She picked up the baby. Kōji and I both got ready, and all of us headed for Kabe. There was no public transportation, so we walked, trudging along the trolley street that runs from Eba to Yokogawa. Passing the site where the concrete wall of Kanzaki Elementary School lay rippled and fallen, I saw the wall again: "Yes, except for that wall. . . ." Near the playground an air raid trench had been dug; I peeked inside and was astonished. It was filled with small slim skeletons—one glance told me they were the bones of children. The kids had gone to school, and the school building had collapsed in the blast. Those lucky enough to survive had rushed for safety to the air raid trench and, engulfed in the fire, they'd burned to death. Among these bones lying around were the bones of my first-grade classmates. I shuddered.

Darkness fell, the city of rubble was painted pitch-black, and the way ahead closed in. Rain began to fall, and Mom quickly wrapped the baby in towels. We walked on through rain that continued to fall softly. There was virtually no light, and we guided ourselves by the trolley tracks, which gave off a dull gleam. When we got to Dobashi, the stench of death was fierce, and it nauseated us; it was so bad we had difficulty breathing. Then a fearsome thing happened.

It felt like countless pebbles were being hurled against my body; I couldn't even open my eyes. When I squinted and looked closely, the white short-sleeved shirt I was wearing blackened even as I watched; my whole body turned black. Quickly I looked at Mom, the baby, and Kōji, and before my very eyes the white towel in which the baby was wrapped, the white apron Mom was wearing, and Kōji's white shirt were all dyed black. When the feeling of being bombarded by pebbles ended, a black wave started wriggling all over me. "What's this? What's this?" I looked closer and was shocked. Round fat flies had leapt onto our bodies, stuck there, and our bodies had turned black all over.

In Dobashi in particular, there were so many piled-up corpses decomposing that larvae bred, quickly matured into flies in the heat, and swarmed. Mom and Kōji both shrieked at the onslaught of the horrific number of flies that had bred on human bodies. Frantically brushing off flies, we dashed through Dobashi. We even had the illusion the flies would eat us alive. Thinking it strange that charred corpses should be wearing white shirts, I looked closer and saw it was larvae breeding. Such corpses were everywhere. In the death streets of Hiroshima, the only things moving energetically were the flies.

We walked on silently through Teramachi, through Yokogawa, and then toward Kabe along the Ōta, chief of the seven rivers running through Hiroshima. In a bamboo grove on the riverbank at Gion-chō, lots of people who had fled there were lying on the ground, moaning. Toward dawn we got to Kabe and napped on the roadside. When Kōji pushed me to waken me, the morning sun hit my eyes. I hadn't had enough sleep and wasn't feeling well, as if my stomach was full of vinegar. We walked around to the schools and assembly points for bomb victims who'd fled there. Tottering among people suffering from the burns and injuries we'd become entirely inured to, we asked after the Tsutsui aunt and her daughter Reiko. Mom went from one site to the next, inquiring of those in charge. Seeing her desperate search, I sensed the bond that unites sisters.

Walking all around Kabe, we became exhausted. Complaining about the fruitless effort, Mom said, "If we can't find her after all this searching, she may have died on the way and never got here." We gave our tired legs a rest at the gate of a temple that fronted the bus road. When we entered the temple precincts, smoke was rising: they were cremating corpses. Bones were piled up at the side, and a foul stench like that of burning hair filled the air. Dozens of white slips, pasted on temple pillars and wall, were fluttering in the wind.

Mom looked up at the slips of paper fluttering overhead and let out a shocked, "Oh!" She pointed to a spot where there were lots of slips. Lo and behold, there on a slip was the name and age of the Tsutsui aunt, stating that she had died and that her body had already been consigned to the flames. I felt a strange connection, as if the dead aunt had called to us. We told the temple people we wanted to take her bones back with us, but her bones had been mixed in with the pile of bones, and it wasn't possible to know which bones were whose. Our only course was to choose some bones from the pile, wrap them in paper, and carry them home. The fate of Reiko, said to have fled to Kabe, remained utterly unclear. With all five members dead, the family line of the Tsutsui clan had come

to an end. Dragging our exhausted feet, we found our way back to the rubbled city of death.

A crowd had gathered on the trolley street near Tōka-machi and was raising a ruckus, so we went to see and found a round water tank fifteen feet in diameter, towering fifteen feet high. One side of the tank had split, and naked men were climbing up into that crack and jumping down into the tank. "What on earth are they doing?" They were spearing dozens of pickled white radishes with a pole, throwing them out, and taking them home. The huge round tank was for storing pickled radishes. This area was the site of a market. Mom told Kōji to go get some. Kōji stripped to the skin, crawled up the tank, and jumped in. We waited for the radishes he threw out and grabbed them. Kōji emerged from the tank with his whole body drenched in vinegar; he smelled like a drunk and looked so strange I had to laugh. Mom laughed along with me. It was the first time she had felt like laughing since the atomic bomb fell.

Dashing about the burned-out waste, I found a charred baby buggy—only its metal parts remained—and piled the radishes onto it. Digging in the burned ground, Mom found usable bowls, plates, pots, and axes, and added them. The iron wheels clattered on the asphalt, and the scorched baby buggy—metal only—served its purpose well. In the surrounding ruins, people had put up a forest of tin and wooden placards to tell missing family members where their families were now. Lots of people were still seeking information about their families.

At the Eba rifle range, as always, the flames from the cremations shot up into the air, scorching the night sky, and the stench of death filled the air. These cremation fires continued night and day for nearly two months after the surrender. So you know they trucked in a huge number of corpses. Some said one hundred thousand people died in Hiroshima with the dropping of the atomic bomb, some said two hundred thousand; the exact figure is unknown.

But one thing was certain: in an instant a bustling city was wiped out and buried in corpses. And another thing, too: for the bomb victims who survived, the suffering and unease that began that day, August 6, last forever.

BAREFOOT GEN: EXCERPT 3

Late in volume II, Gen, his mother, and the baby, Tomoko, flee to Eba, the village at the southern tip of one of Hiroshima's fingers of land. The mountain Nakazawa depicts in the fourth panel is really only about one hundred feet high, but perhaps he emphasizes its size to reflect the perceptions of the child he was in 1945.

The three surviving Nakaokas (in the cartoon version, Nakazawa becomes Nakaoka) find refuge with an old friend of Gen's mother. But the old friend's mother-in-law and the two children of the Hayashi family immediately cast a pall on the welcome. Within a few pages, the children are tormenting Gen, making fun of his baldness, making Tomoko cry, and blaming their own thefts from the family pantry on Gen's mother. After a trip to the police station and the confession Gen's mother is forced to sign, Gen catches the thieving Hayashi children red-handed and then starts to take his revenge on the mother-in-law. Once more, the Nakaoka family sets out to find a place of refuge.

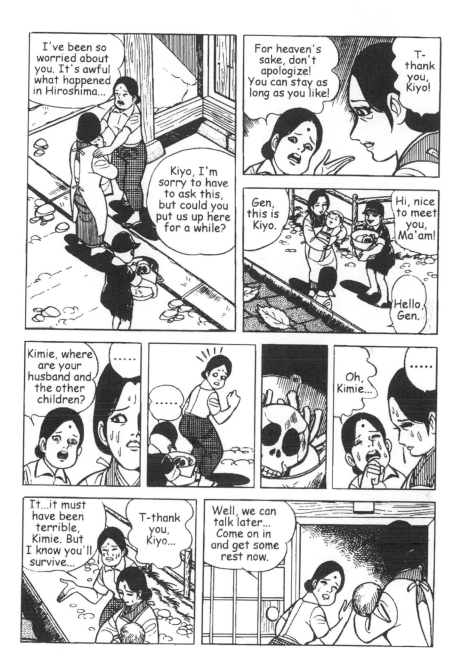

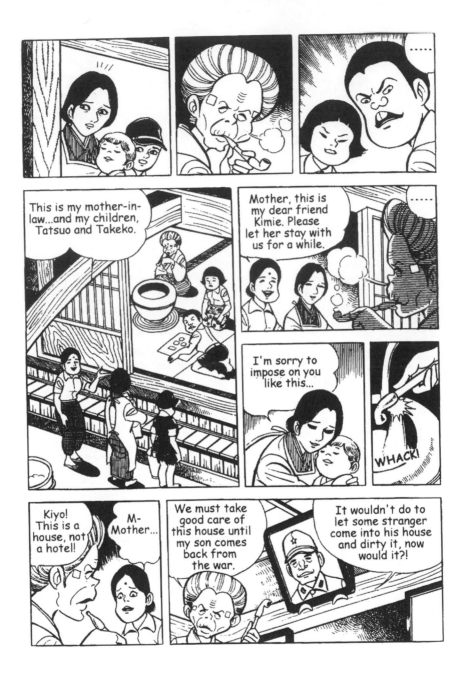

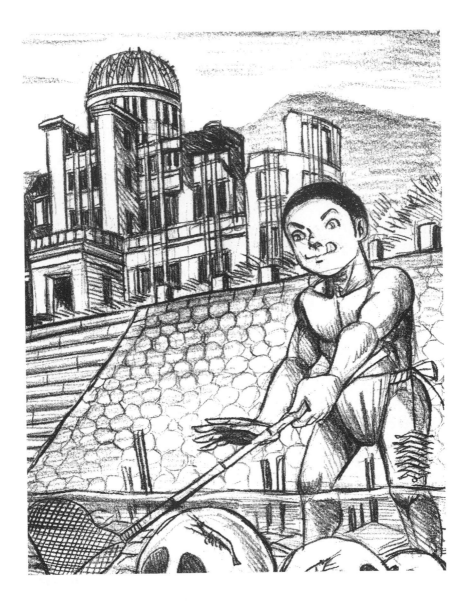

4

TO LIVE

THE STRUGGLE TO SURVIVE

Autumn breezes blew, and in the evenings goose bumps arose on bare arms; the season was changing. Before we knew it, it was September.

Defeat brought about a sudden change in the Japanese people. The town of Eba was set in its parochialism. It was a closed town in which people like us who came from the city were called "Outsider! Outsider!" and rejected absolutely. We outsiders were viewed with hostility. It wasn't easy to get work or food. Hunger oppressed us. For wages and for food, Mom and Kōji worked day and night doing odd jobs for neighborhood farmers and fishermen.

In front of our three-family tenement was a field of barley, and the road on the far side of the field led to the crematorium halfway up Ebayama. Even though a month had passed since the dropping of the bomb, there was a continual procession of coffins, day in and day out, on the road to the crematorium. They were in plain sight from our door: bereaved family and friends, fore and aft, carrying the coffin on their shoulders, bundles of wood in their arms, heading for the crematorium.

When processions to the crematorium appeared, I accompanied them and carried the bundles of wood for the old people. The crematorium was shaded by huge cryptomeria trees, so it was dark even during the day. The entry had bars over the windows, all rusty and bent and sprung. When you went inside, there were three open ovens, surrounded with stones, where coffins rested. To the side were piles of bones and ashes, discarded. You set the coffin on the designated spot, stuck the wood you'd brought around it, lit the fire, and watched as the corpse burned.

I sat on a rock and watched the coffins burning and became completely inured to the sight. As the flames rose, the air inside the coffins expanded and swelled, the wood blew apart with a loud noise, and you could see the corpses inside clearly. As the smell of burning hair grew strong and the flames reached the corpses, their sinews contracted, so the bodies appeared to sit up. Then they fell back, flesh burned, and fat bubbled and flowed. I saw this any number of times and thought that cremating human beings was just like roasting fish on a grill. When one side starts to burn, the fish curls up: the principle is the same with human beings.

I helped out at cremations because in return they gave me rice balls and mugwort dumplings. Seeing a procession heading for the crematorium, I was happy: "This means food!" I was really wretchedly hungry.

One day Uncle Y., repatriated from the Navy, dropped in with his young son. The dashing mien of his officer days was gone, and he was haggard. He had a knapsack on his back. Uncle Y. took a can of beef from the knapsack for us to eat. I savored the taste of the meat: "Never dreamed anything could be this delicious!" That night I listened in on the conversation between Mom and Uncle Y. When the talk turned to his family, Uncle Y.'s expression fell. With the infant in his arms, he said: "In the flash-boom, my wife was protecting this boy when she was pinned under the house, caught by large beams. She couldn't free herself, so she asked a neighbor who was fleeing to take the boy along, and she entrusted the child to him; she burned to death." His shoulders sagged. He spoke forlornly of learning of his wife's death from the neighbor who had escaped with the child.

Uncle Y.'s house was in Koami-chō, and once when Mother was busy, my sister Eiko and I went to visit. I remember being struck by how beautiful Uncle Y.'s wife was. As we were leaving, she gave us several summer tangerines. That this gentle, beautiful woman desperately protected her child and then was burned to death. . . . Uncle Y. told one happy memory of his wife after another. He had truly loved her.

Uncle Y. asked Mom if he could leave the child with us because he was going to look for work and couldn't take the child with him. In return, Mom asked him to go to the temple on the border between Hiroshima and Shimane to which Akira had been evacuated and bring him home. He was on her mind every day.

The next day Uncle Y. and Kōji set off to get Akira. There was no public transportation, so they walked. It took three days to get Akira and bring him back. If they had gone two or three days later, they said, Akira would have been sent to an orphanage. Families had already come for the other children who had evacuated with him, one after the other, and they

had gone off joyfully. How forlorn Akira must have been, seeing them leave! Only a very few children remained, the temple was empty, and the chief priest—"Your families were wiped out in the atomic bomb. Resign yourselves to that fact."—had addressed the ceremonial last words to the dead. At first Akira blamed Mom for having caused him bitter, sad thoughts, but when he learned from Mom of the deaths of Dad, Eiko, and Susumu, the tears came streaming. He cried on and on, his shoulders shaking.

With Akira and N., whom Uncle Y. left with us, the one six-by-nine room that was our household held a family of six; our postwar life started once again. Hunger was on the prowl, as always, and the whole family fought it. The milk in Mom's breasts dried up, and in her desire for milk, the baby—we had named her Tomoko—chewed frantically on Mom's empty breasts as she cried. In the neighborhood Mom inquired about rice desperately and finally obtained four pounds. She made a thick broth and covered absorbent cotton with gauze shaped into a nipple. Soaking it in the thick broth, she put it in Tomoko's mouth. Because Mom went out to work, the task of feeding Tomoko the ersatz milk fell to me. Tomoko's face had been like a monkey's, but with each day it became more expressive and cute. Nestling my cheek to hers, I quickly made the broth and fed her.

On the night of September 17, Typhoon Makurazaki came ashore on Kyushu's Cape Makura and raged over the Chūgoku region and Shikoku. The roar of the wind and the heavy pelting rain kept us awake; we were drowsing when we heard noises at the back wall and knew someone was breaking into the shed in back. We all worried and couldn't sleep a wink. Time passed. The typhoon departed, and next morning we peeked into the back shed, and there was a man, dead. He had died on the road, away from home. I thought, how sad! Pursued by the storm, he'd broken into the shed to rest his weakened body and had died a painful death. Such road deaths were occurring all over Eba. People who had been hit by the atomic bomb and found their way here from the city, exhausted, died. Typhoon Makurazaki caused Hiroshima's rivers to flood, washed out bridges, swept away dirt and sand, flooded people's houses, and left behind major damage. The dead: 1,997 people who'd been burned out by the atomic bomb and were now assailed by wind and water. Houses completely destroyed: 2,101. Bomb victims had been set a harsh, twofold trial: the houses they'd built with a sense of relief at having survived the bomb, were blown away, and they were left homeless.

To feed our family of six, Mom couldn't make ends meet with her part-time jobs, so she decided to stave off crisis by selling the belongings we'd entrusted to the acquaintance in the town outside Hiroshima. Mom,

Kōji, and I begged and borrowed a cart in the neighborhood and set off with it to retrieve the belongings. The house of the acquaintance was in a farm village called Iimuro, far from the city. We left early in the morning and pulled the cart hour after hour. It was after noon before we got there.

When Mom announced that we'd come, the acquaintance was surprised and nervous. Mom said, "Thanks for helping us out. We've come to retrieve the household effects we left with you." The woman's attitude changed abruptly, and she replied curtly, "The river flooded in Typhoon Makurazaki. Your things all washed away!" We looked at the wall of her house, and a waterline was still visible about three feet above ground level. No matter how you figured, it didn't make sense that all the stuff we'd entrusted got washed away. Mom persisted, "It can't all be gone." The acquaintance bared her anger and shouted at Mom: "If I say it's gone, it's gone!"

As this vigorous back-and-forth—"It's here!" "No, it's gone!"—was going on in the entry, a child of about first-grade age came home. Seeing him, I was astonished. The clothes he had on were my best clothes. I pointed that out: "The clothes this kid is wearing are mine!" Flustered, the acquaintance said, "I bought those clothes!" and continued to feign innocence. I replied, "There's a hole in the right pocket and a candy smear in the left pocket!" Saying nothing, Mom turned out the pockets. There, just as I'd said, was the hole and the smear. The acquaintance who'd feigned innocence got all flustered and made the excuse, "Now that you mention it, my child's clothes wore out, so—sorry—but I borrowed it."

Mom said, "I'll just check inside!" Pushing past the woman who was blocking the door, she went inside. In her determined action, I thought, I was seeing a mother's strength. Household effects were piled helter-skelter at the back of the dirt-floored room, and among them were several items we'd entrusted to them. A box in a drawer pulled out of the dresser was stuffed with Mom's clothes. Mom said they were hers. The acquaintance admitted it reluctantly, but this time she barked at Mom, "Those are the only things I was barely able to save from the flood! You should thank me!" Figuring other stuff was still hidden, Mom made as if to search, and the woman tried to throw us out: "There's no more! Leave!" Mom ran her eye quickly around the room and spotted three things that Dad had been at work on—a lacquered ink box and two clasps to wear with fancy kimono. She grabbed them. Cursed by the foul mouth of the acquaintance, we carried out the boxes with dozens of Mom's clothes, loaded them on the cart, and left.

What a bad taste that left! On the way back, Mom kept grumbling: "When she was in trouble, Dad really helped her out. I'd never have expected such ingratitude." That acquaintance had concluded that the whole Nakazawa family was wiped out in the flash-boom and took for herself the stuff we'd entrusted to her. Japan's defeat caused sudden change in all the Japanese. Yesterday's friend became today's enemy, and a sordid struggle to survive raged throughout Japan. War was the greatest evil, robbing us of even our hearts.

The unfinished ink box we'd retrieved had a design, a sailboat advancing among moonlit waves, and half the gold leaf had been applied. The clasps had pictures: a hawk sitting in a red maple, a carp leaping. These three are the only examples of Dad's work that survive.

Among the phrases popular after the war was "bamboo-shoot living." It means stripping away layer after layer until you get down to the very core. One after the other, Mom's precious clothes that we'd retrieved from the acquaintance's house disappeared and turned into food—rice, potatoes.

OUTSIDERS

People said nothing would grow in the ashes of Hiroshima for seventy-five years and thought that it had become wholly a city of death. But weeds flourished, and on October 11, trolley cars went into operation on all the routes, beginning to run among the ruins. The vital force of human beings is an amazing thing. One day Eba was thrown into an uproar. The rumor spread that the U.S. army would come ashore, fully equipped, at Ujina Harbor, that all males would be castrated, all women raped. The report spread instantaneously, even among us children, and people reported to each other where the U.S. troops were at any moment. Curiosity overcame fear, and one among the local brats, I went to watch.

On first sight, the American soldiers truly shocked me. Red faces, white faces, black faces, blue eyes, brown eyes. Huge, goblinlike noses, golden hair, silver hair, enormous height. No matter which one I looked at, I was agog. As they approached, children screamed and fled. But quickly we grew accustomed to chocolates and chewing gum thrown from jeeps and were amazed—"This candy doesn't disappear no matter how long you chew it!" We ran after the American jeeps, calling for chewing gum. The rumor that "males would all be castrated, women would all be raped" died quickly. I boasted among the kids about the chewing gum I got and

chewed it all day. My jaw swelled up so much I couldn't move it. When I went to bed, I wrapped the gum in newsprint and kept it carefully by my pillow. Next morning when I unwrapped it, the newsprint stuck fast to it and the ink transferred onto the gum. I chewed the mixture of gum, newsprint, and ink for nearly a week. Back then, every day was a hungry day.

Uncle H., the second of Dad's brothers, had built a shack in Takajō-machi. He was opening a business painting clogs, the Nakazawa family's craft for generations, so he came to ask Mom to work for him. Uncle H. had lived in Zaimoku-chō, right at Ground Zero. On the day of the atomic bomb, he had set out by bike for the town of Koi, on business, and en route was bathed in the hot rays of the atomic bomb. The left side of his body was burned, and he was sent flying, but miraculously he survived. The house directly below the atomic bomb disappeared instantly, his wife and all; he couldn't even find her bones. Uncle H. was living with his oldest daughter A., who'd been evacuated and survived—just the two of them. When Dad was imprisoned as a thought criminal, it had been Uncle H. who came forward as guarantor and secured his release. He was an optimist—"The things of this world end here. They're not to be carried over into the next world" was a favorite saying—who drummed, sang, danced, and enjoyed life.

Uncle K., the third brother, came to live next door to Uncle H. His wife, too, had been burned to death, and he lived with his daughter S., the same age as I—just the two of them. S. had been bathed in the radioactive rain; her hair fell out, and she became as bald as a monk. Especially for a girl, that was both pathetic and weird. Aunt M., the oldest of the Nakazawa daughters, built a shack in Funairi and settled in. The surviving members of the Nakazawa clan began to gather in the ruins. But the day the atomic bomb was dropped, six relatives on my father's side and seven on my mother's side had been wiped out instantaneously.

Mom commuted to her job painting clogs. The finished clogs were consigned to a guild; if payments from the guild stopped, Uncle H. was in a bind. In the absence of payments, Mom's wages were delayed and delayed again, and because we had no cash income, it stood to reason that we were strapped for food. Seeking work at a coal mine in Kyushu that was doing well and offered work, Kōji set off with one trunk. I thought we could count absolutely on him. We saw him off in the expectation that he'd send money and our situation would become a bit easier. But after several days, he came back, dejected. Mom was surprised and asked the reason. It turned out the mine had an age restriction, and Kōji was too young, so he was turned away: "We can't hire you." We were discouraged. Mom went on

working herself to the bone as she supported the household. Seeing her set out, I thought, "Poor woman!"

One day a neighbor reported, "Your mom's collapsed!" Quickly, Akira and I ran to check, and we found Mom groaning, doubled up, under the eaves of someone's house. We had seen her in that condition many times. Coarse food and overwork brought on stomach cramps, and Mom suffered time and again. No one extended a helping hand to us outsiders; it came home to us how tough the life of survivors is.

Fortunately, Eba had its shore, and when the tide ebbed, Akira and I ran with buckets and, digging in the sand for all we were worth, scooped up crawfish, seaweed, marine plants—anything edible we took home and ate. The seaweed we hung from a line to dry in the open air, then stored it, and ate it fried. When salt ran out, we scooped up seawater, threw in weeds, marine plants, crawfish, whatever we had, boiled it, and ate it. Akira and I went to the shore at Eba every day to find food.

The mouths of the Honkawa and Temma Rivers constituted the Eba shore, and when the tide ebbed, the rivers were full of human bones aligned perfectly with the current. That's how many bodies had been washed down into the Inland Sea. And crawfish teemed precisely where the bones were. The crawfish grew fat on the corpses. Not having the luxury of being disgusted, we focused on catching the crawfish and groped about among the bones.

I carried Tomoko on my back, changed her diaper, and at the appropriate time made the thick soup and fed her. Akira and I took turns cooking instead of Mom, who went off to work. All too soon it was cold when we went in the water, and our feet grew numb and ached; we knew fall was over.

School opened again, and Akira and I transferred to Eba Elementary School. In the old two-story wooden school building were living bomb victims who had burns and injuries and couldn't move. We pupils were forbidden to approach those classrooms. When we did sneak a look, we saw many people bandaged, groaning as they lay on the floor.

Our teacher, a woman, told us, "From now on Japan will be friendly with the Americans, and we must make ourselves likeable." I thought it really strange. Until just recently we'd been taught to make fun of them: "British and U.S. Beasts! Damn Yanks!" Praise of America, an about-face, confused us.

For Akira and me, school life was unbearably tough. We were the targets of bullying by the young brats, hardened in their hostility to outsiders. Akira was polite by nature. Watching him being chased about the school

and bullied in all sorts of ways, I trembled with anger. I too was surrounded and made fun of: they pointed at the spots on the back of my head where burns had finally scabbed over—"Baldy! Baldy!" And they hit me just for the fun of it. My scabs broke, bloody pus went flying and ran down my neck, giving off a stink, and they laughed at me. I got so hot all the blood in my body reversed course, but I clenched my fists and endured it. One on one, I'd never have lost to them, but when they attacked in a group, I was truly mortified.

Bullying continued, not only in the world of the children but in the adult world, too. With Uncle Y.'s son and Akira, our household had grown to six, and the mother-in-law of the M. family that rented us the room didn't like it that Mom did as she pleased. She took the lead, summoning the neighborhood wives and falsely accusing Mom of stealing an umbrella. "This woman's an ungrateful alley cat from the city!" Screaming at the top of her lungs, the mother-in-law grabbed Mom's arm and pulled her outside: "I'm taking this woman to the police to have her locked up!" She didn't accept Mom's suggestion, "Whether I stole it or not is easy to tell. Simply search our one nine-by-twelve room. Be my guest!" Instead, saying, "I can't stand alley cats," she dragged Mom to the police substation on the Eba riverbank. Burning mad inside, I followed after them.

At the substation, fishermen and children who'd somehow heard that "They've caught a thief!" surrounded her, and Mom was exposed as if a freak show at the circus. People who came to see shouted abuse at Mom: "Gotta watch those city folks!" "Can't let your guard down with city folks!" Mom did her best to explain things to the police, but the police believed M.'s mother-in-law and blamed Mom. Had I been an adult at the time, I might have killed all those people on the spot. That's how angry I was. Mortified and trembling, Mom was forced to sign a statement pledging "I won't steal the umbrella again"—she hadn't stolen it in the first place—and, fingers trembling in anger, stamp it with her seal. That night she cried late into the night, shaking with anger: "I hate it. To be called a thief! I won't forget this day as long as I live!" The sight of Mom sad and trembling engraved itself on my sight forever. The Eba folks who bullied Mom were unbearably hateful.

In Eba I saw humanity stripped naked. I saw Japanese people stripped naked. "Democracy," "Charity," "Truth," "Help the weak," "Extend the hand of charity to the needy"—what hollow, empty words and slogans! How can humans say such pretty words? I saw the true nature of the Japanese people: lording it over the weak, bullying them unmercifully. Peel

back the veneer, and they reveal their ugly nature and pounce. War in particular exacerbates man's ugliness, and it suddenly flares up and spreads. That's why I can't forgive those who start wars that plunge human beings into a condition lower than animals.

In Eba our family was bullied, elbowed, chased. Mom said, "Sooner or later, they'll kill us." The family took as a sort of motto, "Let's get out of this hateful place as soon as we can." At night we went to the army barracks that had collapsed, diligently scavenging boards and wood. We wanted to build a house as soon as possible, and we looked forward to the day we'd be able to leave this town behind.

TOMOKO DIES

At school there were no instructional materials, so we received a lot of instruction outdoors, observing the plants in the fields. When the weather was good, the teacher took the whole class to the field at the end of the trolley line in Eba; it had been the army rifle range. Each time we got to the field, I fondly remembered getting absorbed in hunting grasshoppers with Eiko and Susumu. When we entered the field, we came to the place where, day and night for nearly three months, the fires cremating corpses had burned. Bones were piled up nearly six feet high, a dozen scattered piles. We pupils cut nonchalantly through the piles of bones to get to where we were going. The skulls piled up on either side seemed to be glaring at us.

The local brats picked out a skull and started playing catch with it. The others copied them quickly, and skulls flew through the air. For children who had survived the days of the atomic bomb, a skull was simply an object. Moreover, they used skulls for soccer balls and kicked them, and the skulls bounced about the field. I didn't count the skulls piled up, but I think more than a thousand corpses had been cremated. Looking at these heaped-up skulls, I discovered something. Every last skull has an expression. Each one expressed an emotion—joy, anger, humor, pathos. The skulls had simply been left there, exposed to the elements.

One day I was walking on the road past the field, and lots of people were on the embankment, looking down and muttering. I wondered, "What on earth?" and climbed up the embankment. My jaw dropped. Four or five U.S. army bulldozers and steamrollers were clattering about. On the edges were several jeeps, carrying U.S. soldiers keeping an eye on things. The bulldozers scraped up dirt from the sides, pushed it to the piles of bones,

and covered them with dirt. The steamrollers clambered on top of the piles, crushing the bones and burying them deep. The bulldozers crisscrossed, and before we knew it, the separate piles of bones had become one level field. It was a brilliant demonstration of American mechanized power.

The old folks atop the embankment brought their hands together at chest level and chanted the Buddhist prayer, "All Hail, Amida Buddha." One person muttered, "I wish I had more gumption! It's butchery to use machines to crush those bones!" The arrogance of the beefy, red-faced U.S. soldiers chomping on chewing gum as they operated the bulldozers turned my stomach, too. Had Hiroshima asked the U.S. army to bury the piles of bones? Or, feeling its own deep guilt for dropping the atomic bomb, had the United States buried the evidence, the piles of bones left exposed to the rain? I don't know. Today the site where the ground was leveled and the bones of thousands were buried is the schoolyard of Eba Middle School. Dig in the schoolyard even now, and you'll turn up tons of bones. From atop the embankment, I witnessed their burial there, so I know.

Winter winds blew, and it turned much colder. Lacking winter clothing, we wrapped raggedy underwear about our bodies and wore summer clothes on top. There were tears in the seat of my pants, with open holes, and we had no underpants, so flesh was exposed, plain to see. The local toughs poked their fingers into the holes and made fun of me, laughing uproariously. My skin was dry from malnutrition, I had large boils on my legs, and the pus ran down my legs.

Day after day Akira and I searched for food morning and night. Mom worked late into the night and came home each night exhausted. Kōji used the welding skills he'd learned as a student-soldier as a temporary worker at a city factory. The whole family kept up its determined struggle to survive, but our poverty didn't change. We thought that since all Japan was starving, there was nothing to be done about it, although we knew that some people were living a totally different life.

The man next door worked at the Army hospital, and virtually every day he brought home unopened five-gallon cans of tempura oil. The aroma of fish and vegetable tempura came floating on the wind, and it ate at us. At night he'd go out and bring back rice, wheat, beans, fish, and cans of beef and stash it away. I thought he brought all this home from the Army stores, but whatever the case, his family ate very well. He brought chickens home and in our sight cut off their heads, drained the blood, put them in boiling water, plucked the feathers, and made chicken tempura. Seeing him eat it, we were consumed with envy. The next day his children brought chicken bones to school for a snack and ostentatiously smacking their lips,

sucked the marrow. Our mouths watered. Both during and after the war, those attached to the military had it good.

In Eba at the time, daily conversation included, for example, the murder of two children, part of a group that came to steal crops from the fields, who'd had their skulls split open by the farmer's wooden sword. The desperate struggle continued, with atomic bomb orphans and starving people coming to Eba in search of food. War and the atomic bomb: it was hell if you died; it was hell if you lived.

One such day baby Tomoko on my back was peevish and wouldn't stop crying. I didn't know what to do. I changed her diaper and tried to humor her, but she kept crying. While preparing the evening stew, I set Tomoko down on the blanket and kept humoring her, but she wouldn't stop crying. Even Mom, when she came home, said, "Something must be wrong. After supper I'll take her to the clinic." With the whole family gathered around the stew and eating, Tomoko's voice gradually grew faint, and she became quiet. We were relieved, thinking she'd fallen asleep. With supper over, I lay down beside Tomoko's blanket, took her hand, and was shocked. It was ice cold. Quickly I called Mom. Mom picked Tomoko up, whispered, "She's dead!" and went silent.

Born into the carnage of the atomic bomb, Tomoko lived a short life of four months. The continuous crying that day was her voice burning her life's last embers. We didn't know the cause of death—Malnutrition? The effect of radioactivity? Mom stood abruptly, said, "I'm going to the greengrocer's!" and went off. I simply sat there, gazing at Tomoko's face, which was now ashen. Mom returned carrying a fruit crate. She said, "It took some begging, but I finally got one" and silently cleaned the box. Then she dressed Tomoko in her prettiest clothes and placed her body in the box. How long that night was before the silent dark grew light!

The next day we ran about collecting pieces of wood. We placed the box holding Tomoko's body on a borrowed pushcart, loaded anything that would burn, and headed for the Eba shore. At the bleak wintry shore we dug a hole, spread the wood, set the fruit crate on top, and lit the fire. The cold winter sea was rough, and the smoke burning Tomoko danced in the cold wind and was sucked up into the sky. Mom stared at the flames. Silently, we made sure the fire didn't go out. We burned all the wood we'd brought, but when we stirred the embers, Tomoko's body was still not fully cremated, so we rushed about the shore, collecting driftwood to keep the fire going. I felt keenly how much wood it took to cremate even a baby's body.

Silently, Mom picked up Tomoko's small, thin bones and dropped them into an empty can.* With a fierce, stern expression on her face, Mom urged us on, and we headed for home. The winter ocean beat harshly against the shore, and the cold wind pummeled us and blew past. In her own struggle to survive, Mom hadn't even the energy left to cry.

Together, Mom and the rest of us walked into the strong headwind.

*In Japanese funerary practice, once the body has been cremated, the relatives pick out the major bones and place them in an urn.

TWO-FISTED CHAMP

Having found work, Uncle Y. came for the son he'd left in our care, and our household shrank to four. Tomoko had died, and I was forlorn; I had lost all I had to live for. It was hard for me to walk past a woman with a baby on her back. It was tough when I caught the lingering sweet smell of mother's milk and memories came back of the days when I warmed my back carrying Tomoko and fed her the thick soup.

At the time, the wood and boards that we scavenged busily at night from the collapsed Army barracks piled up, and our hopes of building a hut materialized. We asked a carpenter acquaintance of Mom's to build it in the burned-out waste of Takajō-machi, where Uncle H. lived. Loading the wood onto a large cart, we hauled it laboriously through the ruins. Our hearts leapt as we watched our house go up. We savored our joy at escaping Eba, the town where we had nothing but bitter, sad, and hateful memories. The only thing I'd learned at Eba's elementary school was the multiplication tables.

Erected in the burned-out ruins of Takajō, our house didn't have sliding rain doors or sliding screens. We separated the rooms and kept the wind from blowing through by hanging mats made of straw. It was a crude hut, but we were absolutely delighted to call it home. In the candlelight on the night we moved in, the faces of Mom and Kōji and Akira were flushed with excitement.

Our house looked out over a vast sweep of ruins. At night, lanterns were alight in the scattered shacks; it was just as if fireflies were out. When night deepened and we lay on the blankets, straining our ears, it seemed we could hear the pulse of the reviving Hiroshima. There was nothing in the burned-out waste to block sound, so the horns of ships leaving Ujina Harbor off in the distance boomed as if they were nearby. We drank in the sound: "Wonder where that ship is going—abroad?" From the yards of Hiroshima Station came the sound of freight cars coupling; engines blew their steam whistles—Choo! Choo!—and left the station. "Wonder what that freight train's carrying?" The night train went through—clickety-clack—on the main east-west line. We pictured it to ourselves: "Wonder who's on the night train? Maybe it's full of repatriated soldiers. It's going to Osaka and Tokyo. Osaka and Tokyo: wonder what shape they're in." Winter pilgrimages began, with ascetics dressed in white, rosaries around their necks, beating fan-shaped drums—tap, tap, tap—and the sound of feet tramping through the burned-out waste. Night after night we fell asleep with a sense of security because human beings were out there and we had the feeling that Hiroshima was reviving at a good pace.

Akira and I tilled the burned-out waste and worked hard preparing a field for planting. When we removed tiles and turned the soil over, skulls emerged. In the field we planted all sorts of edibles according to the season and worked early and late to produce food. For fertilizer, naturally, we used the night soil from our own outhouse; if we weren't careful, someone would steal it in the night. Times really were tough.

I'd get up early, go to the trolley street, and wait for horse-drawn carts to pass—at that time they were the only transport. When the horses shat, I'd rush right out with a dustpan, scoop up the horseshit, bring it back, spread it on the field, and fertilize the soil. Even in collecting horseshit, if you didn't look sharp, someone else would beat you to it. In this way we made our own the science we had learned at school; the knowledge of how to grow crops—that, too, we applied.

It took a year and a half, but the burns on the back of my head and neck finally healed. I'd simply kept applying squash and cucumber juice to them. But the back of my head was bald, and that was a source of humiliation. To the toughs, I was a target of ridicule—"Baldy! Baldy!"

Akira and I transferred to Honkawa Elementary School, a three-story structure of reinforced concrete on the riverbank opposite the Atomic Bomb Dome. Since the building was at the epicenter, walls burned and collapsed, ceilings fell and large holes opened up, and window frames twisted. The classrooms were covered with broken tiles. They had no desks, no chairs, no blackboards. In winter the cold wind blew through, and dust and snowflakes danced. As for the playground, the iron beams of the auditorium, twisted like pretzels, twined and hung over it.

Since there were no desks, we used concrete blocks instead. We sat astride them and wrote with pencil stubs on flimsy paper. Our pencils caught on the bumps of the concrete, the paper tore, and holes opened up. When it began to rain, we rushed to a corner of the classroom for shelter and waited for the rain to stop. Five heads clustered around a single textbook, and we argued—"I can't see!" "Yes, you can!" I hadn't the foggiest idea what we were studying. Exposed to the cold wind, our bodies went ice-cold. Fingers turned numb and wouldn't move. Teeth chattered. I often marveled that such cold was bearable. Taking the cold into consideration, the teachers chose when to announce, "Exercise time!" We bent our knees, then straightened up, tightened our fists, then flung our hands into the air, warming up by way of exercise. The cold was really unbearable.

When I transferred to this grade school, I scolded myself, "Never lose a fistfight!" Earlier, at Eba Elementary, I'd been humiliated by being

attacked by a group of the local pupils and had resolved never to let that happen again. This time, I'd fight all out.

It's in children's nature to zero in on someone's weakness and show no mercy attacking. Among those in my class was a guy who targeted the scar on the back of my head. He was much bigger than average and always had two or three henchmen at his side. In the very middle of the schoolyard I gave that guy a thorough drubbing. Children's fights are decided simply: someone gets a nosebleed and starts to cry. Since it happened in the middle of the schoolyard, all the pupils saw it. Word soon spread, and leadership of the pack passed to me. I knew how to use my fists. In a swarm of children, I'd select the largest as target and give that fellow a thorough beating, no matter how I was set on by those around; the group would quickly shrink and dissolve. The henchmen feared me and stopped saying anything about my scar. Suddenly I was idolized as two-fisted champ, and everyone kept a wary eye on me. It was just like the fight for the status of alpha monkey in a zoo.

A strange vehicle began appearing in the schoolyard. It was a station wagon. The upper half of the body was emerald green, and the lower half had a wood grain pattern on a cream-colored base. It drove into the schoolyard, took one turn, and stopped. All of us watching from classrooms rushed up to it, stroking the body, peeking under it, and casting longing looks at this strange, foreign car. On the license plate was written: ABCC.

I learned later that ABCC was an acronym for Atomic Bomb Casualty Commission. The Americans entered Hiroshima one month after the dropping of the atomic bomb and established the ABCC in a corner of the Japan Red Cross Hospital. It investigated the effects and damage that the atomic bomb had on material objects and on the human body and secretly collected atomic bomb data. Honkawa Elementary School was at Ground Zero, and children who'd survived the atomic bomb came to it from a broad swath of the city, so it was ideal for collecting data. They were able easily to determine the condition of the children who'd survived.

Virtually every day the ABCC station wagon appeared in the schoolyard. The staff handed out large paper cups to children, had them bring in stool samples, and then loaded the children in the station wagon and drove off. The visits by the station wagon were strange. When we asked the teacher, she refused to answer: "I don't know!" Several pupils from my class were also taken off. When they came back, we asked them, "Anything good to eat at the ABCC? What are they checking for?" They complained, "They didn't give us anything to eat. They stripped us, drew blood, and examined us—down to the tips of our weewees. Embarrassing!" We agreed

among ourselves that "America's doing something strange." I wasn't alone; at that time no resident of Hiroshima understood what the ABCC was up to. Some of our neighbors were even threatened and taken forcibly to the ABCC to be checked.

BOYS' WAR

Even before it dropped the atomic bomb, America knew well that radiation affects the human body. Moreover, it built two types of atomic bomb—uranium and plutonium—and, taking advantage of the war, dropped them on Hiroshima and Nagasaki, experimenting on hundreds of thousands of living people. On learning this later, I trembled in anger. I think America has no right to censure the Nazis for their cruelty—Auschwitz and other concentration camps—to the Jews. In Hiroshima and Nagasaki, America carried out a cruel experiment on living people. Moreover, it imposed on survivors a permanent terror: atomic bomb disease brought on by radiation. I couldn't escape the thought that America's humanitarianism and democracy were a sham, shallow and suspect.

As each year passed, the ABCC's station wagon came more frequently to the schoolyard and picked up more and more children.

On September 19, 1945, GHQ promulgated its press code, making it illegal to inform the Japanese about the realities of the atomic bomb.* It itself was diligent in collecting data in Hiroshima. Any number of times I saw U.S. units setting up instruments in the ruins, measuring distances with surveying instruments, taking notes, and conducting all sorts of research. When we saw U.S. soldiers, we went up to them and bantered, "Daddy! Mommy! The flash-boom left me hongree! Hongree!" Perhaps feeling sorry for us, the U.S. soldiers tossed us chocolate and gum.

Towering on the opposite side of the river from the school, the wreck of the Atomic Bomb Dome became a great playground for us brats. With jungle gym skills, we climbed up and down the dome's outer walls. Standing atop the dome and looking in all directions, we could survey a vast sweep, off to the Inland Sea in the distance. Hiroshima lay spread out at our feet, and looking down, we understood well—with our bird's-eye

*GHQ was General Headquarters of the Occupation—Douglas MacArthur. It promulgated a press code, which stipulated, among other things, that the atomic bomb was off limits. The first serious treatment of Hiroshima in the Japanese press dates from August 1952—the end of the Occupation. The Marukis, artists, entitled their first Hiroshima painting, "atomic bomb," and were forced to change the title to "August 6."

view—the extent of the ruins burned out by the atomic bomb. Doves and sparrows built their nests and laid eggs in the dome's holes and cracks. We competed to be first to climb the dome, find the nests, stick our hands in, bring back the eggs, and swallow them proudly in front of the others.

Later one of my classmates slipped and fell from the dome and bounced off the rubble, but miraculously he survived, breaking only his jaw and twelve ribs. Thereafter a strict prohibition was issued—"No playing on the dome!" We lamented, "That accident cost us a great playground!"

The dome and its surroundings were our yard, our turf. We knew where to find large crabs in the rock walls on both banks and around which girders of Aioi Bridge there were lots of fish. In summer Aioi Bridge became a fine diving board. The bridge pavement had ruptured, and holes had opened, mouthlike. We climbed out onto the middle supports of the bridge through those holes and dived time and again into the middle of the river. When I first stood on the girders, my legs shook because of the height. But I didn't want my buddies to make fun of me, so I made up my mind and jumped feet first. Once I jumped, I quickly became confident and dived headfirst repeatedly.

Among the kids in the Hiroshima region, there were two ways to dive—feet first or head first. Diving feet first, in standing position, was ridiculed as the sissy's way. To prove your guts, you had to dive head first. If you dived head first, your buddies would respect you. As a matter of pride, I dove head first.

When you scrambled up the sixty-foot girders,* danced off into the air, and your head hit the water, the impact felt as if your scalp had ripped open and gone flying in a million pieces. Holding your breath and gliding along the bottom, you saw a shocking sight. The bottom was covered with bones, and as you continued downstream, it was a river of skulls. Diving showed you just how many people had sunk to the bottom and become skeletons. I glided through the water over the bones, then surfaced. Bones covered both sides of the river bottom and lay there, in plain sight. Dig in the middle of the Honkawa even now, and you'll turn up plenty of bones.

When the tide ebbed in the Honkawa, I'd hurry home, run sixteen inches of thread through a needle, tie the ends around a matchstick, and head back to the river with a small round net eight inches in diameter. I'd go in on either bank where there were lots of bones. Freshwater shrimp two inches long came and went through the empty eye sockets of skulls and swam among the bones. I'd aim for large ones with the net and string

*There's some artistic license here. The height of the bridge was closer to thirty feet.

my catch through the midsection on the thread. I'd lose myself fishing for crayfish, squinting, until the thread was full of crayfish or until it became impossible to see the bottom at dusk.

When I went after crayfish with the net from behind, they'd jump backward and into the net all by themselves. No one taught me that, but I knew they always scuttled backward. The crayfish were particularly thick where there were lots of bones. They'd fattened on corpses. The crayfish I brought home we skewered on bamboo spits, roasted, and ate as a family. They supplemented our deficiencies of protein and calcium. The crayfish got fat feeding on corpses, and we ate them, so it didn't feel quite right—as if we were cannibals.

My playground was the black market stalls that sprang up cheek by jowl, like mushrooms after rain, at the Atomic Bomb Dome and along both sides of the river near Hiroshima Station. In this black market, all sorts of people were active. In particular, the atomic bomb orphans who gathered in large numbers at Hiroshima Station caught my eye.

Some seven thousand orphans, alone in the world because their parents and relatives had all been killed, were cast adrift and wandered the burned-out ruins of Hiroshima. Clad in raggedly clothes, grimy, scrawny, their filthy black bodies exposed, they clung to repatriated soldiers and passersby begging for food. Those unable to get food became malnourished and collapsed on the pavement, unable to move. If passersby stepped on their heads, they barely opened their eyes; they'd lost the energy to show anger. The orphans teemed in the plaza in front of the railroad station; each morning several died.

In winter the orphans poked holes in large metal drums, threw in the charred remains of telephone poles and branches from the trees that lived on in the ashes, burned them, and slept in circles about the drums. Watching those orphans, I trembled. Had Mom died, I too would have been orphaned and become one of them, malnourished and unable to move. My survival was a matter of sheer luck: I simply couldn't think otherwise. I gave thanks that Mom had survived.

At one time in the postwar era, Hiroshima led the nation in juvenile crime. To survive, the orphans either became lone-wolf thieves or banded together in groups and entered the underworld. For those orphans unable to commit crimes, the only end was malnutrition, collapse, and death. Only a small fraction of the total number gained entry to the several orphanages that were set up; help for the atomic bomb orphans was extended only seven full years after the atomic bomb was dropped. During that time the orphans persevered, wandering about the burned-out ruins and leading desperate lives.

By 1952, kids who had been sixth graders at the time of the atomic bomb were already young men. There were people who preyed on these adult orphans. Gangsters seeking turf in the new Hiroshima got involved, and in the postwar era, fierce gangster wars took place. In those gang battles many adult atomic bomb orphans died. They were sweet-talked—"Kill one of the other gang's leaders, and we'll make you one of our leaders." They were as expendable as bullets: they jumped into fights, took return fire, and were killed. Because atomic bomb orphans had no parents and no relatives, no one complained when they were killed. So the gangsters found them very useful. I heard any number of stories of children who lived lives of leisure before the war, were orphaned by the atomic bomb, and after the war were in and out of jail.

What bitter days and years the orphans spent! I was deeply angry at the war and the atomic bomb that made the weak—only them—endure so bitter a fate. Those guys, war leaders who started the war and those who dropped the atomic bomb, no longer merited the word human being: I really wanted to kill them all.

August 15, the day of Japan's defeat: on that day, our *true* war began.

REDUCED TO THE STATUS OF BEGGARS . . .

The days of our hunger stretched on and on. When I'd walk in the black market, I'd stare in wonder: "Wow! All those goodies!" Steamed rolls made of brown rice, dumplings, candy, rice cooked with red beans. Swallowing my saliva, I'd look around. Skin was still attached to the meat on skewers, and it betrayed the fact that dogs and cats, too, were being turned into food. All this was too expensive for us to buy, and the prices made us gasp. But it made us feel good simply to see it. I had to wonder at the strange state of the world: even when everyone was hungry and starving to death, if you just had the money, you could buy and eat all sorts of luxury foods.

The spiels of the charlatans selling patent medicines were fascinating: "Let me show you how effective this medicine is! I'll let this terribly poisonous snake bite my arm. Then I'll show that I'll recover quickly simply by applying this salve!" Listening to it, thrilled, for hours at a time, I kept waiting to see the snake actually bite the man. But it was only a pitch for the medicine, a dodge. Street performers—the monkey man, the swordsman—flourished in the black market. It was my favorite place.

When there was a break in Mom's work and she had the time, she took me with her, and we went selling. Carrying a knapsack, two or three

pieces of clothing to barter, and coins, we'd make the rounds of the farm-houses in Gion and ask, "How about letting us have some of your potatoes and rice?" The overbearing attitude of the farmers at the time was enough to make you puke.

In the yard of a farmhouse, Mom would bow and scrape like a toady and beseech the farmer, "Can't you please spare ten pounds of potatoes or a five-gallon bag of rice? I beg you." Standing on his veranda and looking down at Mom, the farmer would puff on his pipe and glare at her, putting on airs, and shout angrily, "Get out!" Mom still begged desperately. As I watched from behind, my stomach would churn with bitterness toward the farmer and sympathy for Mom. A child of that farmer came out onto the porch chewing on a steamed potato and glared at me with hateful eyes. He let the potato he was holding fall to the ground, mashed it with his sandal, then pointed to the yellow lumps of potato and taunted me, "You want it, don't you? Then eat it! Eat it!" Trying desperately to suppress the urge to fly at him, I put up with the humiliation: I won't forget that day as long as I live.

Mom and I walked from one farmhouse to the next, begging, "Won't you please spare us some food?" But the farmers never went easy on us. We met only crafty farmers: grabbing the clothing Mom held out, they'd say, "What makes you think this is worth ten pounds of potatoes?" They'd try to take advantage of our plight and get Mom's good clothes for a few potatoes.

When evening came and the farmhouses were only silhouettes, we'd reach the end of our tether, our feet dragging along the paths between pad-dies. Mom would whisper, "We'll try one more house. If that's no good, we'll give up and go home." We'd aim at the lantern of one of the farm-houses scattered in the distance. Giving in to Mom's desperate entreaty, that farmer said, "I had set it aside for seed, but your persistence is too much for me." We stuffed potatoes pulled out from beneath the veranda into our knapsack. How long the road home seemed! And how heavy our legs, as we shouldered sad thoughts! The farmers swaggered so because they realized that having food gave them that privilege. Even my child's mind thought: the time will come when you get yours!

Nor can I forget the day we had no fuel. Dragging a handcart, Mom and I went to a woodlot in Koi to gather windfall wood. Gathering dead branches and tying them in bundles, I rejoiced with Mom, "This'll last us two weeks!" We shouldered the bundled branches, making many trips to carry them to the entrance of the lot. And just as we finished, a stolid, mid-dle-aged farmer appeared and thundered at us, "Hey, you! Who gave you permission to come here? You can't take dead branches without permis-sion!" He insisted to Mom, "Leave the branches and get out!" Mom asked

whether he couldn't share the branches with us, and he said no, brusquely. We'd come to the lot early in the morning, and we'd worked so hard to collect the bundles, carrying them in exhaustion to the gate at the foot of the hill. To leave them made me resentful beyond endurance.

We learned afterward that the farmer had known we'd entered the woodlot and were collecting firewood. And smiling tightly, he'd waited until we'd carried the wood to the gate. He was a schemer, making us work and profiting dishonestly from our work collecting the firewood. Complaining about having labored to no purpose, we went home, pulling the empty handcart. I can never forget how wretched we felt. Among the brothers, it was I who went most often with Mom. Mom's sad bitterness in all these cases is seared onto my retinas.

From our house in the ruins we'd looked out in all directions over a panorama of ruin. But soon huts covered it, and our panorama closed in. People who had evacuated came back to the ruins, and our house, too, was enveloped in sounds of daily life. Naturally, as the number of people increased, there was competition in gathering wood for fuel for daily living. Such boards and trees as remained in the ruins disappeared quickly. Akira and I dug in the ruins and collected charcoal, and we dug up the stubs of telephone poles that had burned down. A scant six feet of telephone pole remained unburned underground. It took a day to dig out a pole and cut it up with a saw. Desperately we poured energy into collecting fuel. But even those buried telephone poles became the object of competition, and soon they disappeared from the ruins. Each day was a struggle for survival.

After a while our classrooms at school, too, got blackboards on the walls, courtesy of contributions from all over the country. With rows of two-person desks and chairs, the atmosphere began to be that of a place of learning. But there weren't enough desks to go around, so three of us sat at the two-person desks, each trying to establish his own workspace. There were endless quarrels. For textbooks, we received some dozens of sheets of coarse paper, mimeographed; we took the pages home and each made a book of our own design and finally had one textbook apiece. There was no glass in the windows, and the cold wind blew through the classroom. As we shivered, 1946 came to an end.

YEAR OF ANGER

Nineteen forty-seven is especially unforgettable, the year that remains forever in memory. On January 1 of that year, in the middle of winter

vacation, all pupils were compelled to go to school. Intending to play hooky, I had wrapped myself in my blanket, sleeping on, but a classmate came and lured me: "If we go to school, we'll get red-and-white candy." Hearing that, I rushed to school. When, tempted by food, I reached the school, all the pupils were lined up in the schoolyard. Dressed in a cutaway, the principal stood on the podium used for morning exercises. Wearing formal clothes, PTA officers, local bosses, and teachers were lined up in the front. The order came: "All together now, face east! East! Face His Majesty the Emperor in his palace in Tokyo and wish him Happy New Year! All together now, bow deeply!" And all the pupils bowed their heads reverently. The teacher walked around instructing us, "Don't raise your heads until I give the word!" I was astonished at the scene. Dad had told me what a horrible thing the emperor system is: that the war had begun at the order of the emperor, that as a result we were burned out by the atomic bomb, many people were killed, and even now many injured bomb victims were suffering and groaning. I was stunned at how little awareness about the war the principal, teachers, local bosses, and parents showed: to want to thank that emperor, still unpunished, and to delight in making the pupils bow to the palace! With great difficulty, I repressed the urge to thunder, "You people—how stupid!"

Once we'd finished bowing to the palace, we sang the anthem, and in each classroom they handed out the red-and-white candy. On the way home after we were dismissed, I ate the candy at one gulp. I told myself that if I turned it quickly into shit, fertilizer for the field, even the hated candy would serve a purpose. And I went home yelling words that were popular then among the children: "I, your emperor, have farted. You, my subjects, smell it. Hold your noses and step back! Proclamation signed and sealed!"

Someone once said, "War turns small children into adults overnight." It's really true. If you're thrown into the cruel situation of having to fight a life-and-death struggle, it stands to reason that the pampered days of childhood vanish instantly. I came naturally to have eyes that see the dishonesty of human beings, distinguish façade from reality. Akira often admonished me, "You're a twisted one! You have to be a bit straighter!" If you asked me, I was expressing the reality behind the façade, and that made me appear twisted, not at all childlike. I was old for my age. In the teachers' presence I played the role expected of a child, I behaved with calculation.

The anger of December 7 of that year is engraved on my heart.

Saying, "Today I have an important assignment for you!" the teacher passed out a large sheet of paper to each pupil. He said, "Use a compass to describe a circle six inches in diameter in the center of the paper. Color it in with red crayon. Attach it with paste to a thin piece of bamboo. Bring

it to school tomorrow without fail!" He was having each of us make a flag. When I asked what the flags were for, he said, "Tomorrow's a glorious day: His Majesty the Emperor is coming to Hiroshima! Waving flags, we residents of Hiroshima will greet him warmly!"

Once more I was stunned. "Why should teachers and residents be happy?" I was amazed. I despised the foolish teachers who would celebrate and be grateful to the ringleader who turned Hiroshima into a burned-out waste, who stole our homes, killed our relatives, made us suffer and suffer while he himself had it easy in safety. The new constitution had been promulgated, and referring often to Article 9, the renunciation of war, teachers taught us that Japan had been reborn a new country that did not arm itself or use force, one that sought peace. But what they were doing, worshipping the emperor as a god as in the old order, was militarist education. It was "old wine in a new jug."

The next day I said to Mom, "He was the ringleader in wrecking our whole family, pushing us down into the depths of poverty, causing us to moan every day—and we should wave a flag for His Nibs?" I went to school without making a flag. As a cold wind blew, all the school's pupils, each one holding the flag he'd made, were lined up along the riverbank at the eastern end of Aioi Bridge. It was the route the emperor's car would take on his way to worship at Gokoku Shrine at the castle. Nervous teachers flew about among the pupils, straightening and restraightening the row. I watched them with disgust. I thought of the human being, the emperor. I thought of Hiroshima, with countless bodies buried all around in the rubble. What was the emperor feeling in this place? I was shocked that he could look calmly at these ruins. The emperor, I concluded, must be a cold-blooded, insensitive person. If he were a normal human being, he wouldn't be able to see the sights in Hiroshima, riding in comfort in a car through this site of the horror brought on by the war he himself started. He wouldn't be able to face the ruins.

From a distance came shouts of "Banzai! Banzai!" and the emperor's car appeared. The teachers ordered us to shout "Banzai!" and wave the flags. I could see him through the car window: he had on a black coat, with a white scarf about his neck, and he was waving his soft hat to the people lining the road. In the instant the car passed in front of me, I felt the impulse to leap at the emperor, set my teeth in his neck, and kill him. I got hot all over even in the cold wind; I was so worked up I had sweat on my back: "This guy! How dare he kill Dad and Eiko and Susumu! How dare he consign the rest of us to life in the depths!" I shook in my fury, my whole body hot with anger, and I glared at the emperor. With my worn clog, I kicked a piece of tile lying at my feet. It hit a tire and bounced back.

I desperately repressed my rage amid the flags teachers and pupils waved, amid the shouts of "Banzai!" That scene I engraved on my heart; I'll never forget it as long as I live. The teachers and citizens waving flags to the emperor seemed utterly foolish. I knew the fearsomeness of "education," that apparatus that brainwashed the Japanese people, that beat militarism into them.

In the next day's paper, I read an article saying that with the emperor's visit to Hiroshima, the residents hoped to rise above the disaster of the atomic bomb. I roared: "Ridiculous! To place your hopes of life on such a shitty emperor! If you want us to have hopes of living, then bring us a bushel of rice!" A distasteful expression on her face, Mom said sternly that I should stop criticizing the emperor. Mom had learned from experience, draining the dregs from when Dad had been arrested and locked up by the Special Police. I really hated that attitude of simply giving up: "yield to superior power," "there's nothing for it but. . . ." I couldn't bear to live with bowed head and not to go against the establishment, to be a toady as a strategy for getting ahead in the world.

ENCOUNTERING *NEW TREASURE ISLAND*

In order to earn a bit more, Mom stopped painting for Uncle H. and turned to needles, making use of a craft she'd learned as a girl. Needles and pins were a product for which Hiroshima Prefecture was noted. Mom could grasp dozens of finished needles in one hand and sort good from bad. It wasn't something just anyone could do. A person whose palms sweated easily was said to have a "salty hand" and couldn't get work in the industry. If your palms sweated, they got salty, and the pins rusted and were no good. At good times, Mom often hummed popular romantic tunes from the twenties. In particular, she loved the *Gondolier's Song*: "Life is short. . . ."* She sang as she looked at the needles in her palm. When she was in a good mood, I was truly happy.

Although Mom and Kōji were working hard, we were still poor. It was not uncommon for wages to be delayed and for us to go several months without cash income. During such times I worked hard to increase my

*"Life Is Short" is a song from 1914. It is the song the bureaucrat sings in Kurosawa Akira's 1952 masterpiece *Ikiru*. He has been diagnosed with cancer, and the movie traces the major changes in his life. During his night on the town, he requests that the band play the song, then sings it himself in the snow as he swings on the swing in the playground he's built: "Life is short—fall in love, young woman / before the red fades from your lips / before the hot blood cools within you. / There's no tomorrow."

own small earnings, gathering metal, glass, and bricks from the burned-out waste. I could sell copper and brass and lead in particular at a high price, so even on my way to school, I always kept my eyes peeled for these metals. If I saw something that looked promising, I'd scratch it on the pavement. Copper shone red when scratched; brass shone yellow. Rejoicing—"Red!" "Yellow!"—I'd tuck it away in my pocket, take it home, and save it up. Then I'd sell it to a metal dealer and earn a few pennies.

With that money I'd buy a penny's worth of sweet potato jelly and go to the movie house that had opened in front of Hiroshima Station and, entranced, watch the old silent films. The storyteller came by each night and I would watch, enthralled, my heart racing.* I got to know the storyteller and took on the job of walking around clapping the clappers to summon an audience. I went around the neighborhood—Clap! Clap!—summoning the children. In return, I got to watch for free and was given a chopstick wrapped in pickled seaweed and dipped in malt syrup. The storyteller prided himself on narrating with seven different voices. Enraptured by his impassioned performance, I worshipped him. *Golden Bat* and *Little Big Man* were hits that transported the children of the ruins during the postwar period.

There was a comic saying, "With the new education, we're good only at baseball."† I, too, loved sandlot baseball. We used cotton army gloves in place of mitts, and we broke off tree branches and peeled the bark to make bats. To make balls, we wrapped string around the glass balls from lemonade bottles.‡ We ran about barefoot on the burned waste, among the shards of glass and pebbles, immersed in three-base baseball. We threw ourselves about recklessly.

One day I encountered a terrific manga book; it changed my life. Artwork by Sakai Shichima, story by Tezuka Osamu: *New Treasure Island.*§ A classmate had brought *New Treasure Island* to class and was reading it. Around him gathered a human wall, one child's head beside the next, unmoving. I too was one of them, waiting for the owner to turn the page, following the frames intently. The boy who owned the book was a stinker, and he'd close the book or take forever to turn the page. I'd read along, getting angry and scolding him, "Turn the page! Open it wider!" *New*

 **Kamishibai* was a traditional form of storytelling. The storyteller narrated scenes that appeared on picture boards he inserted into a frame on the back of his bicycle.

 †Japan's postwar educational system, inspired by the United States, featured six years of grade school and three years of junior high.

 ‡*Ramune* bottles had a ball that rolled back and forth in a groove near the mouth of the bottle. Hold the bottle the wrong way, and no soda would come out.

 §*Shin Takarajima* was a retelling of Robert Louis Stevenson's *Treasure Island.*

Treasure Island unveiled a truly fresh and adventurous dream. I wanted to read what happened next and couldn't wait for recess to come. To get the owner to turn the page, I toadied to him and flattered him. Thrilled, I lost myself in reading it.

I wanted to read *New Treasure Island* at my leisure, all by myself, and pleaded with him earnestly to let me borrow it. But he refused stubbornly: "If I let you, Dad'll scold me!" So I asked, "Well, then, tell me where you bought it!" He replied, "Dad went to Osaka on business and bought it for me there!" I couldn't go all the way to Osaka to buy it, but I was utterly in love with *New Treasure Island* and had to have a copy. I made the rounds of all the bookstores in the heart of the city, on Hatchōbori, and at the Hiroshima Station plaza, scanning the bookshelves, eyes peeled.

Finally, at a small bargain bookstore at Yokogawa Station, I spotted *New Treasure Island* on a shelf, and I was madly happy. I grabbed the money I'd saved up selling scrap metal—I always kept it in my pocket so I'd be able to buy the book—and thrust it at the bookstore man. I always squeezed the ten yen notes, so they were all crinkled.* I'll never forget my joy and excitement when the long-desired *New Treasure Island* was finally mine. I danced my way home and immersed myself in it. I read it hundreds of times, thousands of times. I memorized the icon at the top of the page where the main character rode on a giant snake. I memorized the text, of course, even the sound of the drums of the attacking natives.

New Treasure Island is an important work—you simply can't write the postwar history of manga without including it. During the war, of course, there were manga. But I didn't find those manga all that fascinating. *New Treasure Island* was so dazzling that for me it might as well have been the very first manga. Today's manga boom got its start with *New Treasure Island*.

New Treasure Island was issued in 1947 and is said to be the single best seller of the early postwar era. I learned later that it sold between four and five hundred thousand copies. The author's name engraved itself on my heart and never faded. For me, "Tezuka Osamu" was godlike. For a long time we didn't read the characters of his given name "Osamu;" among Kōji and the children, it was "Jimushi" or "Harumushi."†

Collecting scrap metal, saving up my money, I searched intently for Tezuka's works and bought them all. *Pistol Angel, Twenty Tobies, Enchanted Forest, Big City Metropolis, Lost World of the Last Century, The World of the Future, Faust, Crime and Punishment:* every one of Tezuka's works, so numerous as to be uncountable, had an impact on me.

*At the 1940s exchange rate, ten yen was less than three cents.

†"Osamu" is normally written with other characters than those for Tezuka's name. These two misreadings are alternate readings of the first character of Tezuka's given name.

Dad had been an artist in traditional ink painting, and from my earliest days I'd been fond of seeing and drawing pictures. I hated virtually all my schoolwork and liked only the art class. There's an adage, "Become expert at what you love." I'd become a manga fanatic, and it wasn't enough simply to read them. I wanted to draw them myself. I began to copy lots of them and develop my own style of drawing. With enormous excitement, I devoted myself to drawing manga. No matter how poor you are, the day you spread your wings and set off into a world of your own is truly fulfilling, impossibly happy. I couldn't buy expensive sketch paper, so I'd wander the black market at Hiroshima Station plaza and tear down movie posters and the like, take them home, cut them to size, sew them into a notebook, and draw manga on their blank backs.

Day after day I drew manga. I became a movie fan, too. The worlds of manga and movies, I thought, seemed mutually intelligible. The construction of the film image and the manga frame, the use of words, the ways of presenting the progress of the drama and building tension, and the like: there were tons of things in film to learn from. Wanting to learn, I watched the screen intently.

In Matoba-chō, right next to Hiroshima Station, there was a movie house that split the week between old foreign movies and Japanese movies. The price of admission was the odd sum of two yen ninety-nine sen. According to the tax law, if you charged three yen, you had to add tax, so this odd price avoided the tax. Playing hooky from school or after school, I'd grab three yen and, not wasting any of it on tram fare, plod barefoot on my frequent visits to the movie house. There I saw countless films. And I gained a great storehouse of treasure—the philosophy, ideas, and history necessary for life. The messages I learned from films were far more significant and useful than the lessons I learned at school.

At that theater I saw virtually all the famous prewar films and engraved them scene-by-scene on my heart. In particular, I'll never forget *The Hunchback of Notre Dame*—the adroitness of its camera angles against the backdrop of Notre Dame, the power of its drama. It was remade later starring Anthony Quinn and Gina Lollobrigida. In Japanese cinema, *The Far Side of the Mountain* and *Silver Peaks* had a permanent impact.[*]

I memorized, too, the names of actors, more and more of them. All the Japanese actors and actresses, of course.[†] Gary Cooper, Tyrone Power, James Cagney, Randolph Scott, Clark Gable, Robert Taylor, Alan Ladd,

[*] *Yama no kanata ni* (1950); *Ginrei no hate ni* (1947).

[†] Bandō Tsumasaburō, Ōkōchi Denjirō, Ichikawa Utaemon, Kataoka Chiezō, Arashi Kanjurō, Hasegawa Kazuo, Tanaka Kinuyo, Irie Takako, Yamada Isuzu, Ichikawa Haruyo, Hara Setsuko, Takamine Mieko, Takamine Hideko.

Humphrey Bogart, John Wayne. Susan Hayward, June Allyson, Ava Gardner, Deborah Kerr, Piper Laurie, Martha Hayes. I stored countless names in my memory. Chaplin, the Mutt-and-Jeff combo Abbott and Costello, the Marx Brothers, Bob Hope, Danny Kaye—all were important characters useful in comic manga.

As I came to love film, my desire to draw manga increased. We were forbidden by the school to go to see movies alone, without father or older brothers, but had I obeyed that rule, I would never have become the person I am today. I saw countless movies, so they were a great source of inspiration in drawing manga. Teachers and well-intentioned fathers and older brothers believed that if kids went to the movies on their own, they'd turn into delinquents. I hated people who held that crazy idea so much it made me want to throw up. Sitting on the stage, the shadow of my head falling on the screen, I watched films that forbade admission to people younger than eighteen because of sexual content or violence.* To say that children would immediately run amok if they saw such films! Or that on seeing a gangster film they'd suddenly become no-goods! I had no love for a school that had such simplistic, silly ideas.

When I saw Walt Disney's *Snow White*, I couldn't forget it. For weeks afterward, scenes came to mind, one after the other. Moreover, learning that it was made, in color, before the war, I was speechless at the splendor of America's power. To go to war with that America! I had no sympathy for the bunch of fools who were Japan's wartime leaders. That Japan would lose was a foregone conclusion.

At the Hatchōbori trolley stop was Hiroshima's only seven-story department store. On its seventh floor there was a movie theater, and there I saw famous films like *Beauty and the Beast* and *Black Narcissus*.† If you went out onto the roof garden, Hiroshima lay spread out, a panorama. By 1950, the burned-out ruins of atomic desert were completely covered by huts. I was stunned by the power of man's drive to live. Three or four years earlier, this burned-out store had housed many moaning burned and injured bomb victims, but year by year it was rehabbed, and high-class goods came to be displayed, more and more, on the store's counters. It was a great playground for us. From early in the morning on vacation days, we'd ride the elevator, going up and down over and over again. In summer we'd run

Gate of Flesh (*Nikutai no mon*, 1964); *Scarlet Peonies of the Night* (*Yoru no hibotan*, 1950); and *A Fool's Love* (*Chijin no ai*, 1949).
†*La Belle et la Bête* (1946); *Kokusuisen* (1946).

about the store virtually naked, wearing only loincloths. The store clerks were amazed and disgusted.

The area around this store was also the site of gangster fights. In summer these thugs swaggered about, sunglasses glittering, in bright aloha shirts and loud, colored belly bands. Although Hiroshima hoisted the banner "Peace City Reconstruction," Hiroshima gangster fights increased dramatically; it was an ironic Hiroshima, the desire for peace coexisting with murder. Outwardly, year by year the scars left by the atomic bomb were covered over, and it became a gaudy city, but inwardly, the excruciating groans from the atomic bomb and its aftereffects were pushed deep into the background.

At our house, too, we installed shutters and sliding screens to divide the rooms, and our furniture increased by two or three items. We installed classy mats on our floors, and it became a bit more like home.

As for the lyric "Life Is Short" of the *Gondolier's Song* that Mom sang when she was in a good mood, little by little her singing grew more beautiful. A man proposed to Mom. Worried lest Mom abandon us and run off, we were unbearably uneasy. Each time he appeared, I glared at him. I was overjoyed to hear Mom's reply, "I definitely won't remarry until the children are on their own!" But the unease remained, and mornings as soon as I opened my eyes, I looked at the sliding screen into the kitchen. When I saw it dyed red by the light of the stove and Mom silhouetted against the light, I relaxed.

Mom and Kōji kept working as hard as they could, but we were still poor. I was so struck by the pathos of Mom's working from early to late that I wanted to go right out and get a job and earn money so things would improve a bit. But on being convinced that my job prospects would suffer if I didn't complete compulsory education, I went to school, albeit reluctantly.

The Korean War broke out (1950), and suddenly the metal industry prospered. Lead, copper, and brass rose in value and began to sell for a lot. I ran about the ruins of Hiroshima, eyes peeled, looking for metal. The money from that went for my own school materials, drawing manga, movie admissions, and the like. I couldn't say to Mom, "Give me money." As a fifth grader, I had the spirit of independence, of providing for myself, and I was no mean worker. I was confident I could support myself.

Realizing that in order to make manga storylines I needed to read more, I went often to the rental libraries and consumed novels of all kinds. I read Yoshikawa Eiji's historical novels, and they set my fifth-grade heart racing. I admired the clever structure of *Miyamoto Musashi*,

and I read Osaragi Jirō's *Demon of Kurama* and Nomura Kodō's *Zenigata Heiji* utterly enthralled.*

The school still had no library, so each of us brought in his own books, and we made a class library. It was only a few books, and it was hard to wait your turn. The grade school shared the building with a junior high, so there were morning and afternoon sessions. But as schools were built in the various parts of Hiroshima, the number of pupils decreased, glass was set in the window frames, the twisted metal was cleared from the schoolyard, the buildings repaired, and finally the atmosphere became a school-like one, of going to school and learning. No sooner had this happened than I graduated. I said my good-byes both to the milk supplied by the Occupation army and to the school lunch's single roll. Because the milk was supplied by America, I'd thought it was full of nutrition, so I'd downed even what others left in their cups.

I have only bitter, unhappy memories of that school. A particularly sad memory was of the sports days that began in the fall. The lunch break was truly tough. On this day, people made fancy box lunches, and classmates scattered to their families in the stands, gobbled down their sushi and scrambled eggs, and talked and laughed happily with their families. Watching them was very hard. My lunchbox held barley rice, and it was barley bran—unhulled at that—what people fed to cows and other livestock. I squeezed hard, trying to make that barley into rice balls, but it crumbled and slipped between my fingers and wouldn't hold together. When it finally hardened, I wrapped it in paper and brought it to school, but I wasn't brave enough to unwrap it and eat it in front of people. It was too different from their lunches.

The Honkawa was just below the playground, so I'd climb down the riverbank and, conscious of being watched, force that lunch down quickly. I was sad, unbearably sad. "Had Dad lived, I wouldn't have to be so bitter." I too wanted desperately to have a lunch I could spread out and eat grandly in the presence of others. But I'd seen Mom working herself to the bone, so there was no way I could say, "Make me a lunch I won't be ashamed to eat in public." I resented the school that forced us to bring lunches. If the school let us go home for lunch, I thought, I wouldn't have to have such hateful, sad thoughts. Each time sports day came, I separated myself from all the others, climbed down the bank of the Honkawa, and ate my lunch alone. How long those lunch hours seemed!

*Yoshikawa Eiji (1892–1962), author of many works, including *Miyamoto Musashi* (an epic serial beginning in the 1930s). Osaragi Jirō (1897–1973). Nomura Kodō (1882–1963).

I resisted in more ways than one, so I was scolded often by the teachers. I thought I never wanted to see again the hateful faces of the vice principal and teachers who summoned me to the teachers' room, pulled my ears, bounced my head off the wall, and threw heartless words at me: "Bad eggs like you are sure to wind up in jail! I guarantee it!" So I was very happy to finish.

We were divided up by sections of the city, and I entered Eba Junior High. And we were driven out of the Takajō we had grown used to.

BAREFOOT GEN: EXCERPT 4

The death of Tomoko takes place late in volume IV. It includes one of the most lyrical, most beautiful panels of the entire work. This excerpt begins with Gen watching as Tomoko's makeshift coffin burns and remembering August 6, Tomoko's birth, and some happier times. The stunning two-page panel of the cremation on the beach echoes the scene Nakazawa drew especially for the autobiography. (Remember that both images have been flipped.)

Volume IV concludes with Gen's discovery that his hair is growing back and the blossoming of wheat in a nearby field. Gen remembers what his father had said back on page 1 of volume I: "Boys, I want you to grow up just like this wheat grows." Grasping a stalk of wheat in his left hand, Gen says, "That's right! I'd forgotten what Papa said! I've gotta be strong . . . just like this wheat. No matter what happens, I won't give up! I'll be strong. Papa, I won't forget! I'll grow strong, whatever it takes! I promise!"

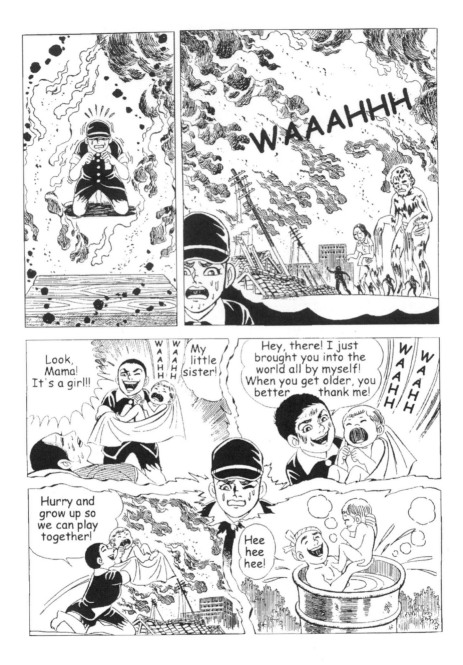

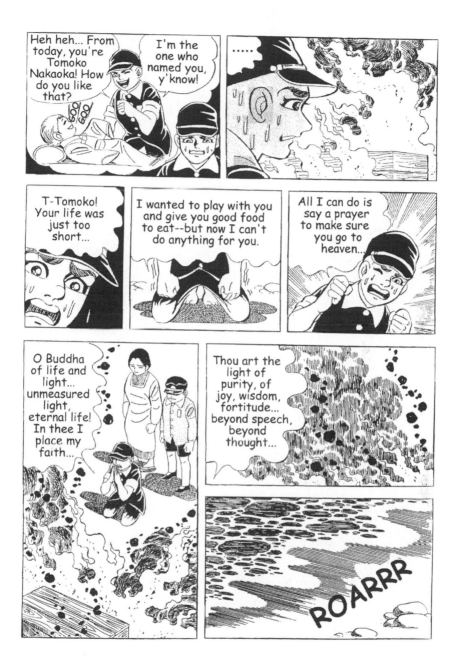

Behold the countenance
of man
Changing from moment
to moment
This world is a fleeting
thing
Dreamlike as life itself

The rosy face of youth in
the morning
Is by evening but a pile of
whitened bones
When the wind of imperma-
nence blows
The eyes close, the last
breath is taken

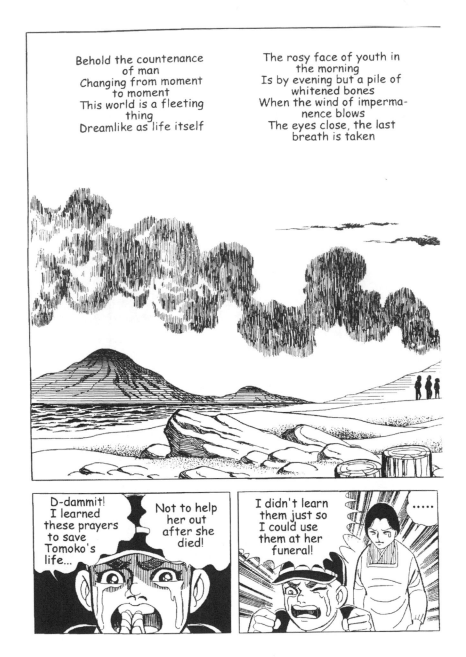

D-dammit!
I learned
these prayers
to save
Tomoko's
life...

Not to help
her out
after she
died!

I didn't learn
them just so
I could use
them at her
funeral!

.....

Only the white bones
remain
We may grieve, yet it means
nothing
Death has no favorites;
young or old
We know not when our
time will come

So now is the time for
all men
To prepare their hearts for
the next world
Pray devoutly to
Amida Buddha
And chant his name that
you may be saved

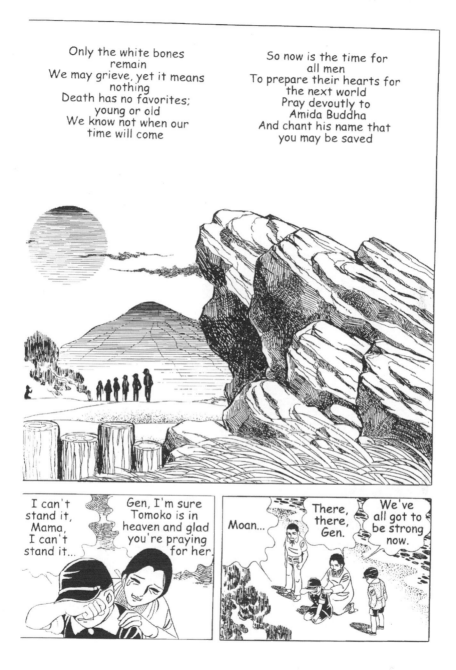

I can't stand it, Mama, I can't stand it...

Gen, I'm sure Tomoko is in heaven and glad you're praying for her.

Moan...

There, there, Gen.

We've all got to be strong now.

5

I SET OUT

MOM'S *GONDOLIER'S SONG*

Our house stood in the way of urban planning for the building of Peace City, so city hall ordered us to vacate.* For a substitute piece of land we were instructed to go to the site of a burned-out factory beside Yoshijima Prison. Mom went to city hall to complain that this was too raw a deal and to negotiate, but they refused flatly and got angry: "Your plea won't work in Japan. Go tell it to the Americans!" Mom grew angry: "That high-handedness at city hall really got my goat!"

We were stripped naked by the atom bomb. We wandered about the ruins. At last we found a place of refuge and, working hard, erected a hut. Now even that was stolen from us. We trembled with anger and vexation. The machinations of the authorities were no different from the old days. They used the sweet-sounding term "peace" to inflict pain on residents who'd been hit by the atomic bomb and were suffering grievously. I thought, "'Peace City' construction—what nonsense!"

Accounts of the reconstruction of Hiroshima after the bomb tell of how the mayor and other officials were helpful, distributing relief supplies to bomb victims and encouraging townspeople, but when I read them, I'm astonished. We have no memory of receiving a single shirt or one sweet potato from the city. On the contrary, we heard rumors: that officials were getting rich by selling relief supplies on the black market, that lots of sharp operators had increased their holdings by transferring to their own names the property of families that had been wiped out. There was much talk that couldn't be glossed over.

*"Peace City" was the slogan of the new Hiroshima.

The only relief we received from the city was the rice balls the Army trucked in after the bombing. We managed to survive entirely on our own. And even our home, the all-important site for that survival, was stolen by the city. Swallowing our tears, we dismantled it.

Uncle H. told us that the Yoshijima land we got in exchange had no running water, was overgrown with weeds, and was utterly unlivable, so we were uneasy as we set out for Yoshijima. We erected the hut on a lot that, just as he'd said, was cold and desolate, and moved in. The public water source was thirty yards off, and each family sent someone with a bucket to collect the trickling water and carry it back. While the weather was hot, that was okay, but when you were exposed to cold wind, it was really tough to wait long hours for your turn to draw water. Akira had graduated from junior high school and gone to work at a shop on Hondōri. Filling up the water bottles and doing all the cooking fell to me, alone at home.

The Eba Junior High I entered was a school in name only; it had no building. We were taught in a borrowed corner of the commercial high school. The schoolyard, too, was sectioned off, and we were forbidden to use the other section. We exercised in a tiny strip of land almost glued to the two-story wooden structure. And I was welcomed once more by a hateful bunch. I was in the same class as the baddies who at Eba Primary School had called me "outsider" and had bullied me unmercifully. I smiled bitterly: "Eba really does have bad karma." However, when I showed that I had backbone—"Don't try to bully me any more!"—they grew scared and didn't come after me.

The parts of junior high new to me were English, homeroom, and the clubs. I joined the art club, of course, but it was a club without materials, so we simply went somewhere and sketched. In science class there was only one microscope, and the entire class lined up and each of us got to peer into it for about three seconds. If you stayed and tried to look any longer, the others got upset. A pitiful education!

What I did gain at Eba Junior High was a library with a larger collection of books than I'd had in grade school. When break time came, I frequented the library. I immersed myself in world classics, one after the other. *The Man in the Iron Mask*, *The Count of Monte Cristo*, *Don Quixote*, Frances Hodgson Burnett's *Little Lord Fauntleroy* and *Little Princess*, and the rest I read with total absorption. *Les Miserables* stirred me particularly. It was a translation of the original, not something translated for use in the lower grades, so it was a thick book that repaid reading. I empathized with the life lived by the main character, Jean Valjean; it's a work I'll never forget.

Receiving these new stimuli, I applied myself even more than before to drawing manga.

With Akira too working, we had things a bit easier, and meat and fish began to appear on our table. Mother's *Gondolier's Song*—"Life is short"—grew sweeter, even sweeter.

I loved playing sandlot baseball with classmates, but at a certain time, I had to go home; I envied my classmates who could play till the sun went down. I had to prepare the meals for a family that came home with empty stomachs.

At the time, the only way to buy rice was on the black market. You'd enter the greengrocer's by the back door, keep your voice low, and ask, "Please, I'd like ten pounds of rice." You'd be invited into the storeroom in back, rice would be piled into a one-quart measure, leveled off with the swipe of a stick, and it would be dumped into the bag you held open. That's how you bought it, but you had to look sharp going and coming, and it left you feeling like a thief. I really hated it. But when supper was over, the whole family sat around, and each reported, with laughter or anger, what had happened that day, and we were filled with a contentment that transcended the suffering of the atomic bomb. I loved seeing Mom smile.

One day, a middle-aged man appeared who looked like a door-to-door salesman. Mom went out to deal with him, and I listened to their conversation. He pressed her, "What became of the baby born the day of the bomb?" Mom replied, "She died within the first half year." His shoulders sagged, and he said almost with a groan, "I've been searching for your baby for six years. . . . I searched with a fine-toothed comb all over Hiroshima Prefecture, narrowed the target area and searched the city. Now I finally find her, and she's dead." He went away much disappointed.

At the time Mom wondered why he had searched six years for the dead Tomoko. We figured out later that a baby born immediately after the dropping of the bomb was a valuable "specimen." The ABCC had hired full-time Japanese staff to carry on the search. It was about then that voices of bomb victim discontent began to be raised, saying that what the ABCC did was merely take viscera from corpses, collecting specimens: "Vultures searching for the corpses of bomb victims! Hyenas swarming over corpses!"

In 1951 the ABCC completed its research facility, a barracks–like Quonset hut atop Hijiyama in Hiroshima. Surveying Hiroshima from on high, it tracked down bomb victims and carried out follow-up studies, data on the effects of the bomb on the human body. Neither Mom nor I understood what it meant. Uneasy, we watched the dejected middle-aged man leave.

I MAKE A SMALL RESOLUTION

I continued to immerse myself wholly in drawing manga. I drew manga after manga. Not satisfied, I tore them up. I tackled new themes and failed again. I sent work I'd finally completed off to publishers to be critiqued. In drawing manga, I gained specialized knowledge. When I first drew manga, I used a fountain pen and blue ink, but when I sent manga to publishers, they couldn't make photoengraving plates from the blue ink. So they suggested I draw with black or India ink, and I realized, "Aha, drawing manga does have its limitations." Looking into printing processes, I learned that the end product differs according to how it is printed: lithography, relief printing, movable type, offset. The paper, too—when I knew how to use it properly, I saw that the results varied with the paper: Kent paper, imitation Japanese vellum, drawing paper. To draw even one manga took specialized knowledge. As with any occupation, there was a bottomless well of knowledge, countless details to master.

The same held true of manga magazines, too. There were many of them, and they filled the store shelves: *Adventure King, Manga King, Boy's Graphic, Fun Book, Boys, Boys' Club.** The day they hit the newsstands each month was a great day. When a sketch I had drawn and sent in appeared among the "readers' contributions," I was delighted, all the more avid to send in more. The magazine I was particularly eager to send manga to was *Boys' Manga.* It had an unusual square format, and it served as gateway for new manga artists. I rejoiced when I saw my own name in small type in the "Honorable Mention" section and continued to draw virtually daily: "I'll soon show them!" I resolved to be a manga artist: "I *can* make a go of it!"

Meanwhile, Kōji had begun to drink and carouse. Angry that he hadn't been able to follow the path he wanted to because of us, he found fault with Mom and Akira and me. I understood his bitterness, but his carousing caused problems. I think this, too, was an evil for which the atomic bomb was responsible.

I moved up to ninth grade, and a two-story wooden building we could dub our alma mater was completed. Each of us picked up his own desk and chair from the building we'd been squatters in, lined up, and moved to the new building—and were amazed at the site on which it stood. It was the very site where the bodies of countless bomb victims had been burned, where the bones had been piled high, the site that American

*Bōken'ō, Manga King, Shōnen gahō, Omoshiro Book, Shōnen, Shōnen Club.

bulldozers had leveled. I sensed a strange irony, karma, in the fact that my alma mater stood atop buried bodies. Each day after morning ceremonies, all of us pupils lined up abreast, and on signal, squatted down and picked up the rocks lying in the playground, pulled up the weeds, and worked to tidy the desolate schoolyard.

At school I submitted test papers with only my name on them, and they came back with a large zero in red ink. I spread them out in front of everyone and smiled boastfully. I didn't care about my grades. As for club activities, the biggest news was that a tape recorder had been donated to the Radio Club. I graduated not having learned what I'd studied.

Of the class, only a minority was able to proceed to high school; more than half got jobs to help their families out. I too had wanted to go on to high school, but seeing Mom working each day until late at night and knowing all too well the family's economics, by virtue of being in charge of the kitchen, I couldn't say, "Let me go on to high school!" Perhaps because she understood the situation, Mom said, "You're the youngest, the last child, so we can let you go on to high school, beyond the compulsory ninth grade." But I decided to go to work. I wanted to earn money to lighten Mom's burden a bit.

If I had to get a job, there must be jobs that would lead to manga, so I chose sign painting. A job with a sign painter would teach me design fundamentals, and I'd understand the relationships among colors and study lettering and draw pictures. All were essential foundations for manga. At the time it was very hard to find a job; I went to a sign painter, pleaded desperately to be taken on, and got a job at 4,000 yen a month. At the time 4,000 yen a month was the best a middle-school grad could get.*

Graduation day arrived. There was no auditorium, so we hung up red-and-white curtains beside the building, and the ceremony ended with the cold wind whipping. Afterward, some teachers were called out by the baddies, and a melee began. Students had been beaten by teachers for carousing with a two-quart bottle of sake in the middle of the playground during school, and many of them were out for revenge. Among them were some who lived in the same house with prostitutes and came to school from the red-light district. As if it were a matter of course, they took revenge on the teachers who'd hit them. School violence didn't start yesterday. Still, the teachers back then didn't take their revenge on the pupils by, for example, calling the cops.

*The exchange rate at the time was 360 yen to the dollar, so Nakazawa's monthly wage was less than $12.

I haven't a single pleasant memory of junior high. On the contrary, my memories are all bitter ones. Heading for school, I'd wrap some salt in paper and stick it in my pocket, steal tomatoes and cukes from the fields on the way to school, add salt, and eat them, easing my hunger. I'd be seen by the owners of the field and chased off. Or school excursions, the loneliest times: I couldn't pay the fee, so I was one of those who didn't go. I'd spend those days touring the Itsukaichi shipyard and waiting for the class to return from their trip to Osaka and Kobe.* It was really tough to watch the group of classmates returning happily, reveling in the memories of their trip. Poverty was truly pathetic. After the graduation ceremony, I headed home happily: "Now I'm going to make a ton of money!"

AT LAST, I BEGIN WORK!

My sign-painting life began in March 1954, the day after graduation. The boss of the company was a short-tempered man, a fiery former soldier. With his low boots, he treated those in my cohort like soccer balls. I read him very quickly and didn't get kicked. Any number of times I saw members of our cohort hiding behind signs and crying bitterly after getting beaten. I observed the artisan world closely. This artisan world became fodder for me, and later I turned it into *Guzuroku, Act!* and *The Guzuroku March.*† The artisan world was an old one; it employed corporal punishment to make you realize what work was. "The craftsman knows his trade," and if your technique is good, you'll get recognition, not complaints. I learned the sign arts for all I was worth, at several times normal speed, giving the other craftsmen no opening to criticize me. The boss evaluated my work and said, "Guys with an aptitude for painting get ahead."

Films were changing to Cinemascope. When I saw the first one, *The Robe,* I was overwhelmed by the huge screen and the stereophonic sound—the voices of characters not yet visible on the screen materializing out of the background, the sounds of the special effects. In Japanese film, Kurosawa Akira's *Seven Samurai* was released, all of three-and-a-half hours long, and I was lost in admiration of its tremendous force.‡ I tried for all I was worth to see whether I could duplicate that film's impact in manga. Even when exhausted from hard work at the sign maker's, I raced home at the end of work and immersed myself till nearly 1:00 A.M. drawing manga. In winter

*Itsukaichi is about five miles west of Hiroshima, on the west side of Hiroshima Bay.
†*Guzuguzu-suru* means to be slow or tardy, to dawdle or idle. So Guzuroku is a slacker.
‡*The Robe* (1953); *Shichinin no samurai* (1954).

I lit the charcoal fire, put the charcoal heater under my desk, and warmed my freezing hands and feet.

With my first month's 4,000 yen, I bought the bananas I'd always longed to eat, brought them home, and ate them with Mom. Mom ate happily: "Delicious, delicious!" Watching her as she ate them delighted me. With all of us working, things got easier at home. Mom's laughter echoed through the house.

Saying he wanted to learn business in earnest, Akira left home and went off to Osaka. Had Dad lived, Akira surely would never have become a tradesman. Because Dad hated business: "Merchants are the filthiest of all!" Time and again, he stressed that the war had come about because merchants of death profited from the sale of weapons. For Akira, son of that father, to become a merchant was an ironic turn of fortune. Our family shrank to the three of us—Mom, Kōji, and me.

Hiroshima continued to develop rapidly, and at night the voices of the prostitutes in the red-light district echoed in the night air. An industrial exposition was held at Peace Park, and I went to the site to paint signs and work on construction. Day after day in Peace Park, tourist buses were parked. From their windows, soda and beer bottles came plopping down, and the buses disgorged herds of U.S. soldiers. They gathered in front of the atomic cenotaph and, raising loud voices, kicked up a row. It made me sick. They wrote graffiti on the walls of the Atomic Bomb Dome—"Remember Pearl Harbor!" My bile rose at the attitude of the swaggering victors.

Day after day American soldiers came for "atomic tourism" from the U.S. bases at Iwakuni and Kure, and atomic orphans sold them the skulls of bomb victims as mementos. I witnessed that many times near the Dome. But I couldn't blame the orphans struggling to survive. They even stole the countless weather-beaten skulls that had been collected by residents in the burned-out waste and placed in a grave for those with no survivors. They extracted the gold teeth and traded the gold for cash. On the surface, Hiroshima was being swaddled in beautiful clothing, but beneath the surface, the ugly struggle for survival went on.

On August 6 each year the peace ceremony on atomic bomb day begins, and each year more people crowd in from other prefectures and make a great to-do. But Mom, Kōji, and I never once took part in the ceremony at the cenotaph in Peace Park. Our first feeling was this: "The very idea! That the suffering and anger and sadness of the atomic hell will be laid to rest by so barefaced a ceremony!" We had no desire to attend. Mom would go early that morning to the Nakazawa family grave, and by the bombing

hour, 8:15 A.M., she'd have started her all-too-demanding physical labor. She wanted to forget the atomic horror, if only for a moment.

I too had no desire to recall the atomic hell and immersed myself at work painting signs. At 8:15 the sirens would ring out across the city. I even got angry at the sirens that willy-nilly brought back memories of that day. But I think it's better to hold the annual ceremony than not—as a sign of opposition to war, opposition to nuclear weapons. If it ever became impossible to hold it, then Japan's peace constitution would be doomed. I look to the atomic bomb ceremony as a barometer of the state of peace.

I spent my days working on signs, my nights working on manga, and on Sundays I'd make the rounds of the three theaters that showed triple features. That life continued, and I learned to drink and smoke. In the full flush of vigor at seventeen and eighteen, I fought with thugs on the busy streets of Hatchōbori and Yagenbori and—perhaps because I was a contrary sort of guy—was quick to fight; in clashes with my fellow artisans, I sent other guys flying and injured them seriously, and at work sites I sometimes went wild with my long-handled shovel.

But even then I didn't abandon my goal of drawing manga. The days continued: I'd buy up the manga magazines published each month, study the artwork or clever layout of each artist, and be amazed—"How did that artist get this clever?" I'd tear up and chuck my own immature work and think about giving up—"I've got no talent!" Mom didn't want me to be a cartoonist. In Dad's life as artist, she'd had more than enough of the impoverished artist's life, and she worried that I was entering a world of the same poverty and hardship. She consulted Uncle H. about how to make me give up manga. When I was absorbed in drawing manga, she'd frequently say, "Please stop!" Disputes arose between us.

Then a sixteen-page manga I'd drawn and submitted to *Fun Book* was named a winner, and my cover page was published as an illustration. I was deliriously happy. A registered letter came with the prize of 1,000 yen inside, and I checked my name on the envelope many times over. Wanting to use my first-ever payment to buy a memento that I'd have forever, I bought a ceramic palette and a water jar. I still use that palette and that water jar today.

My *Fun Book* success swept away my discontent and reignited my dream of becoming a manga artist, a dream that had seemed on the point of shattering. I immersed myself again in manga. The world of manga magazines saw a succession of big hits. I burned with ambition: "I'll show them! I'll soon draw a hit just as big!"

DECLINE

Mom had long complained of not being her usual self, and now her physical condition grew markedly worse. She had severe headaches, the ringing in her ears continued, and her blood pressure rose. She watched her health, switching to a vegetarian diet, but went often to the clinic, complaining of aches and pains. No matter how bad she felt, Mom liked work and didn't take time off. The doctor at the clinic to which she went advised her strongly to go and get checked at the ABCC on Hijiyama. He kept at her: "The ABCC has the latest equipment; you'll obtain good treatment there. I'll refer you. Go soon and have them check you out." So reluctantly—"I'll try the ABCC"—Mom went.

When she got back, I asked her about the ABCC. She told me in great detail. She was made to strip to the skin, draped in a doubled sheet with an opening in the middle for her head, and with the sheet hanging down fore and aft made the rounds of the exam rooms. A lot of blood was drawn, and she was examined from head to toe. Looking upset, she said, "I took offense when they went so far as to examine my uterus." On leaving, she was given no medicine at all, nor did they say they'd tell her the findings later. Mom grumbled, "Why ever did I go? The ABCC has no respect for us!" It angered her to see her name on the file as "specimen name." "The idea! I'm no guinea pig. I'll never go back!"

Years later, I boiled inside all over again when I read internal accounts by ABCC staff. Hiroshima doctors knew that in return for sending bomb victims to the ABCC to have their data recorded, they'd receive honoraria and new medicines developed in the United States. I wanted to thrash the doctor who sent Mom to the ABCC. Moreover, I trembled with anger at the doctors, those inexcusable fools, who opposed the ABCC treating bomb victims for free because their own business would suffer. They turned bomb victims into fodder for their own profit.*

Unease about the effects of radiation grew year by year among surviving bomb victims. The numbers of sudden-onset leukemia victims increased sharply before finally subsiding, but then the number of cancer patients increased rapidly. Articles reported, "Atomic aftereffects are systemic!" When we read them, Mom and I both thought dark thoughts and were assailed by intolerable unease: we wondered when the effects of radioactivity would show up in our own bodies.

*The author is wrong here. The ABCC refused on principle to treat atomic bomb patients since treating them might imply U.S. responsibility.

What relieved that unease a bit for me was the Hiroshima Carp, the baseball team, organized in January 1950 in the atomic ruins. It was a weak team that vied each year for last place, but there was a sense that Hiroshima residents had created the team. If they won, our victory sake tasted delicious; if they lost, we drowned our sorrows, and the sake tasted ordinary. The Carp was one aid to the psychological rebirth of residents beaten down by the atomic bombing. When the team couldn't pay the players' salaries, and it looked as if the team would go defunct, Hiroshima residents responded to the appeal to save the team, tossed their five or ten yen into the large barrels at the entrance to the ballpark, narrowly averting financial disaster. That was the context of Hiroshima residents' avid support for the Carp.

In 1957 Hiroshima Baseball Stadium was completed near the atomic dome. My sign painting, too, had made good progress, and I went any number of times to paint billboards in the park. At night I was an avid Carp fan.

That year "atomic bomb IDs" were distributed to bomb victims. We were told it was best to apply for one, that if you went to the hospital with your ID in hand, you'd get better treatment. So with mixed feelings, Mom, Kōji, and I accepted the IDs from city hall. We stared at the document with distaste, thinking that if we had to use the ID, it'd be because we were dying.

Kōji married, and our house was sparkling and bright. The neighbors congratulated Mom—"You can stop worrying now!" She answered happily, "Not yet. I've still got two more to go, so I can't relax yet."

Mom was a straight shooter, a modern woman, and she was popular with the young women at work. But perhaps her words sounded pointed to Kōji's wife, and dissension grew between mother-in-law and daughter-in-law. Kōji and his wife built their own house and moved out.

Fearing I might cause trouble in Kōji's life as a newlywed, I'd thought of renting an apartment and moving out, but Mom had opposed that. She didn't want to part with me. The household became just the two of us, Mom and me. It pained me to see Mom, back bent, stooped from working constantly, leaving for work at the company.

Wanting to show gratitude to Mom, I said, "If I get a bonus, I'll take you to Osaka and Kyoto!" Mom smiled, "I'll wait—but will the day ever come?" I used all of that summer's bonus to keep my promise to Mom. We left Hiroshima Station with the further aim of learning how things were going with Akira, in business in Osaka. Mom said, "I've never been so far in my life." And on the train she was in good spirits. At the station in Osaka

we met Akira and toured the variety shows, and Mom held her stomach laughing at the comic monologues. After spending half a day walking about Osaka's theater district, we took our leave of Akira. That night we stayed in a cheap hotel near Kyoto Station. Mom exclaimed repeatedly, "What a lovely time!" and at supper the two of us drank beer.

Perhaps it was the beer: complaints about the hard times after the atomic bomb spilled from Mom's mouth. Virtually every day the voices of Susumu and Dad resounded in her ears; they'd been pinned and died crying, "Mommy! I'm hot!" and "Kimiyo, can't you do something?" When she slept, the voices inside her head awoke; she blamed herself, and the tears flowed, unbearably. I grew heavyhearted and shouted, "Don't rehash the past!" Then thinking again, I said, "We'd be better off if we could simply forget that tragic past! As long as we live, we'll never get away from that horrible past!" Mom smiled bitterly at my scolding. That night as we slept side by side, Mom had nightmares. I fell asleep with the gloomy thought that once again she was seeing Dad and Susumu in her dreams.

The next day we toured Kyoto on a sightseeing bus. The Temple of the Golden Pavilion had only just been rebuilt after the arson, and the gold leaf newly covering it glittered garishly and spoiled the impression.* In front of the Chionin, the entire tour group took a formal souvenir photograph, and we returned to Hiroshima. They mailed the photo to us, and any number of times Mom gazed at it, repeating, "That was fun! I really enjoyed it!" I was a bit self-conscious: I might have faked some of that filial piety.

1954. In the waters off Bikini, the *Lucky Dragon #5* was bathed in the death ash of the hydrogen bomb test, one crew member died from the radiation, and terror of radiation gripped the nation.† Voices of opposition to nuclear weapons spread, but the number of U.S. and Soviet nuclear tests only increased; I was stunned. In desperation, I thought, "I wish both the United States and the Soviet Union would get their fill of atomic warfare and learn how fearsome atomic bombs are. Die in an atomic blast, why don't you? Then I'd have a big laugh—'Serves you right!'" The lesson of Hiroshima and Nagasaki was of no avail. I boiled in anger at the foolishness of human beings avid to develop nuclear weapons.

1959. Akira came back from Osaka, and our household grew to three. In winter around the space heater, we talked of our lives. I spoke

*In 1950 a crazed monk set fire to the Kinkakuji. The incident is the inspiration for Mishima Yukio's novel of 1956, *Kinkakuji* (*Temple of the Golden Pavilion*, tr. Ivan Morris [New York: Knopf, 1959]).

†See Ōishi Matashichi, *The Day the Sun Rose in the West: Bikini, the Lucky Dragon, and I*, tr. Richard H. Minear (Honolulu: University of Hawaii Press, 2011).

of my dream: "My talent's as good as gold! With my talent, I'll draw a major hit, earn a bundle, and travel around the world!" I said I'd take Mom along. Listening to me, Mom smiled. Akira made fun of me: "What a lot of hot air!"

At the end of the year, on New Year's Eve, Mom said, "It's bad luck to be lazy and see in the New Year with laundry undone." And standing in the cold wind at the common hydrant, she toiled away at the laundry.

I GO TO TOKYO

The next day, exhausted from drawing New Year's signs, I was at work. A phone call came for me, informing me, "Your mother's collapsed." In a daze, I rushed home on my bike. I found Mom collapsed atop the living room mats and, thinking it strange, asked, "Why not put her on a mattress?" A neighbor said, "She collapsed of cerebral hemorrhage, from being exposed to the cold wind. If we move her, there's a danger that blood vessels in her brain will rupture. Better leave her like this." The doctor came, and four of us picked her up and moved her to a mattress.

Mom slept on, snoring hugely, as if expelling anger at the world. The doctor said, "Tonight's the critical period," and left. I'd heard from a neighbor about Chinese herbal medicine that was supposed to be effective against cerebral hemorrhage, hopped on my bike, and raced around the dark streets, looking for it. With our fingers, Akira and I forced Mom's mouth open and stuffed in the medicine I'd bought. That night Akira and I took turns standing watch. Mom slept on, still snoring heavily. Something must have worked, because she survived the critical period. The doctor advised her, "You'd be better off in the hospital," so she sought admission to the Hiroshima Atomic Bomb Hospital very close to our house, just across Minami Bridge.

The Atomic Bomb Hospital had been built in September 1956 with money raised from the sale of New Year's postal cards.* It was opened as a hospital specializing in atomic bomb disease, and bomb victims rejoiced that help was at hand. Mom, too, might have atomic bomb aftereffects. Taking her atomic bomb ID and thinking there were no fees, making her load lighter, she sought to be admitted. Akira ran about frantically getting the paperwork done to get Mom admitted. But hearing the hospital's ex-

*The Japanese postal authorities sell New Year's cards that carry numbers. People buy them in great quantities to mail to acquaintances. There is a drawing, and winning numbers get prizes. The proceeds of the sales go to causes deemed worthy.

planation—"Cerebral hemorrhage isn't one of the designated atomic bomb illnesses, so her atomic bomb ID doesn't apply"—I got boiling mad. From that explanation, I knew Mom's atomic bomb ID was absolutely useless.

Akira and I raged: "The atomic bombing made her writhe in agony, but cerebral hemorrhage isn't a designated illness, so she can't get treated on her atomic bomb ID! Even when a bomb victim is suffering illness. Throw in the fact that the state doesn't compensate for its war responsibility, isn't it a foregone conclusion that the state takes care of her?" Fortunately, the company Mom worked for had health insurance, and with that she was admitted to the hospital. If she was found to be incurable, the health insurance had a two-year cap, and thereafter our costs would rise. With that in mind, we hoped that somehow she'd recover completely in the two years. Out of our monthly salaries, Akira and I paid for a private nurse to take care of Mom, and we kept an eye on her condition. We realized that this would be a very long-term illness.

You often hear that "siblings grow up and turn into strangers." It's really true. Kōji said, "My wife hates taking care of the old lady, so you two do it," and he played absolutely no role in Mom's care. With Mom's illness, the blood link between brothers disintegrated. I shook with anger. How unfeeling he was! I said, "How can you say that about the mother who bore and raised you!" I'd respected Kōji, who'd exerted himself to survive, even going off with his one trunk to the coal mine. But once he married and set up his own home, we couldn't rely on him any more. Can human beings change so radically? Akira did all he could to restrain me in my anger. He made me see that this was no time for brothers to quarrel. I paid heed to his words.

Mom's condition improved gradually. She was paralyzed on one side and couldn't enunciate clearly, but she was able to converse in few words. On the way home from work, I'd look in on her in her hospital room and bring her fruit. Thinking that the cold white walls of her room weren't very friendly, I painted scenes at work and hung them on the wall over her bed. I learned from her nurse that Mom boasted happily to her roommates about my pictures, which made me happy, too.

In going back and forth to the Atomic Bomb Hospital, I became acquainted by sight with apparently healthy bomb victims who had rooms in the hospital with their own facilities and were eating food of their own choosing that they cooked themselves. When one of them was suddenly gone, I'd ask Mom, and she'd say, "He died." I was stunned. There were many days when I encountered the hospital deaths of bomb victims and came home gloomy. With massage therapy and the beginning of physical

therapy, Mom got back her spirit, smiling and blurting out words almost impatiently. Akira and I breathed a sigh of relief.

Discussing the insurance that would run out after two years and Mom's prospects, Akira and I lamented the fact that we had no sister. Eiko had died in the atomic bombing; had she survived, she would have been a great help. When I, a male, pushed the chamber pot under her so Mom could move her bowels, she got embarrassed and was reluctant to relieve herself, even though I was her own child. Asking a nurse led to issues about work time. Akira told Mom that she needed a female relative at her side. Our house was both closer and more convenient to the Atomic Bomb Hospital, and Akira suggested that we move out and turn it over to Kōji and his wife, have them move back, and get his wife to help out. I agreed. Akira and I asked her to help Mom, and we each rented an apartment and moved out. Since first grade I had done the cooking and the laundry, so even on my own I got along absolutely fine.

My apartment adjoined the red-light district, and women of the night and gangsters thronged the streets. It was a very raucous place: in a fight between gangsters at a nearby cabaret, dynamite exploded. Seventy millimeter films made their debut, and the impact of the giant screen and the sound increased; when I saw *Ben Hur*, I was blown away—it was a great movie.*

Mom learned to walk grasping handrails. Mom hated being dependent on others. With her fierce will and never-say-die spirit, she sighed and hummed the *Gondolier's Song*. Things were okay now, and I relaxed.

Taking advantage of a vacation, I went to Tokyo with manuscripts in hand and visited a certain publisher and asked for criticism of my work. An editor looked my work over and said, "If you really want to become a manga artist, your best course is to join the world of the pros and learn. If you're game, I can introduce you to a manga artist who needs an assistant." I returned to Hiroshima and talked frankly with Akira about my desire to go that route.

Akira had gone to Osaka for work, so he understood my desire and encouraged me to go to Tokyo: "You don't want to live in obscurity in Hiroshima. Get on with your chosen path on Tokyo's broad stage, with all its opportunities! Leave Mom to me. But if you come back to Hiroshima in tears, don't expect sympathy from me." I was deeply grateful my brother understood.

Ben Hur (1959).

It was agreed that I'd become an assistant to manga artist K.,* and when it came time to send my belongings to Tokyo, Akira packed my stuff beautifully, using skills he'd learned in Osaka. That night I visited Mom at the Atomic Bomb Hospital and told her, "I'm going to Tokyo to learn manga." Mom looked forlorn but said, "It's what you want to do. Go for it!" I said, "You learn to walk again! I'll come for you and show you the Tokyo sights!" Mom nodded happily.

The next day I left Hiroshima on the noon train. The moment the wheels started to turn, the impulse hit me to jump off the train "I don't know a soul in Tokyo. How can I get along there? Can I really become a manga artist?" I was sad, forlorn at leaving the Hiroshima I knew, and unease spun like a kaleidoscope in my head. Bucking myself up—"I've got the sign-painting skills of a professional. If manga doesn't work out, I'll become the best sign painter in Japan!"—I headed for Tokyo.

It was February 1961. I was twenty-two.

*Kazumine Daiji (1935–).

BAREFOOT GEN: EXCERPT 5

Early in volume VIII Gen vows to take political action. The year is 1950, the year of the outbreak of the Korean War. Gen's teacher encouraged his class: "All of you must take responsibility for the future of Japan. You must never stop hating war with a passion and working for peace. And to do that, you have to keep a close eye on what's going on in politics. If you look the other way, before you know it, the drums of war will be beating and by the time you notice, it will be too late."

Gen encounters a peace demonstration, with his teacher as one partici-pant, and here delivers political thoughts perhaps unrealistic for Nakazawa, then thirteen years old. Then he hearkens back to the words of the family's Korean neighbor, Pak.

In following segments Gen takes a leading role in routing right-wing "patriots." By the end of volume VIII, Gen has "set off on a new path of self-reliance"—both for himself and for Japan.

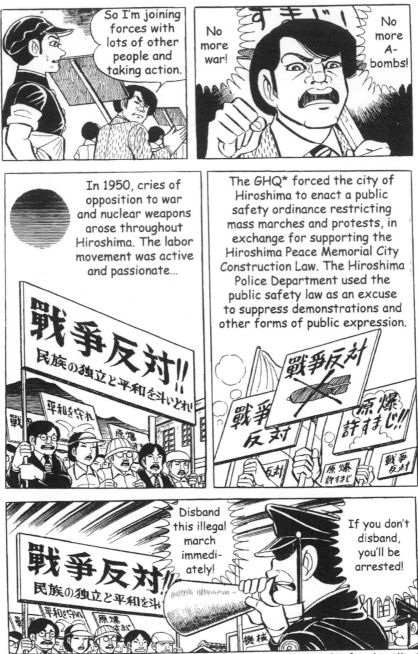

So I'm joining forces with lots of other people and taking action.

No more war!

No more A-bombs!

In 1950, cries of opposition to war and nuclear weapons arose throughout Hiroshima. The labor movement was active and passionate...

The GHQ* forced the city of Hiroshima to enact a public safety ordinance restricting mass marches and protests, in exchange for supporting the Hiroshima Peace Memorial City Construction Law. The Hiroshima Police Department used the public safety law as an excuse to suppress demonstrations and other forms of public expression.

Disband this illegal march immediately!

If you don't disband, you'll be arrested!

*GHQ: General Headquarters of the Supreme Commander for the Allied Powers, which ruled Japan during the postwar occupation until 1952

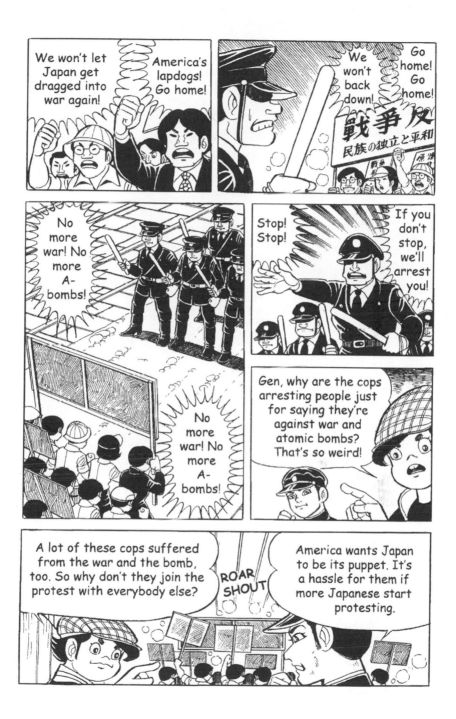

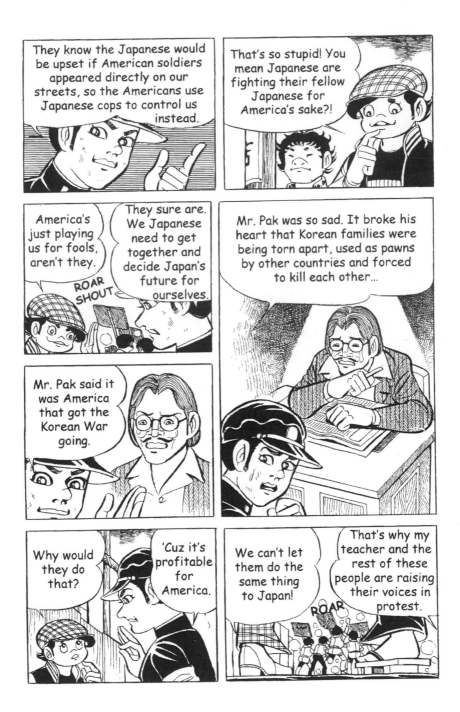

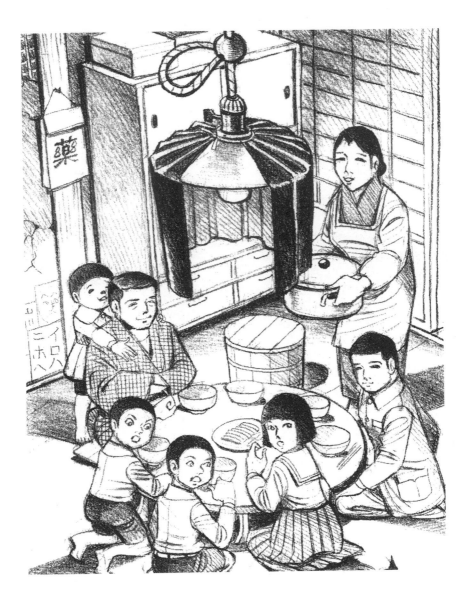

6

GEN AND I, TOGETHER

LIFE IN TOKYO

I arrived in Tokyo the year after the Kishi Cabinet resigned in the 1960 Security Treaty struggle.* Collecting the luggage I'd sent to the home of manga artist K., I settled into a rented apartment—one six-by-nine room—behind Yanaka Cemetery near Nippori Station on the Yamanote Line. My total capital was 30,000 yen,† and thinking not to waste a penny, I'd searched for a cheap room. The window was blocked by a wall next door, and even during the day it was very dark, but it was cheap, so I made do. My Tokyo life began with me humming a line from a song popular at the time, "A home of my own, small but nice."

Earning day wages as assistant to manga artist K., I was keen to draw my own manga. Yoshinaga Sayuri's song "Cold Morning" poured from loudspeakers on the Yanaka Ginza,‡ and hugging myself to stay warm, I paced the cemetery dreaming up ideas. Wandering in Ueno Park, I searched out cheap movie theaters and made sure I didn't miss any movies. I frequented cheap movie theaters in several parts of Tokyo.

I was enormously fond of Yanaka, part of Tokyo's working class section. From my apartment I always went to the "World Bath," and there I saw three disciples supporting Master Kokintei Shinshō§—letting him

*In 1960 Prime Minister Kishi Nobusuke rammed through the Diet (Japan's legislature) a renewal of the U.S.–Japan security arrangement. Mass protest led to the death of one protester and the cancellation of President Dwight D. Eisenhower's planned trip to Japan.

†Yanaka is two JNR (Japanese National Railways) stops north of Ueno. At the 1961 exchange rate, 30,000 yen was less than $100.

‡Yoshinaga Sayuri (b. 1945), singer and movie star. The Yanaka Ginza was Yanaka's (much smaller) version of Tokyo's Ginza, a shopping and entertainment district.

§Kokintei Shinshō (1890–1973), master of comic monologues.

down into the bath and washing him. He had suffered a cerebral hemorrhage, and his disciples took care of him. I thought the comic storytelling apprenticeship, too, must be tough. And I thought of Mom, felled by hemorrhage and trying to recover. Since I was a freelance professional, my time was flexible, and one of my pleasures was to be first into the bath. Soaking in the clean water of the bath, facing the mirrors on the wall of the washroom, I questioned myself uneasily: "You really think you can make a go of it as manga artist?" Sometimes I even forgot the time and, lost in dreaming up stories, I once stayed in the bath nearly five hours, became unwell, and collapsed.

When I finished the work I had contracted to do for manga artist K. and was free, I immersed myself in drawing my own manga. The summer was hot, and staying in my room, I'd be drenched in sweat, as if I'd poured water all over myself. The composition paper would get sweat-soaked, the ink would run, and I couldn't draw, so I'd flee to the coffeehouse right next door, which had air conditioning. Drinking coffee at 40 yen a cup, I'd hole up in a corner of the cafe until sundown, drawing manga. The proprietress didn't look askance but put up with me, and I was really grateful. Taking finished work, I made the rounds of publishers. I learned from the criticism and used it to make my next work better. I drew and drew.

In my second year in Tokyo I landed a one-year serial in *Boys' Graphic*. Even I felt uneasy: "Is it really a good thing to land a serial so early?" I knew many assistants who'd stayed for ten years on the lowest rung of the ladder yet hadn't been able to sell their work, had grown discouraged, and had quit. So the speed of my debut surprised even me.

Spark #1, involving a racecar manufacturer and an industrial spy, began its run as a serial, and I got paid 1,500 yen per page. For the duration, life became easier, and I jumped for joy. What with helping out at manga artist K.'s and the side job of my own serial, it was manga! manga! all day long. I was truly fortunate to be able to immerse myself in what I loved. How the months flew!

May 1962. A major accident took place, the collision of two trains at the JNR Mikawajima Station.* I was living in Nippori, so I could hear the sirens of the ambulances and other vehicles rushing to the scene. The sirens continued to sound into the evening, and when I went to Mikawajima to look, bodies were strewn about in the twilight. I averted my eyes from the grisly sight as corpses were carried away.

*In a major collision on May 3, 160 people died and 296 people were seriously injured.

1963. Life in Tokyo was full of bad news. The incident in which the little Murakoshi boy was lured away and then murdered made me angry. On the subway to deliver a manuscript to the publisher, I looked at the newspaper the man in the seat ahead of me had spread out and was shocked to see the big headline: "President Kennedy Assassinated!" My first serial came to an end. Intensely conscious of how little talent I had, I felt completely frustrated. I resolved to relearn manga once again from the ground up and became an assistant to manga artist T., a popular author.*

The difference between manga artist K. and manga artist T. was that between commercial and professional. Manga artist K. kept it simple: he drew manga and was happy if they became popular and earned money. Manga artist T. worked right up to the deadline redrawing parts he wasn't happy with. I saw that both had their points, but my sympathies were with manga artist T., the professional. For three months I serialized the sci-fi tale "Space Giraffe" in *Boys' King Weekly*, and I learned how rapidly deadlines loomed for the weeklies. I was so driven by deadlines that I wanted to cry out, "I don't need the money, so let me sleep!" I was absolutely exhausted. Manga artists need strength and nerves—it's almost a matter of the survival of the fittest! Around then I came to understand in my bones the true rigors of the professional world.

In October 1964, on the day the Tokyo Olympics opened, I got off at Harajuku Station. Manga artist K. was in a pinch with a deadline and had asked me to help out. I realized I'd worked through the night. When I looked up, Self-Defense Force planes were skywriting the five rings. Back then in Harajuku, you hardly met anyone, and Omote Sandō was a quiet pedestrian street. Taking a break from work, I walked about near the Olympic Main Stadium and watched the sacred flame burning. In stark contrast to the high spirits about me, I grew gloomy, anticipating that the job of working through the night on manga would continue.

What I remember most about the Tokyo Olympics isn't the performance of Japanese competitors or the great skill of the contestants, but a small sidebar a foreign reporter wrote about the Japanese. It slammed the Japanese viciously: "What a sight! In the gallery for distinguished guests: Emperor Hirohito, one of the world's three great mass murderers. Brazenly, Hirohitler† waved happily to the foreign athletes. What crazy people, the Japanese who watched him with tears of joy!" I agreed with the article: "Absolutely! That's

*The author has misremembered here: the kidnap took place in 1964, not 1963.

†A combination of the names Hirohito and Hitler, intended to tie the Japanese emperor closely to Japan's wartime ally Adolf Hitler.

accurate!" Japanese shouldn't forget the sharp eye of that foreign reporter. That has always stuck in my memory.

NEVER AGAIN SAY THE WORDS, "ATOMIC BOMB"!

Akira married, so after four years away, I went back to Hiroshima. Mom was partially paralyzed and couldn't walk freely, but she smiled and was in good spirits. The *Boys Graphic* that carried my first work was displayed prominently atop the chest of drawers beside her bed. Mom said, "I've read it countless times!" I was happy, but a bit self-conscious. Some time earlier Akira had visited my apartment in Nippori. We'd shared the bed as he told me about things at home. But the true purpose of his Tokyo visit was that Mom had been worried about how I was doing and had asked him to come see. He'd told me, "The old lady worries only about you." I really appreciated her concern. She was staying with Kōji while going regularly to the Atomic Bomb Hospital for rehabilitation.

At Akira's wedding, I sang an old Kyushu folk song from the bottom of my heart, full of gratitude to him. Uncle H. danced to the song splendidly. Congratulated by the people there, Mom exchanged greetings happily. And she stressed that she had to keep at it until she saw me married: "I can't rest. There's still one more." On departing, I said to Mom, "You learn to walk. I'll show you Tokyo."

I returned to my one-room, six-by-nine Nippori apartment, and life went on. I earned day wages as an assistant and drew my own work. I hoped the time would soon come when I could live a settled life as manga artist so I could rent two rooms and bring Mom to live with me. I kept drawing stories and trying to market them. I published work in *Adventure King*, *Manga King*, *Boys*, *Boys Sunday*, and the others, but I continued to wrestle with the difficulties manga presents.

I was shocked to learn that there was atomic bomb discrimination in Tokyo. When talk of home arose and I mentioned to acquaintances that I'd experienced the atomic bombing in Hiroshima, the glances sent my way were indescribably chilly and strange, and I was bewildered—I couldn't recall ever having experienced such hateful looks. If you live in Hiroshima, everyone has bomb victim relatives, and you can speak of the atomic bombing freely and frankly. So I wondered, "Why do Tokyo people give you such hateful looks when they know you're a bomb victim?" Noticing that if I spoke the words, "atomic bomb," the atmosphere went chilly, I took care not to raise the topic.

Each year when summer came, the mass media would raise a fuss—"Atomic bomb! Atomic bomb!"—and my mood would turn dark. Like it or not, my Hiroshima experience would return, and I'd be made to feel things I hated to feel. I'd feel the illusion that I'd done something wrong by being a victim of the bomb. I'd get really angry at the unpleasant glances of Tokyo people, true pains. Near the Ginza and elsewhere I met members of bomb victims groups collecting signatures for the abolition of nuclear weapons, and I thought highly of them: "In a dignified manner, these people go out in public and act." I didn't have their courage.

When I was in Hiroshima, I disliked the words "atomic bomb" and avoided them. But having moved to Tokyo, I disliked them and avoided them more and more. When people from Hiroshima asked me in bars or meetings whether I, too, was from Hiroshima, I prayed that the topic of the atomic bomb wouldn't come up. And in conversation, too, I was careful not to provide an opening for anyone to refer to the atomic bomb. One time I had the opportunity to talk with a person from a bomb victims group and asked, "Why are Tokyo people so cold and disagreeable when they know you're a bomb victim?" I was told that lots of people really believed that "if you get near a bomb victim in Tokyo, you'll catch radiation, or that if you touch a cup from which a bomb victim has drunk, radioactivity will invade your body and infect you. So never touch the cup!" Tokyo was an assemblage of people from all over the country who knew absolutely nothing about the atomic bomb, and they believed false rumors. I was aghast. I trembled with anger: how dare they say nonchalantly, "Japan's the only country to be atomic bombed!" I was disgusted. I came to understand that the cold, disagreeable looks I'd encountered were the glances of fools who didn't know the reality of the atomic bomb.

I resolved never to speak the words "atomic bomb" again. When I went to bookstores and there were books about the atomic bomb on the shelves, I averted my eyes and moved on. When the characters "atomic bomb" leapt out of a newspaper article, I didn't read a word of that article. I truly came to hate the word and the characters "atomic bomb."

Tokyo put forward a different face from one day to the next: the bullet trains ran, impassioned antiwar Vietnam demonstrations raged, and electric guitars wailed all over town.*

I frequented cheap movie theaters and watched all sorts of films and turned them into material for my manga. In particular, I went often to a

*Beginning in 1964, Japan's bullet trains ran—at first only between Tokyo and Osaka—at speeds up to 180 mph. They shortened the travel time between those two cities from nearly seven hours to just over three.

theater at the east entrance to Ikebukuro Station. Kurosawa Akira's *No Regrets for Lost Youth, Splendid Sunday, To Live,* and the rest have stayed with me forever.* The scene in *To Live,* when with the snow falling, the bureaucrat swings on the swing in the park he himself has pushed through to completion and the *Gondolier's Song* rolls from his lips—"Life is short—fall in love, young woman, / Before the red fades from your lips"—reminded me especially of Mom, who loved that song and hummed it. I thought that film was Kurosawa's greatest achievement. I'd hear the *Gondolier's Song* and think of Mom, quickly grow homesick, and want to go back to Hiroshima.

In August 1965, wanting to see Mom, I returned to Hiroshima. I knew that Mom was living with Kōji so she could go back and forth to the Atomic Bomb Hospital for physical therapy, so I went to her room on the second floor. When I pulled back the sliding screen to enter her room, Mom's face brightened suddenly at sight of me, and she was greatly delighted at my return. Soon tears welled up in the eyes she fixed on me, and she started to cry.

Seeing Mom cry for the very first time, I was shocked, confused. Worried, I asked her why she was crying, and she said that Kōji's first grader had asked, any number of times, "When's Grammy going to leave?" She reproached herself: she should leave soon. Why should a very young child, who didn't understand right and wrong, ask such a thing? Because, she said, he listened when Kōji and his wife talked in his presence about sending her packing. Mom wept on: "It's mortifying! It's mortifying!" She wept, flinging at me, back for the first time in a while, what she'd kept bottled up. I was unbearably sad. Had I had the money to do so, I'd have taken Mom on the spot and returned to Tokyo. I'd never before thought as much as I thought then, "Oh, for money!"

We'd been through so much together—fleeing the hell of the atomic bomb, her giving birth on the sidewalk, overcoming with great difficulty the postwar shortage of food. Yet even in those hard days, I'd never once seen Mom cry. As long as I live, I'll never forget the sight of her, tears pouring down her face. I encouraged her, "Concentrate on your therapy and learn to walk again. I swear I'll come get you from Tokyo." And I left. It was a trip home enveloped in dark thoughts.

The only redeeming feature of this trip was that I met with the group from my sign-painting days and was introduced to a young woman. Destiny is strange. After returning to Tokyo, I exchanged letters with her, and

**Waga seishun ni kuinaki* (1946); *Subarashiki Nichiyōbi* (1947); *Ikiru* (1952).

we started dating. And when I told Akira I was thinking of her as a marriage partner, before I knew what was happening, marriage talks were under way; Akira took charge of everything. But I had one worry about marriage. I was uneasy: would the fact I was a bomb victim break up the talks? In both Hiroshima and Tokyo, I'd heard many stories of marriages that had been called off when it was learned that one party was a bomb victim and of the man and woman committing suicide. Fortunately, both she and her family were understanding, and I breathed a sigh of relief. In later years my wife confessed that when she married me, she was uneasy and worried about the marriage because of the issue of aftereffects of the atomic bomb.

February 1966. With Uncle H. serving as go-between, I became a married man. At the ceremony Mom said any number of times, "Keiji! Wonderful! Isn't it wonderful!" Her beaming face pleased me even as it turned me shy. And to the people about her, she said, "Well! Now I can die!" I took alarm and said angrily, "Don't tempt fate!"

Little did I know how right I was.

"MOM DEAD"

After the wedding ceremony, we went to Tokyo; the trip doubled as honeymoon. We rented a one-room, nine-by-twelve apartment near Shiina-machi Station on the Nishi-Ikebukuro Line and started our married life. I carried on, earning wages as an assistant during the day and drawing my own manga at night. On October 9 of that year, about 10 p.m., I was summoned from downstairs: "Nakazawa-san, you've got a telegram!" I had been drawing manga, so I went downstairs to get the telegram thinking, "Maybe it's from a publisher."

I opened it and read: "MOM DEAD. COME AT ONCE." I was stunned. I read it over and over again. Then, as the message sank in, my legs started to tremble uncontrollably, and it seemed to take a very long time to get back to our room on the second floor. My wife, who was pregnant, wept that we'd never be able to show Mom our child. I crawled under the blanket and struggled to control my shivering. I simply couldn't believe Mom wouldn't be here any more. In Hiroshima twenty-one years earlier, I'd seen the corpses of many who'd died in the atomic bombing, and I'd seen how they burned. Thinking Mom had become like them, I was intolerably sad.

I reached Kōji's house the next evening. The coffin sat in front of the altar, and when I peeked inside, I saw Mom's face, faded and

shrunken. In a daze, I studied Mom's face. I realized the truth of the adage, "By the time you want to be filial, your parents are already gone." I thought for a moment that Mom's long tension had eased when she witnessed my wedding, that it had hastened her death. She had collapsed and died in the bathroom of Akira's house. While holding the wake and keeping incense burning through the night, I gazed at her commemorative photo. The days Mom and I had been through together materialized and dematerialized, as in a kaleidoscope. Every last image of Mom that floated up was a cruel scene: of being knocked down by the atomic bomb and fighting desperately to live. I kept thinking of Mom's life: had the war and the atomic bomb not happened, I'd probably have had plenty of very happy memories. I'd expressed my appreciation to Mom for having protected and reared us brothers. The regret remained that I hadn't been able to carry out my promise to show her Tokyo.

Akira was upset, and when I heard why, the blood in my body suddenly stopped flowing, and I got hot. Immediately after Mom died, the ABCC came running with wreath and incense and pressed him: "For the sake of medical progress, please let us conduct an autopsy on your mother's body!" They wouldn't move from the entryway, saying they only wanted to remove Mom's organs as specimens, that they'd sew her up and give us back a beautiful corpse. Akira got angry and chased them away, shouting, "What makes you think we'll let you ABCC people cut up our beloved Mother?" I frightened myself wondering what I'd have done had I been there. I might have knocked those ABCC guys head over heels.

I couldn't forgive the ABCC. It didn't offer bomb victims a single bit of help. It treated them as specimens, guinea pigs. Always hot on the trail of bomb victims for the purposes of their own country's nuclear war, it took the data it collected back to the United States. The existence of a spy network to report to the ABCC as soon as bomb victims died surprised and terrified me. In Hiroshima a network of contacts extended in every direction, on the lookout for the deaths of bomb victims—those jackals hunted corpses. Today the ABCC facilities have been turned over to Hiroshima, the name changed to "Radiation Effects Research Center," and the center operates under joint Japanese–U.S. management. But what happened then gravely wounded me, and I have serious doubts that it's actually being operated for the sake of Japanese now.

My name, too, had been entered in the ABCC records, and documents came to me in Tokyo any number of times, asking that I respond to follow-up studies. But I always ripped them up and threw them away. Deep in my heart I was angry: "Why should I put up with always being

observed like a guinea pig, under cover of the euphemism 'for the sake of medical progress'?" How our lives were deranged because one atomic bomb was dropped! I couldn't help hating the America that dropped the bomb. That night of the wake, Akira and I were united in our anger.

The next day we headed for the city crematory on the hill behind Hiroshima Station and consigned Mom's body to the flames. As we sat in the waiting room, waiting for Mom's ashes, we stared at the smoke rising from the crematory chimney. I had seen many corpses burning in the atomic ruins, so I could picture Mom's body burning. Skull, shoulder blades, sternum, arm and leg bones would remain, whitened, just like the bones of Dad and Eiko and Susumu when we'd dug them up. I looked up at the smoke rising from the chimney and watched it dissipate and vanish.

"Please pick out the bones."* At the attendant's direction, we all gathered in front of the oven in which Mom had been cremated. The doors opened, and the dais on which Mom's coffin had sat was pulled out and set in front of us. The dais was covered with the embers and ash of coffin and body. Uncle H. had instructed us that when we picked out the bones, we should take the Adam's apple and put it in the urn first. I searched with bamboo chopsticks the spot where the skull had been. But it was disconcerting: I couldn't find the skull, let alone the Adam's apple. When we searched the ashes thoroughly and there were no bones, I was shocked. All we found was small bits of bone, an inch or two long. Akira said, "The fire really completely consumed her," and he admired how well the furnace functioned. But pretending a calm I didn't feel, I opened my eyes wide in astonishment and asked myself: "How can this be? When human bodies burn, skull, sternum, arm and leg bones clearly keep their original shape." I grumbled, over and over. In my mind's eye, I contrasted Mom's bones-become-ashes with the bones of Dad and the others who were burned to death. And I remembered a Tokyo conversation.

I'd heard from a member of a bomb victims' group that when they'd cremated the bodies of a bomb victim couple living in Tokyo, absolutely no bones had remained, and I'd said, "That can't be!" Rebutting the story that there'd been no bones, I'd mentioned my experience retrieving the bones of Dad and the others and said I'd seen many charred bones. But it came as a severe shock when so few of my own mother's bones were left after cremation. In the twenty-one years since the atomic bomb was dropped, Mom's bones had been penetrated by radioactivity, eaten away,

*In Japanese funerary practice, once the body has been cremated, the relatives pick out the major bones and place them in an urn.

and turned brittle through and through. Cremate them, and they turned instantly to ash. As we picked out the small fragments of Mom's bones and put them in the urn, my stomach was churning with anger. "That damned atomic bomb! It made Mom's life go haywire and made her suffer, and now it's even stolen her bones—she who had been reduced almost to crawling!" I was trembling with anger and had a hard time pretending to be calm. The next day we interred Mom's urn in the Nakazawa family grave. Standing in front of the gravestone and lighting a cigarette from the incense, I drew a deep breath.

We took the night train back to Tokyo. I couldn't get to sleep. To the clickety-clack of the train, the days I'd lived through with Mom floated up one after the other, then faded. I tried once again to get to the bottom of the causes—the war and the atomic bomb—that tormented Mom's life and had now stolen even her bones. I thought and thought, and it always came to this: "Have the Japanese pursued and settled responsibility for the war?" "Have the Japanese pursued and settled the issue of the atomic bomb?" I realized that both issues had been rendered ambiguous, that neither had been settled. So long as we didn't pursue and settle these issues, the deaths of Dad, Eiko, Susumu, Tomoko, and now Mom were without meaning. I came to want to avenge our Nakazawa family. I resolved to fight a one-man battle: "Say who—the Japanese government? the U.S. government?—was responsible for the war and the atomic bomb! Speak! Speak! Speak! Never forgive!"

Courage welled up: "The only thing I'm good at is manga. I'll do battle through manga!" As if demons had fallen away, I calmed down: I don't have the time any more to run around hating the words "atomic bomb." If each single Japanese person who was dealt a grave blow by the war and the atomic bomb musters all his bitterness to wage an angry struggle, he can smash those guys who rejoice at war and the atomic bomb. It's not something a group of people can do.

THE BIRTH OF ATOMIC BOMB MANGA

Returning to Tokyo, I shut myself up in the nine-by-twelve room and began to draw feverishly, pouring out all my anger. In one week I completed *Pelted by Black Rain*, the first atomic bomb manga. Usually I was slow at drawing, needing about a month to compose a short, single-issue manga. But I surprised even myself by immersing myself and drawing *Pelted by Black Rain* at one go. The main character, a young bomb victim, tracks

an American arms smuggler to Hiroshima and kills him. In turn, the main character runs into someone who avenges his victim, and as he lies dying, asks that his corneas go to a blind woman, a second-generation bomb victim. He hopes she'll set her new eyes firmly on never allowing the tragedy of war and atomic bombing to be repeated, and then he dies. In writing so hard-boiled a story, I vented my own anger at the atomic bomb.

I hoped high school students, the next generation, would read this work. Shooting for major publisher S.'s magazine for the high school audience, I took the work in. The editor who read it showed a friendly feeling for it and said he'd submit it to the editorial board; he wanted to publish it in the magazine, so he asked me to leave the manuscript with him. I went home hopeful.

At the time I wanted to put an end to my dual life of working as assistant and doing my own work, and I asked my wife, "We won't have as much money. Will you mind?" She said, "If you expend all your effort on a book of your own, I won't complain." The birth of our child was approaching, and I realized we'd need money, but I feared becoming inured to the life of an assistant. If you were an assistant for a long time, you were paid a reasonable amount of money, but with your welfare assured, you got lazy and lost the energy to do your own work, and your resolve to become a manga artist weakened and died. There were many of whom that was true. If only for that reason, I wanted to end my time as assistant soon. And I was fed up with the slick cleverness of manga artist K.: he had me create stories and draw the under-drawings, too, then published many volumes under his own name and made a tidy profit. If you inquired, the manga world was filled with sad tales that could not be told or heard without tears.

I continued to wait for word about *Pelted by Black Rain*, which I'd left with publisher S., but word didn't come, and having grown impatient, I went back. The editor returned my manuscript: "Sorry, we can't run it." I asked him, "What's wrong with it?" but I couldn't get him to respond. Discouraged, I set out for home. Wanting above all to publish *Pelted by Black Rain* in a major magazine, I took the manuscript around to publishers. The editors all said, "the content's good, but it's a bit too intense," and refused to run it. I lost all hope and simply stared at the manuscript, depressed. The subject matter—sharply-worded political criticism, scathing indictment of the atomic bomb—was too much for the normal commercial magazines: that's what I'd learned shopping the manuscript to major publishers. I put the square envelope holding the manuscript of *Pelted by Black Rain* beside my desk, and there it sat, gathering dust.

1966 came to a close. During the year I'd experienced simultaneously the happy and the sad: marriage, funeral, total independence. And it was the year that became in every way possible a turning point for my work. I resolved to rework my concept of atomic bomb manga.

January 1967. Our first daughter Eiko was born in a Hiroshima hospital. "This year will be good. Hang in there!" With that thought in mind, I went back to Hiroshima to see the baby. I was shocked when I saw her face. When I first saw it, her face seemed the spitting image of Mom's. Akira's wife too was astonished. I sensed the mystery of blood ties. Bringing the baby with us, we returned to the one-room, nine-by-twelve apartment in Shiina-machi, and I resumed drawing day and night. The baby cried, so I drew in the middle of the night, too.

My wife's uncle, who lived in Tokyo, died of old age. I witnessed his cremation. I wanted to check once more the workings of crematory ovens. It still bothered me greatly that no bones had remained after Mom's cremation. After this cremation, when the remains were pulled out and lay atop the stand, there were large bones that corresponded precisely to the human body. Without a doubt, Mom's bones had been eaten away by radiation. On the road home, my anger at the atomic bomb bubbled up once more.

In June of that year, learning that China, too, had become a nation with nuclear weapons, I grew angry: "Humans really are fools!" Watching on television, I was astonished to see Chinese soldiers rushing into the nuclear test site. "How dumb! Going into a site full of radiation." I was terrified. I thought, "Those soldiers will die of sudden-onset leukemia or cancer." As I watched the screen, I thought to myself: the lesson of Hiroshima and Nagasaki hadn't been learned.

We needed money to raise the baby, and I devoted myself for all I was worth to drawing manga that would sell. I continued to earn money for animations of television programs—*The Guardsman, The Picture Book of Ultra-Seven, Gamera vs. Gyaos, Son of Godzilla, Monster Gampa.* In a pause in my work, my eye fell on the dust-covered manuscript of *Pelted by Black Rain* beside my desk, and I pulled it out and reread it. And I realized how foolish I'd been. I thought, "Why had I insisted on finding a major publisher? Even a magazine that's third- or fourth-rate will do. If it's in print, someone will read it. If even one person reads my work and hears what I want to say, that will count as success, that will have value. Indeed, the third-rate magazines may make more sense. If no one can read it, it has no significance." I took *Pelted by Black Rain* around to *Manga Punch*, one of the

many comic manga magazines published at the time that aimed at young men. It was a magazine that the PTAs and good parents of the world would likely target as bad, as "dirty."

My meeting with *Manga Punch*'s editor in chief, H., was a truly lucky break. He read *Pelted by Black Rain*, was moved by it, and said right away he'd run it. He decided it all so quickly I was almost disappointed. How could it be that this work that had such long, tough sailing when I took it around to other publishers was accepted so simply?

Editor H. told me that for publishing *Pelted by Black Rain*, "You and I may be arrested by the C.I.A. Reconcile yourself to that." I was stunned. I asked, "What's the C.I.A. got to do with it?" He replied with a smile, "We're publishing a work that indicts the atomic bomb harshly, so we'd better assume the United States will interfere. I'm ready to be arrested with you." I answered, also with a smile, "That's fine with me!" And I made a request about the publication: "Under no circumstances put the subtitle, 'atomic bomb,' on the cover!" I didn't want readers to be thinking from the first that this was an "atrocity manga." From the first, I thought it better to fool the readers into thinking that this is a hardboiled manga, the exciting story of a murderer and let them encounter the facts of the atomic bomb in the process of reading. I was ecstatic to have met an understanding editor, and on my way home, I skipped on the sidewalk.

The day the *Pelted by Black Rain* issue went on sale was pure joy. As soon as it appeared, I got a phone call from editor H. He told me, "I just had a phone call from manga artist T. He's read your work, and he cheered us on, 'Well done!' There were tears in his voice." I was delighted. Utterly delighted. It was good to know that there really is a manga artist who understands me. An editor for another publisher let me know his candid reaction: "As I read *Pelted by Black Rain*, I began to tremble with anger."

Pelted by Black Rain, the first atomic bomb manga, got good reviews, so the editor encouraged me to do a "black" series. Gratefully, I published a series that vented my anger about the atomic bomb: *The Black River Flows, Beyond Black Silence, A Flock of Black Pigeons*. I also published a social-themed manga in *Manga Action Extra*, another magazine for young people, and work went well. But drawing exclusively manga with only oppressive themes was tough, and I began to suffocate. I had wanted to become a manga artist because I yearned to draw children's manga; I really wanted to draw for children's magazines. So I took a manga about boxing to the editors at *Boys' Jump*, right after it was founded.

THE MEETING WITH EDITOR-IN-CHIEF N.*

Meeting N., the founding editor-in-chief of *Boys' Jump*, filled me with gratitude: I had found the person in my manga life who understood me best. Advice from editor N. broadened my imagery incredibly. I'd met many editors in chief of major magazines before, but they'd searched out the weaknesses of my work and pointed out only its flaws. No one had given me criticism that would improve it. On the way home, I'd often thought, "That jackass is editor in chief of a manga magazine?!"

When I'd taken my work to show it to publisher K., he'd told me haughtily, "We publish only the work of major manga artists. It's ten years too soon for a newcomer like you to come to us!" I'd returned boiling mad, thinking I'd never again take work to him, that I'd die first. Soon after its founding, *Boys' Jump* overtook those haughty weeklies, its circulation leaving them far behind. Thrown for a loop by the *Boys' Jump* editorial policy of using only newcomer artists, they quickly set out to imitate it. I was disgusted. It was a case of "how the mighty have fallen!"

After publishing in the very second issue of *Boys' Jump*, I drew light manga. It was a relief to be liberated a bit from the suffocating theme of the atomic bomb. At the time, will-power manga were at their peak, and manga aimed at macho males were popular—intense stories in which the protagonist endures harsh training to become strong. Reading such manga made me puke. Lots of offensive words that embarrassed readers, stories puerile to the point of foolishness—it made me mad as a manga artist. As a counter, I thought, how about a nerdy, weak boy? I composed tales of a nerdy guy: *Guzuroku—Let's Burn, Guzuroku March*. These drafts editor N. okayed on the spot. I was shocked by his decisiveness. Soon afterward, imitating *Guzuroku*, other magazines began to run manga with nerds as protagonists. I felt great: "Told you so!"

April 1970. Grim articles abounded in the press—stalemate in the Vietnam War; pro or con on the 1970 Security Treaty; from the previous fall, the issue of the reversion of Okinawa to Japan in 1972 without nukes, on the same footing as the rest of Japan.†

I had no choice but to concern myself with nuclear issues. My anger about the atomic bomb returned quickly. I asked my editor, "How about

*Nagano Tadasu.
†The U.S.-Japan Security Treaty of 1960 came up for revision; Okinawa remained under total U.S. control until 1972. Both the U.S. and Japanese governments claimed that there were no nuclear weapons on Japanese soil or on American warships in Japanese waters, but that claim was not true.

letting me do a manga on the atomic bomb?" For reference I showed him my work from *Manga Punch*. N. praised *Manga Punch*: "I'm glad they were willing to run this." And he said to me, "Okay, let's do it."

In Hiroshima and Nagasaki at the time, second-generation bomb victims were dying of the aftereffects of the atomic bomb, and I was uneasy lest my daughter, too, have aftereffects. I wanted to deny them—"Aftereffects? What aftereffects?"—but facts are facts, and you have to accept them coolly. I experimented with a single-issue work, sixty pages long—*Suddenly One Day*. I gave my feelings as a parent to the protagonist, a second-generation bomb victim. I showed the rough sketches to editor N. I sat opposite N. and watched uneasily, thinking he'd likely say no. As he read, editor N. grabbed tissues from his desk and blew his nose—snort, snort!—time and again. I was astonished to realize editor N. was weeping. When he finished reading, he said, "Add another twenty pages! Make it an eighty-pager!"

For manga weeklies at the time, eighty pages was an enormous page count for a single-issue story. He pointed out several passages that I needed to work on, and he also expanded my imagery several times over. He said, "This is the first time I've been so moved by rough sketches." *Suddenly One Day* appeared in *Boys' Jump*, which proper parents always pointed to as "a lowbrow manga magazine." I realized anew the value of the "lowbrows."

Mail poured in virtually every day, from all over Japan, from adults and from students in college, high school, junior high, grade school, even kindergarten. Readers' letters filled a cardboard carton. I sorted the letters and read them. No matter what the age group, more than half the letters spoke of shock at the subject matter: "The atomic bomb as you drew it in *Suddenly One Day*—is that fact? I didn't know that the atomic bomb caused such enormous destruction." I was shocked. I'd thought that textbooks contained accounts of the bomb, that of course they taught the reality of the bomb in school, in civics and history classes. But the exact opposite was true. People didn't know a thing about the atomic bomb. In the face of this basic lack of knowledge, it was disgusting to hear successive prime ministers state, "Japan is the only country to suffer atomic bombing." The letters taught me just how ignorant the Japanese were about the bomb. It didn't surprise me to learn that even in Hiroshima half the children didn't know the facts about the bomb.

Readers encouraged me to tell more about the bomb, and so did editor N.: "Each year for a week or more, they convene a huge assembly on the abolition of nuclear weapons, and they argue. If they read *Suddenly One Day*, they wouldn't need a lot of argument."

A letter came from a grade school teacher in Niigata. A pupil had brought *Boys' Jump* into the classroom, and he'd said angrily, "Never bring manga to class!" The pupil had responded, "But some manga are good!" and showed him *Suddenly One Day*. He got a great shock; he thought he'd received a blow to the head. He passed it around to teachers in the staff room and had them read it, and they were all astonished. On a school day during summer vacation, he'd spread out my work in front of the pupils and talked to them about the atomic bomb. They followed him easily, and when he consulted with other teachers, a plan surfaced to turn *Suddenly One Day* into a slide show. His letter asked my permission. I told him to go ahead if it served his purpose. Later I learned that they'd figured it was more effective for the pupils to read it in manga form and abandoned the idea of a slide show. Readers' reactions varied widely, and I was impressed by the numbers and energy of the readers of the manga weeklies. The downside was that it got harder for me to draw about the atomic bomb.

When I drew scenes of the atomic bombing, the cruel realities of the atomic bomb came back to me, one after the other: the stench of rotting corpses, the stench of pus flowing from burns. My mood darkened, as if I was trapped in a hole with no way to get out. I grew utterly depressed. What's more, in introducing *Pelted by Black Rain* and other works, the *Asahi* newspaper wrote that I was a Hiroshima bomb victim, and my image as atomic bomb manga artist spread. A coarse-mouthed neighborhood woman said to me, "Go ahead and write about your relatives. Me, I'd never bring shame to my own family!" She criticized my wife, "You married a bomb victim. He'll die soon of aftereffects of the atomic bomb, and then you'll be in a fix!" My wife shook with anger.

Taking those thoughts, too, into consideration, my wife asked me to stop writing about the atomic bomb. I also disliked being labeled "atomic bomb manga artist," and I wanted to stop drawing manga about the atomic bomb. But on the other hand, my anger toward the war and the atomic bomb grew and burned all the more. The city was full of avant-garde coffee shops, people dressed in psychedelic colors, hippies; on international antiwar day, Shinjuku Station was occupied by protesters and set ablaze. With the university struggles that occurred one after the other and the 1970 struggle over the Security Treaty, Tokyo was in an uproar.

Having been selected in a drawing for city-managed apartments on the eastern edge of Tokyo, we were finally able to get a two-room place. In advance of the reversion of Okinawa to Japan scheduled for 1972, I wanted to tackle the true nature of the specter that is war. I asked my editor, "Can

I do something about Okinawa?" Editor N. gave his okay right off and advanced me money for travel to Okinawa and for materials. Having read up on Okinawa and hammered the stuff into my head, I set off.

I went through the procedures for foreign travel—I got a passport and a visa—and landed at Naha Airport.* Chain-link base fences stretched endlessly on both sides of the road, the whole way from the airport to Naha City, until I got to the hotel on International Road. The latest planes took off for Vietnam. Warships clogged the harbor. The route was a weapons expo. I'd seen the bases at Iwakuni near Hiroshima and Yokota near Tokyo and had imagined Okinawa would be like them, but I was astonished at the unimaginable size of the U.S. bases. It was as if the people of Okinawa lived on a mere spot of land among the bases.

At Kadena Air Base I got out my camera to take a picture of B-52s taking off, and a patrol car came rushing up, red light flashing and guards with carbines. It was further confirmation that Okinawa was really America. Their land having been stolen for use as bases, farmers tilled their fields and grew crops right up to the fences. Children learned at school amid the incredibly loud noise. Racial fights took place between blacks and whites on the streets of Koza. Squat munitions storehouses contained nuclear weapons. Okinawa had been turned into a battlefield. It might explode at the slightest touch and Okinawa itself vaporized instantly. I trembled at the thought.

Walking the battlefield of southern Okinawa, where artillery shells had poured down like iron rain, I peered into a foxhole in the field. I was overcome, thinking, "They crouched in so small a hole to keep from getting torn apart in the violent bombardment?" Fear oppressed me. As I imagined the wretched people fleeing across the battlefield, these images superimposed themselves on the images of me fleeing atomic hell, and I had trouble breathing. As I walked about Okinawa, the only battleground in the Pacific War in which land fighting involved Japanese civilians, the cruelty of war, war's screams enveloped me. I returned to Tokyo in a very dark mood. I realized the issues involving Okinawa were too large for a single manga artist to treat.

My editor asked me, "How's the Okinawa work coming?" At the point of tears, I replied, "Let me off, please. Okinawa's utterly impossible to draw. You even advanced me money for materials, so I apologize." In fact, I did suffer greatly trying to make a manga about Okinawa. With the

*Okinawa had been Japanese territory since at least 1873, but from 1945 to the reversion in 1972, Okinawa was U.S. territory, and the Japanese needed both passport and visa to travel there.

persuasion and advice of my editor, I tried again to draw Okinawa. All I could do was draw honestly what I'd actually seen, so I made it a report on Okinawa, entitled "Okinawa," and published it in *Boys' Jump*. Mail poured in from readers. Once again I realized the power of the "lowbrow weeklies." Many letters were filled with prejudice and naive Japanese thinking about war: "The Okinawans speak Japanese? I thought they spoke only English," and the like.

I understood clearly just how biased many Japanese were about Okinawa. They forgot that during the war it was damaged so thoroughly and that after the war it was occupied by the U.S. army and was cast off from Japan proper. Given that many Japanese didn't even know the facts of the atomic bombing of Japan, that wasn't surprising. A cocky letter came from a young Self-Defense Forces man: "Okinawa is forever crucial as an important base for the defense of Japan proper, so even after reversion, we'll keep the current bases; we'll take over and defend Japan. It's not something for manga artists like you to get worried about. Don't complain about Okinawa." I got angry. I got savage: "If we leave it up to young Self-Defense Force members like you who don't know the reality of war, there's no telling what will happen!"

Usually I'm astonished when I see Self-Defense Forces people. Seeing them, fodder for American and Japanese merchants of death profiting from the manufacture of weapons, I want to thunder, "Don't waste the taxpayers' money!" If you want to defend the country, then reforest barren lands and turn them green; clean up polluted rivers and bring the fish back. That would be a true Self-Defense Force. The only way to defend Japan is peaceful diplomacy, talking with all countries. I was there when the atomic bomb fell, and I knew more than I ever wanted to know about the reality of the atomic bomb. I'm convinced the Self-Defense Forces serve no purpose and aren't needed.

Another thing about Okinawa angered me. I'd thought that Okinawa was *occupied* by the United States after Japan's defeat, but I read an article that according to U.S. documents, in negotiating the terms of defeat and seeking clemency for himself, the emperor had said it was okay to *hand over* Okinawa to the United States. My blood boiled all over again. "Dumb emperor! How could you say that about Okinawa so nonchalantly?" I was astonished. Under the banner of "for the emperor," how many Okinawans died senseless deaths? How many Okinawan young people and residents had pledged loyalty to the emperor—"Long live the emperor!"—and died? I'd collected data on the subject, so I knew the nauseatingly cruel conduct carried out in the name of the emperor. I wanted to grab the emperor by

the collar, throw him into a foxhole on the battlefields of southern Okinawa, and show him the suffering of those who died.

Turning Okinawa into *Okinawa* was hard work, and I suffered doing it, but I was grateful to editor N. for having had me draw Okinawa. Afterward my editor encouraged me to do a serial of *Suddenly One Day*, and I composed a story of a second-generation bomb victim, titled *Something's Up*, eighty pages long. The reaction was enormous. More than half of all the letter writers said they hadn't known the true facts about the atomic bomb. And they encouraged me to teach them more of the truth, of what really happened. Then I published a single-issue sixty pager, *Song of the Red Dragonfly*, about an old man whom the atomic bomb left without relatives.

As I continued to draw the atomic bomb, I grew depressed and bitter, so for a while I tried a change of pace, abandoning the topic of the atomic bomb and drawing lighthearted stories. But after a while, my anger and my grudge against war and the atomic bomb bubbled up again, and I realized, "You still haven't exhausted your hatred of the atomic bomb!" In September 1971 I was asked to do a yearlong serial for the Sunday edition of *Red Flag*, and I published *Song of the Clang-Clang Trolley*.* It depicted relations between a bomb victim trolley man and a second-generation bomb victim. It got very good reviews. They told me it got more response than any manga serial the party organ had ever published, and they asked me to keep the serial going. Though I was delighted, I was exhausted from thinking only about the atomic bomb for a year. So I declined and told them I wanted to end it, as per contract, at one year.

I heard from *Boys' Jump* editor N., who'd read the Sunday serial: "If you can compose for other papers, compose for *Jump!*" I owed him, so I could only agree. Editor N. said, "There are a great many editors in the publishing world, but I'm the only one who really understands you." I was grateful to editor N. himself for having advised me how to create this new manga field. I was filled with gratitude that I'd been blessed with a really good editor. Anger toward the atomic bomb bubbled up again, and running headfirst into my anger—"Damn! Damn!"—I continued to draw the atomic bomb theme: *Our Eternity*, *Song of Departure*, *Song of the Wooden Clappers*, *One Good Pitch*.

August 6, 1971. The memorial ceremony for the atomic bomb. Emperor and empress bowed at the cenotaph and visited bomb victims at a facility for bomb victims. An article reported what he said to them: "He was utterly sympathetic and hoped that world peace would continue. Learning

**Akahata (Red Flag) is the organ of the Japan Communist Party.*

that many citizens are still receiving treatment went to his heart. In the future, he hopes that you will have cheerful feelings for one another, continue your treatment, and quickly regain your health." I read it in Tokyo and boiled over: "What gall! How can bomb victims have cheerful feelings? Atomic bomb sickness has no medical solution. If there were an easy solution, why would they suffer? This suffering happened on your watch, didn't it?" I trembled with rage: "By attending the Hiroshima ceremony, you want to relegate the atomic bomb to the past and buy a get-out-of-jail-free card for your war guilt. But I won't let you!" I was so angry at those minor functionaries who'd picked well-behaved bomb victims to sit there in the emperor's presence and who carried out the ceremony, I could have puked.

October 1972. *Boys' Jump Monthly* decided to have each manga artist draw his autobiography, and I was urged to be leadoff batter and do the first issue. I was flustered. I declined: "Draw my autobiography? How embarrassing! Impossible!" The editor kept at me, arguing that I should set my life down in manga form. I thought it over and published in *Boys' Jump Monthly* a single-issue, forty-five page autobiography, *I Was There*. The reviews were good, but for me it was sheer embarrassment. A letter contained this reader's apology to me: "Nakazawa was always doing atomic bomb manga, so I thought he was a hateful manga man always advertising himself and profiting off the atomic bomb, but reading *I Was There* and realizing he had experienced the atomic bomb and was drawing the truth, I felt sorry I'd doubted him." My own feelings were complicated and dark.

Editor N. read my autobiography and said, "In forty-five-pages, single-issue format, you depicted only a fraction of what you really have to say. You still have much more to say. Please use this autobiography as draft and do a long serial for *Boys' Jump*!" He encouraged me: you choose the serial length you want; I'll guarantee you'll get the page count you want. I could only agree. I was full of gratitude to editor N., who had given me a place to publish earlier. Moved, I started in on a long serial on my autobiography. Up till then, I'd published many atomic bomb manga, but I'd always wanted to stress the prewar years, something that had been impossible because of page count.

How do wars begin? Who plans wars? I'd long thought it wasn't possible to talk of war and atomic bombs without depicting the process whereby free speech and action and thought were stolen away under emperor-system fascism and Japan plunged into aggressive war. So my thoughts ballooned: I wanted to depict in depth Japan's dark politics of terror, including Dad's

horrible experience of being arrested by the Thought Police, as well. My feelings ripened, too. I asked for my wife's cooperation: "This next serial I'm really going to do it, so there'll be hateful letters and phone calls, and bad guys may come calling, so be careful. If they want a fight, I'll fight them to the finish." I too firmed up my resolve and set to work.

THE BIRTH OF *BAREFOOT GEN*

June 1973. Using my own life and introducing as protagonist my alter ego, "Gen," I began to draw *Barefoot Gen*. I portrayed my family as it actually was; I made "Gen" roam the atomic wasteland barefoot. I called the protagonist "Gen" in the sense of the basic composition of humanity so that he'd be someone who wouldn't let war and an atomic bomb happen again.* I began the serial in the pages of *Boys' Jump*. In drawing *Gen*, I went back to prewar and wartime Hiroshima. One after the other, scenes came floating up: the streets of Hiroshima on which I'd wandered, starving; our neighborhood; the guys I'd fought with. In the manuscript I ran about, all over Hiroshima. And I raised my voice to sing Mom's favorite tune, "Life is short."

Boy's *Magazine* and *Boys' Sunday* were the founding fathers of manga weeklies and boasted of their circulation. But in the blink of an eye *Boys' Jump* overtook them and overwhelmed them, selling consistently one million, then two million copies. This circulation even became a source of public concern. I was absolutely delighted that *Jump* sold. My work caught the eye of many readers, and it was good for them to encounter the reality of war and the atomic bomb. *Barefoot Gen* was heavy subject matter, and I knew perfectly well it wouldn't become a big popular hit. But steadily, if rather inconspicuously, *Gen* attracted fans.

I got letters. From adults—"I remember the suffering of war and don't want there to be another war." From grade school pupils—"I pity Gen, who was starved for food, so I'd like to give him my food." People thanked me for *Gen*—"You've rendered the wartime give-and-take between parent and child smoothly." Editor N.'s second-in-command told me, "When I take *Jump* home with me, my mother reads only *Gen*." A young editor assigned to me just out of college had thought little of being assigned *Gen*—war was no concern of his. But as the book's installments advanced, he realized that war destroyed all that is human, and he wept over Japan as

**Gen* is the first half of the compound *Genso*, which means chemical element.

it tumbled down the slope to defeat. In a state of high excitement, I drew the panels that told *Gen's* story.

One time, I was with other manga artists; they formed a group. One of them, A., said to me, "Enough with the atomic bomb manga!" He said, "They're too cruel, too shocking, for children! They're not good for them!" He said, "Manga have to give children dreams!" A. had received publisher S.'s prize for children's manga and said proudly that his own manga, which featured pigs flying through the air, were good manga. I was aghast and nearly puked: how can I associate with these worthless people?

Where in this life can you find the sweet and gentle world of children's fairy tales? If you hide harsh reality from children and sugarcoat war and the atomic bomb, they'll wind up thinking naively, "So war and the atomic bomb are not so bad after all?" Writers who choose that path make me angry. It's an eye-for-an-eye world. I think it would be a very good thing if, seeing the cruelty of the atomic bomb, more and more children throughout Japan cry, "I'm terrified!!" "I don't like this!" "I don't want to see it again!" I hope that if the number of children who hate to see the words "war" and "atomic bomb" increases, they won't repeat in their lifetimes the experiences we went through. Do those people imagine that if war comes, if atomic bombs are dropped, there'll be time for the artistic discussion of fairy tales and the like? In an instant all that will be wiped out. I was disgusted: what un-serious, silly artists! It turned my stomach that A., who gave himself airs as a man of the fine arts, thought he could get on his high horse and tell someone else to stop.

To be accepted into that manga group of A. and his fellows, you had to be recommended by three manga artists. A. said self-importantly that okay, he'd recommend me. I thought, "Eat shit!" I puked at the thought that anyone would want to be accepted into that group. I believe in belonging to no group. I think it's an unfortunate thing to be constrained by the rules or the pressure of the group and not be able to speak your mind. I don't associate with other manga artists. That's because I'm unhappy associating with fellow cartoonists—it's as if I'm only seeing myself. It's when I associate with people from professions with which I'm not acquainted that I learn and gain.

Slanderous voices like that of A. came to my ears, but I didn't respond to them. Instead, I thought, "Say what you will!" Even if I worked my whole life, I couldn't dispel my hatred of war and the atomic bomb; knowing that, I kept drawing *Gen.*

I drew what happened on the day the bomb fell. Even my editor reacted negatively to the harsh scenes that unfolded in the burned-out ruins

of atomic wasteland: he said, "It's horrible." But I continued to struggle, unable to re-create the truth that was still burned onto my retinas. Quite the opposite of the editor, I wondered: "Wishy-washy depictions like these make such an impact on him?" With each episode, as I drew pictures of maggots wriggling in burns or the putrefaction of corpses, readers grew increasingly uncomfortable. I became dejected and decided to change my drawing, even though the result wasn't realistic. If, merely because they get uneasy, people won't follow the story, why draw it? So I drew it in much softer fashion.

The speed of the weeklies' cycle dumbfounded me. The days were tough. I continued to be pursued by deadlines, and my killer schedule exhausted me. I hated the production system, where you hire lots of assistants to produce the manga. I couldn't bear to be like the manga artists who have several monthly and weekly magazines. As in a factory production line, they hire dozens of assistants and set the manuscript on a conveyor belt. The only way was for me to draw my own story myself, difficult though it was. I couldn't talk myself into working in a drab manga factory.

As the weeklies became established and the demand for manga grew, the method of producing manga became established: bring together authors responsible only for the stories and manga artists who did the drawings to suit. It was the method used in making movies and was said to be the trend of the times. But I didn't want to become a manga man who takes someone else's stories and churns out drawings like so much wallpaper. To my mind, manga should be the unified expression of your own ideas and emotions. I couldn't take the cheerlessness of drawing pictures for a story that wasn't my own. I couldn't go along with the "anything for a buck" mentality. In that sense, I plodded along, self-confident, with the help of my wife and, at crunch time, temporary assistants. I prided myself on my method even when people told me, "You're old-fashioned."

I continued to draw criticism of the emperor system and censure of the United States for dropping the atomic bomb, so I thought I'd get plenty of harassment. But I was disappointed that *Gen* provoked neither a single polemic nor the harassment I'd anticipated.

Then came the oil shock. It brought a shortage of paper and economic chaos. The page count of the weeklies suddenly shrank, and the page count of manga books was reduced time and again. Told to keep *Gen* to thirty-page installments and many times to skip an installment, I grew unhappy, thinking, "This happens just when the story is developing!" My exhaustion became extreme, and the energy to draw *Gen* disappeared. At

that point, founding editor N. was promoted and left the scene, and I got *Jump* to let me stop *Gen*, even though it was still unfinished; it had run in *Jump* for eighteen months. I realized *Gen* was not at the top of fan popularity in *Jump*. In the harsh world of commercial magazines, unpopular works got cut one after the other. I was indebted to editor N. and the others for *Jump*'s conscience in continuing to run *Gen* even though it wasn't popular.

I hoped to regain my health and resume the serialization of *Gen*, but for the moment I'd lost the energy to draw *Gen*. The manuscript of *Gen* came back, and I packed it away in the storeroom. Rereading my own work made my flesh crawl. It was really tough. I grew dejected—"I really am lousy!" Issues of magazines carrying my work I immediately stuck in a drawer. Ideas for *Gen* continued to rattle around inside my head, but for a change of pace I drew light works. Six months passed.

GEN AND BEYOND

Year by year, the U.S.–U.S.S.R. nuclear arms race grew more fierce, and in desperation I found fault with both sides: "Yeah, let's have more and more nukes. Both of you go all the way, and we'll all die!" I boiled over: "You think there are winners and losers in a nuclear war?! Damn fools!" One day I got a phone call from reporter Y. at the *Asahi* newspaper. He covered things atomic and had learned that there was a manga titled *Barefoot Gen*. He asked, "Won't you let me read it for my own enlightenment?" I was puzzled—"Why should work I did six months ago be useful now?"— but I said okay.

Pulling from the drawer issues of *Boys' Jump* that carried *Gen*, I piled up eighteen months' worth. While I worked, reporter Y. sat in a chair behind me, mumbling and shifting back and forth in his chair as he read *Gen*. I thought that was a strange way to read, but I kept on working. When it began to get dark, Y. had read nearly half of *Gen* and said, "I'd like to come back tomorrow morning and read." He put me on the spot. With someone sitting behind me, I was distracted and couldn't work, but reluctantly I said okay. Next day Y. read the ensuing installments of *Gen* and mumbled a lot. All that shifting in his chair and muttering: it was really strange.

Only afterward did I understand that Y. was crying as he read *Gen*. Embarrassed to show tears, he kept shifting in his chair to hide the fact that he was crying. He mumbled to hide his sobs. Once he'd read all of *Gen*, Y. asked me, "Why not issue *Gen* as a book from the company that

published it as a serial?" I explained the restraints under which commercial publishing operates.

My *Okinawa* had been serialized in *Jump*. To turn it into a book, I'd reduced the page count and drawn a four-color cover, and it was ready for the presses to roll; we'd be able to put it on sale right away. I too rejoiced that for the first time my work would appear in book form. But the process of turning *Okinawa* into a book came to a sudden stop. Afterward, I learned the reason from those in charge. A work with heavy political coloring that questioned real war and atomic bomb was okay in a weekly because it vanished after that week; as a book, it would remain the company's product and give the company a bad image. So the company couldn't publish it. I learned there was pressure from above: "We can't produce works that oppose the current government!" It was the same as the self-censorship of the commercial magazines. I lost hope. I was appreciative of the attitude of the editors who'd been good enough to carry through with the serialization of *Okinawa* and *Barefoot Gen*. That was the explanation why there was absolutely no way to turn *Barefoot Gen* into a book.

Y. was avid to turn *Barefoot Gen* into a book. He talked with groups and people he knew. I'd never experienced such friendly assistance from anyone outside manga publishing. Y. approached bomb victim groups, too, and pushed the idea of a book aimed at those who hadn't seen the serial version, arguing that *Gen* was significant because it had communicated the war and atomic bomb candidly to twenty million Japanese.

If the decision was made to publish *Gen* as a book, Y. said, he wanted to write articles about the process. I, too, thought it would be a shame if the manuscript of *Gen* wound up buried in the storeroom, and I asked acquaintances whether they knew of a willing publisher. I was given introductions to several publishers, but the conventional wisdom held that atomic bomb stuff didn't sell, so they didn't take the project on. At that point, from a conversation with an acquaintance, I learned of a press that would publish it as a book. It was a publisher who had absolutely no connection with manga, who specialized in academic texts and textbooks.

May 1975. The book version of *Gen* went on sale. Y.'s article about *Gen* was reported widely in the arts pages. Triggered by his article, the mass media—TV, radio, and the rest—joined in. Demolishing the conventional wisdom that atomic bomb stuff didn't sell, the four volumes of *Barefoot Gen* sold in a rush. The number of *Barefoot Gen*'s readers increased several times over.

Then, aware that *Gen* was incomplete and that the structure of the rest was all set, Y. gave me an introduction to a magazine that would serialize *Gen*. It was the monthly *The People*, a magazine that ran hard stories and works, and I felt out of place. But I was grateful to Y., and in September 1975 in *The People*, the first installment of the postwar part began. Serialization in *The People* ended after one year. It folded because of poor management. The postwar part of *Gen* ended in midstream.

Although I was puzzled that the reaction to *Gen* was so huge, I searched for a magazine to complete the unfinished serialization of *Gen*. Publisher S., an acquaintance, introduced me to the monthly *Literary Review*, and it ran the postwar part of *Gen* for about three and a half years, but the editor in chief told me, "I can't pay you, so please stop." *Gen* came to a halt once more. I was asked by *Education Review* whether I might do an eight-part manga. I asked them to run *Gen*, and *Education Review* ran it for three and a half years. Even though I was ruining my health, I finally completed it. From the start of serialization, it had taken fourteen years.

Even I agree that that was an astonishingly long time. In book form *Gen* became ten volumes, and they quickly made the rounds among children. In libraries, they were read so much that the copies became dog-eared and broken. For a manga man, that was the highest honor. Manga are destined to be read once then chucked. I was truly grateful for readers' letters, saying things like "I've read it twenty times."

Thank you to the female college student from Akita who, having read *Gen,* is taking part in the antinuclear movement.

Thank you to the Sendai housewife who said that if I kept writing *Gen*, she'd keep reading it no matter how many years she had to wait.

Thank you to the many girls who saw the anime of *Gen* and sobbed, "I'm terrified!" You all really understood foursquare the horror of war and atomic bomb.

Thank you to the many people who nurtured Gen and supported me. You have my sincere gratitude.

The History of Hiroshima Prefecture says, "Before the war, there was an antiwar movement in Kanzaki." Kanzaki is where our house was. The reference is to the antiwar activities of Dad and the others. Just recently, a monument was erected to "unsung soldiers" on Peace Boulevard in Hiroshima. It lists the names of those who carried on antiwar activities despite official repression and who died in the atomic bombing. Their names are

listed, and they are enshrined together. Those who erected the monument inform me that on the list is Dad's name, Nakazawa Terumi.

> Life is short—fall in love, young woman,
> Before the red fades from your lips,
> Before the hot blood cools within you.
> There's no tomorrow.
>
> —Yoshii Takeshi

The *Gondolier's Song* that Mom sang is my theme song. I resolve from now on to my dying day to keep drawing works that fill in the void of Hiroshima, the void which, fill it though I try, can never be filled. And I tell myself that this time I'll be the one singing the *Gondolier's Song* Mom sang.

As the child of Nakazawa Terumi and Nakazawa Kimiyo, I swear I'll keep singing.

AFTERWORD

B*arefoot Gen* was born as a manga based on my actual experience. It became a picture book and a children's book. It also became a documentary, an animation, a stage play, and an opera. Indeed, Gen's been running around in many shapes and forms.

Barefoot Gen was serialized in *Weekly Boys' Jump* twenty-one years ago, in 1973. That, in human terms, means it's about to become an adult.

Next year (1995) will be the fiftieth year since the end of the Pacific War, and it will be the fiftieth anniversary of the dropping of atomic bombs on Hiroshima and Nagasaki. On the major occasion of the fiftieth anniversary of the atomic bombs, the media will treat it at length.

But even if they treat it at length on the fiftieth anniversary, once the fiftieth is past, interest will probably ebb like the tide. The media will stop covering it—"The story of the atomic bombing of Hiroshima is over"; "We can stop talking about the war now."

There are the bomb victims, and there are those who have suffered damage from nuclear weapons all over the world. The globe has been contaminated by nukes. So long as one atomic bomb exists, Hiroshima will remain an issue.

Nineteen ninety-five will mark Gen's twenty-second birthday and the fiftieth anniversary of Hiroshima. I hope to make it a starting point for *Barefoot Gen* to set out. I've had ideas and made plans for further installments of *Barefoot Gen*. I hope Gen himself will mature and communicate the spirit of peace not simply to the children of Japan but also to the children of the world.

Together with Gen, I hope to travel to various places and collect material—Chernobyl, Semipalatinsk, the Urals in the old Soviet Union; Nevada and Three Mile Island in the United States; the islands of the South Pacific (Bikini, Muroroa); Auschwitz; Nanjing in China.

Barefoot Gen will set out.

Won't you, too, set out with him?

APPENDIX

Interview with Nakazawa Keiji

BAREFOOT GEN, JAPAN, AND I: THE HIROSHIMA LEGACY
An Interview with Nakazawa Keiji
Asai Motofumi, President, Hiroshima Peace Institute*

*I*n August 2007 I asked Nakazawa Keiji, manga artist and author of Barefoot Gen, for an interview. Nakazawa was a first grader when on August 6, 1945, he experienced the atomic bombing. In 1968 he published his first work on the atomic bombing—Pelted by Black Rain—and since then, he has appealed to the public with many works on the atomic bombing. His masterpiece is Barefoot Gen, in which Gen is a stand-in for Nakazawa himself. His works from Barefoot Gen on convey much bitter anger and sharp criticism toward a postwar Japanese politics that has never sought to affix responsibility on those who carried out the dropping of the atomic bomb and the aggressive war (the United States that dropped the atomic bomb and the emperor and Japan's wartime leaders who prosecuted the reckless war that incurred the dropping of the atomic bomb).

Nakazawa: In my writings there's a ferocious anger toward power, toward rulers, and I don't trust people who say nothing about the emperor system. The emperor system—that's really what it's about. That emperor system, the horror of the emperor system, still exists today: the Japanese simply have to recognize that! And I'm horrified that once again they're fanning it, pulling it out. I remember well when the emperor came to Hiroshima in 1947. I wrote about it in my autobiography. . . .

*The interview took place on August 20, 2007. An abbreviated translation appeared in *Hiroshima Research News* 10, no. 2 (November 2007): 4–5. This translation is by Richard H. Minear and appeared first on Japanfocus.org and then in *International Journal of Comic Art* 10, no. 2 (fall 2008): 308–27; this excerpt, slightly amended, is reprinted with permission.

Asai: In Hiroshima greeting the emperor, there was virtually no anger or hatred toward the emperor. Why not?

Nakazawa: Because of the prewar education. The prewar education changed the Japanese people completely. I feel acutely how horrible that education was. I'm angry: "If that guy had only swallowed the Potsdam Proclamation, there would have been no atomic bombing." He survived in comfort, that impudent, shameless guy. Some people did feel the anger I felt toward the emperor, but all of them probably died in prison. I learned from Dad: the emperor system is horrible. When I asked why should Japanese have to bow and scrape so to the emperor, Dad replied, "to unify Japan." Turn him into a living god and make people worship him. That system. Since I heard things like that from early on, when I was lined up and made to shout *Long live the emperor!* I got really angry. The rage welled up. That feelings like mine didn't surface in Hiroshima was probably because Hiroshima was conservative. In Hiroshima Prefecture, there really is a prefectural trait—conservatism. Impossible. It'll be very difficult to change.

Asai: Looking at the process in which Hiroshima mayor Hamai Shinzō drew up the Peace City Construction Law and set about rebuilding Hiroshima, I get the sense that it was not a reconstruction that took the atomic bomb victims into careful consideration, that reconstruction took priority.

Nakazawa: It really left the bomb victims out. And in the Mayor Hamai era, virtually everyone was a bomb victim, so maybe they couldn't think about compensation.

Asai: When you consider that the population of Hiroshima, which the atomic bombing had reduced radically, rebounded rapidly after the war, and that the seventy to eighty thousand bomb victims didn't increase, it was the increase of nonvictims— repatriates and people coming here from other prefectures—that made it possible for the population to rebound rapidly. In the "empty decade" right after the war it was the nonvictims who bore the recovery; it was a recovery in which bomb victims were chased to the fringes. That's my feeling, at least. What do you think?

Nakazawa: You're not mistaken. And in the process discrimination arose. Given the discrimination, you couldn't talk about having been exposed to the atomic bombing. You simply couldn't say publicly that you were

a bomb victim. So the discrimination was fierce. You couldn't speak out against it. I was living in Takajō, and I often heard stories, such as the neighbor's daughter who hanged herself. Discrimination. Dreadful. There were lots of incidents like that, in which people had lost hope.

Asai: Ōta Yōko's City of Twilight, People of Twilight *depicts a group of bomb victims living in one household in Motomachi in 1953. It was reconstruction Hiroshima, with the bomb victims relegated to the edges. And the August 6 commemoration, too: I get the sense that from the very first it was carried out without the bomb victims as main actors. How did you, someone who was there on August 6, feel?*

Nakazawa: There was discrimination, and if you emphasized the atomic bombing openly, they'd gang up on you and say, "Don't put on your bomb-victim face!"—a strange way to organize a movement. When there were atomic victims on the Japanese fishing ship, the *Lucky Dragon #5,* that received fallout from a U.S. nuclear test at Bikini in 1954 and it became a big issue, Ōta said, "Serves you right!" Meaning, *now* do you get it? That's how badly bomb victims were alienated. Even if you wanted to speak, you couldn't, and if you spoke, the result was discrimination. Discrimination meant they wouldn't let you complain. An acquaintance of mine proposed to a Tokyo woman, and they celebrated the wedding in Tokyo. And no one came. There was that sense: it's risky to say you're a bomb victim. That was what the powerful wanted. Because there was discrimination, you couldn't say anything: that suited their convenience. Bomb victims were pressured not to assert themselves. Bomb victims first came to the fore at the 1955 World Convention to Outlaw Nuclear Weapons. After all, atomic tests were being carried out one after the other, and death ash was falling; maybe it was the sense of danger that did it.

The World Convention to Outlaw Nuclear Weapons splintered in 1963, and that, too, is a strange story. There were some who made the ridiculous assertion that Soviet nukes were fine and all other nukes bad. I couldn't buy that argument. How can it be a matter of left or right? Doesn't the goal of the abolition of nuclear weapons apply to all?

Asai: At first bomb victims had great hopes of the movement to abolish nuclear weapons, and in 1956 the confederation of bomb victim organizations also came into existence. But they felt great disappointment and disillusionment at the splintering of the movement to abolish nuclear weapons, were critical of it, and ended up turning their backs on the movement itself. Isn't that the case?

Nakazawa: Yes, it was. They couldn't go along with it. People like me felt, "What are these people doing?" If we joined forces for the abolition of nuclear weapons, we'd be twice as strong.

In 1961 I moved to Tokyo and, until Mom died in 1966, thought I'd never return to Hiroshima. Return to Hiroshima, and you experience only gruesome things. So I thought I'd die and be buried in Tokyo. Had Mom not existed, I might have become a common criminal or fallen by the wayside in Hiroshima; when she died, I'd accomplished something because of her. She played a major role in my life. Her death was a great shock, and I came back to Hiroshima. Thankful for Mom, I sent her body to the crematorium; I thought I knew what a human body that's been burned looks like. I'd retrieved Dad's bones and my siblings' bones. I thought I'd get Mom's skull or breastbone in similar shape, too. But when her ashes came from the crematory and were laid out on the table, I found not a bone. I couldn't find even her skull. Thinking this couldn't be so, I rummaged for all I was worth. There were only occasional white fragments. And I got very, very angry: does radioactivity plunder even bone marrow? It made off with the bones of my dear, dear Mom.

I shut my eyes entirely to the atomic bombing, but Tokyoites' discrimination against bomb victims was awful. If you said that you were a bomb victim matter-of-factly, among friends, they made weird faces. I'd never seen such cold eyes. I thought that was strange, but when I mentioned it to people in the movement, they said that if someone says, "I'm a bomb victim," Tokyo people won't touch the tea bowl from which he's been drinking, because they'll catch radioactivity. They'll no longer come near you. There are many ignorant people. When they told me this, for the first time it clicked: "Yes, that's how it is." And I thought, "never speak of the atomic bomb again!" So for six years in Tokyo I kept silent, and when Mom died and none of her bones were left, I got really angry: both she and I had been bathed in radioactivity, so it made off with even the marrow of our bones. The anger welled up all of a sudden: give me back my dear Mom's bones! I thought, "manga's all I know how to do, so I'll give it a try." And I wrote *Pelted by Black Rain* in that anger. I wrote it to fling my grudge at the United States. Its contents were horrific, but that's how I truly felt. I wrote it in hot anger and just couldn't get it published. I hoped to have high school students read it. That if they read it, they'd understand. So I took it around to the major magazines that aimed at the high school student audience. I was told the content was good but it was too radical, and for a year I took it around. I was about to give up, but I thought again:

even if it wasn't one of the major magazines, wouldn't it do if it just got read? And I took it to the publisher of *Manga Punch*, the porno magazine. The editor in chief there was a very understanding person, "It moved me greatly." But "If I publish this, both Nakazawa and I will be picked up by the CIA." It was a magazine for young people; "the guys"—truck drivers, taxi drivers—read it.

Within the press, the reaction came back that it was "new." So it came about that I should write a "black" series.

Asai: Did you get reactions from readers focusing on the bomb victim aspect?

Nakazawa: "Did such things really happen?"—people expressed doubts like that. Which means they know absolutely nothing about the atomic bombing. Since I write only about what I had seen, it's not fiction. But although lots of people say Japan's "the only country to suffer atomic bombing," it's not understood in the least. On the contrary, I was the one who was shocked. I received letters, and they brought me up short. It was virtually the same as when I published *Barefoot Gen*: "Is that true?" "Tell us more!"—the vast majority of messages was like that. "I never dreamed that war and atomic bombing were so brutal."

Asai: Barefoot Gen *is in the libraries of primary and middle schools, and if they take courage and read it, I think they'll be able to understand Hiroshima better. How do you as the author feel about that?*

Nakazawa: After all, the overwhelming majority became aware of war and atomic bombing via *Barefoot Gen*. I don't pride myself on it, but in that sense I'm a pioneer. Even though Hiroshima figures in children's literature, there's nothing that takes it that far. I think manga offers the best access. That people are being made aware of war and atomic bombing via *Barefoot Gen*: that's the height of luck for an author.

Asai: Why on earth does the Ministry of Education allow the libraries of primary and middle schools to keep work that's so anti war and anti–emperor system?

Nakazawa: I too find it strange. As for manga in school libraries, *Barefoot Gen* was the very first. It paved the way. Thanks to *Gen*, it's permeated by now to the average person. For me, it's a delight to think that something I wrote has permeated that far.

Asai: It was dramatized recently for TV. I felt then the limits of TV dramatization.

Nakazawa: There certainly are limits. They removed a core issue—the emperor system. Nothing to be done about that. I think the emperor system is absolutely impermissible. The Japanese still haven't passed their own judgment on the emperor system. I get angry. Even now it's not too late. Unless we pass judgment on such issues. . . .

Asai: Pass judgment—how?

Nakazawa: By a people's court, actually. The Japanese people must ask many more questions: how much, beginning with the great Tokyo air raid, the Japanese archipelago suffered because of the emperor, how the emperor system is at the very root. To speak of constitutional revision, my position is that it's okay to change the clauses about the emperor—but only those clauses. The rest can't be changed. Article 9? Preposterous! Absolutely can't be changed.

Asai: In your autobiography, you say that as you keep writing about the atomic bombing, you sometimes need to write light stuff.

Nakazawa: When I write scenes of the atomic bombing, the stench of the corpses comes wafting. The stench gets into my nose, and appalling corpses come after me, eyeballs gouged out, bloated; it's really unbearable. Because I'm drawn back into the reality of that time. My mood darkens. I don't want to write about it again. At such times, I write light stuff. For a shift in mood.

Asai: In Suddenly One Day *and* Something Happens, *the protagonists—second-generation bomb victims—get leukemia. Did such things actually happen?*

Nakazawa: It's possible.

Asai: I've heard that as of now the Radiation Effects Research Foundation doesn't recognize effects on the next generation.

Nakazawa: I think such effects exist. I worry. I worried when my own children were born because I was a bomb victim. I was uneasy—what would I do if the radiation caused my child to be born malformed?—but fortunately he was born sound. I try to have him get the second-generation bomb

victim check-up. There's a medical exam system for second-generation bomb victims; the exam itself is free of charge. But we were uneasy at the time my wife conceived him. We were also uneasy when we got married. Fortunately, there were bomb victims in her family, too, so she was understanding. I worried at the time we got married that there would be opposition. Luckily, people were understanding, and the marriage went off without a hitch. When the children married, I worried secretly. Now we have two grandchildren.

Asai asks about Kurihara Sadako.[*]

Nakazawa: She and I appeared once together on NHK TV. Eight years or so ago. On an NHK Special. A dialog. The location was Honkawa Elementary School. We discussed the experience of the atomic bomb. In broad Hiroshima dialect, Kurihara said to me, "Nakazawa-san, good that you came back to Hiroshima"—that's how we began.

Asai: I thought Kurihara was a very honest Hiroshima thinker.

Nakazawa: I too liked her. She wrote bitterly critical things. Like me, I thought. She wrote sharply against the emperor system, too. After all, our dispositions matched. But in Hiroshima she became isolated. If you say bitter things, organizations divide into left and right. Even though you're stronger if everyone gets together . . . Say something sharp, and people disagree, and label you. That's not good. The peace movement has to be united. That's why I never join political parties. It's something I hate—that Japanese are so quick to apply labels. Immediately apply a label and say, "he's that faction or that one," and dismiss him. No broad-mindedness. If a job comes, I respond with an "okay." But I never concern myself with political parties.

Asai: How did you come to want to return to Hiroshima?

Nakazawa: Up until ten years ago I stayed absolutely away from Hiroshima. Merely seeing the city of Hiroshima brings back memories. The past. Seeing the rivers, I see in my mind's eye rivers of white bones. Or the good spots for catching the freshwater crayfish that grew fat on human flesh. Such

[*]Kurihara Sadako (1912–2005), noted Hiroshima poet and activist. For her poems in translation, see Kurihara, *Black Eggs*, ed. and tr. Richard H. Minear (Ann Arbor: Center for Japanese Studies, University of Michigan, 1994).

memories come back, and when I walk about, I remember, "This happened, that happened." I can't bear to remember the smell of the corpses. I wanted to stay away from Hiroshima. I can't express that stench in words. It brings back things I don't want to remember. This frame of mind of mine is likely the same as for other bomb victims. My former teacher is here, and classmates gather for his birthdays. So I think, "Yes, Hiroshima's okay." I have friends here. Time has swept them away, those vivid memories. So I've come to want to be buried in Hiroshima. I like the Inland Sea, so I'll have them scatter my ashes. I don't need a tombstone.

Asai: Why can't Hiroshima become like Auschwitz?

Nakazawa: Japanese aren't persistent about remembering the war: isn't that the case? When at Auschwitz I see mounds of eyeglasses or human hair, I think, "What persistence!" There's no such persistence among Japanese, and not only about Hiroshima. I wish the Japanese had what it takes to pass the story on. To erase history is to forget. I'd like there to be at least enough persistence to pass it on. I'd like to expect that of the Japanese. I do expect it of the next generation. I've given up on the older generation. I have hopes of the next generation: reading *Barefoot Gen*, they're good enough to say, "What *was* that?" On that point I'm optimistic. I want them to put their imaginations to work; I absolutely want them to inherit it. I want to pass the baton to them. On this point, the trend in Japanese education today is terrifying. I'm afraid the Liberal Democratic Party and the opposition parties will never abandon the idea of educational reform.

But defend Article 9 of the Constitution absolutely.* Because it came to us bought with blood and tears. People say it was imposed on Japan by the United States, but back then the people accepted it, and there's nothing more splendid. To forget that and think it's okay to change it because it was imposed—that's a huge mistake. What the peace constitution cost in the pain of blood and tears! We simply must not get rid of it. That's been my thinking about Article 9, from middle school on. Precisely because of it, Japan lives in peace. At the time of the promulgation of the constitution, I was in primary school, and when I was told that it transformed Japan into a country that no longer bears arms, will not have a military, will live in peace, I thought, "what a splendid constitution!" And I remembered Dad. Indeed, what you learn from your parents is huge. Parents have to teach.

*Article 9 commits Japan to the renunciation of "war as a sovereign right of the nation . . . Land, sea, and air forces, as well as other war potential, will never be maintained."

Not rely on schoolteachers. Teachers ask me how they should teach. What are they talking about? I say they should at least say, "On August 6 an atom bomb was dropped on Hiroshima." How to convey that to students in more expanded form: I say that's the teachers' function. There are all sorts of teaching materials, so if they don't do it, it's negligence on their part.

Asai: That's hope for Japan. How about Hiroshima?

Nakazawa: The conservative aspects of Hiroshima have to be changed. I think Hiroshima people are really conservative. The numbers of reformists must increase. In order to effect change, each person has to work away at it. I'm a cartoonist, so cartoons are my only weapon. I think everyone has to appeal in whatever position they're in. Wouldn't it be nice if we gradually enlarged our imaginations! We have to believe in that possibility. Doubt is extremely strong, but we have to feel that change is possible. Inspire ourselves. And like Auschwitz, Hiroshima too must sing out more and more about human dignity.

INDEX